ICONIC
RESTAURANTS OF
ANN ARBOR

FRONT COVER (clockwise from upper left): Del Rio's illustrated transom window (Courtesy of Susan Wineberg and the Bentley Historical Library), Drake's Sandwich shop (Photograph by Jim Rees); Pretzel Bell sign (Authors' collection), Zingerman's Delicatessen (Authors' collection), Le Dog (Courtesy of Jules and Ika Van Dyck-Dobos); Fleetwood Diner (Authors' collection)

UPPER BACK COVER: Old Heidelberg matchbook (obverse and reverse) (Authors' collection)

LOWER BACK COVER (from left to right): Brown Jug medallion sign (Authors' collection), Pizza Bob's (Authors' collection), Cottage Inn sign (Authors' collection), and Betsy Ross Shop blotter (Authors' collection)

ICONIC
RESTAURANTS OF
ANN ARBOR

Jon Milan and Gail Offen
Introduction by Ari Weinzweig

ARCADIA
PUBLISHING

Published by Arcadia Publishing
Charleston, South Carolina

Library of Congress Control Number: 2016937471

For all general information, please contact Arcadia Publishing:
Telephone 843-853-2070
Fax 843-853-0044
E-mail sales@arcadiapublishing.com
For customer service and orders:
Toll-Free 1-888-313-2665

Visit us on the Internet at www.arcadiapublishing.com

My lifelong kinship with Ann Arbor went from visitor to student to resident and back to visitor. And food has always been a huge part of it. As a child, I spent all my summers nearby and was lucky enough to have a bon vivant, food-obsessed uncle. Thanks to Uncle Mort, I tasted my first limeade at Drake's, Chicken in the Rough at Curtis, chop suey at Leo Ping's, Thompson's Pizza, DeLong's sweet potato pie, egg rolls and chap chae at Kosmo's, muffins at Afternoon Delight, fragels at the Bagel Factory, a Detburger at Del Rio and lobster bisque at Le Dog.

And very possibly all in one day.

Every generation of permanent, or temporary, Ann Arbor residents has their own longing, their own Drake's. A place they visit every time they are in town, or wish they still could. So, just like pizza toppings, this book is highly subjective. The debate rages on. And so does our appetite for Ann Arbor. Thanks, Uncle Mort.

—Gail M. Offen, 2016

CONTENTS

Acknowledgments 6

Introduction 7

1. The Legendary and the Long Forgotten 9

2. Local Favorites and Student Standbys 25

3. Hamburgers, Hot Dogs, Pizza, Popcorn, and Sodas 37

4. Around the World, Just up the Block 47

5. I Sure Miss _____ 57

6. Still Here and Going Strong 73

7. The Ann Arbor Food Continuum 83

ACKNOWLEDGMENTS

This book was made possible through the efforts, assistance, generosity, patience, and support of many. For that reason, we would like to extend as special thank you to the following individuals: McCabe Ash, Robbie Babcock, Diana Bachman, Maggie Bayless, Erin Bedolla, Jim Brandstatter, Laurie Brown, Camp Michigania Seventh Week Campers, Amy Cantu, Leonard A. Coombs, Frank Corollo, Monique Deschaine, Ray Detter, Katie Dixon, Jules and Ika Van Dyck-Dobos, Cindy Edwards, Ena, Murray Engel, Jessie Gerstenberger, Mike Gibbons, Sharon Gillespie, Tom Hackett, Betsy Hartwell, Roger F. Hewitt, Chris Hill, Liliani Ho, Dan Hunstbarger, Rick Ingalls, Tom Isaia, Tessie Ives-Wilson, Andy Jacobs, Alex Kales, Don Knight, Sara Konigsberg, Don Kosmo Kwon, Carl Lagler, Janice Bluestein Langone, Nikki Leibold, Clayton Lewis, Chelsea Lund, Andrew MacLaren, Louie Marr, Sarah McLusky, John McPartlin, Mike Monahan, R. Michael "Mike" Montgomery (posthumous), Dennis Moosbrugger, Malgosia Myc, Jerry Offen, Michael Olejnik, Lora Parlove, Chris Pawlicki, Sherry Perkins, Rick Peshkin, Jeffrey Pickell, Pamela Pietryga, Jay Platt, Nikki Polizzi, Doug Price, Kerry Price, Charles A. Rasch (posthumous), Tim Redmond, Ruth Reichl, Bonnie Ross, Randy Schwartz, Jeremy Sell, Paul Saginaw, Grace Shackman, Dick Siegel, Don Simons, Rudy Simons, Wystan Stevens (posthumous), Susie Sutter, Emily Swenson, Craig Tascius, Villabeth Taylor, David V. Tinder , Robert Vedro, Dennis Webster, Ari Weinzweig, Rita Whidby, Julie A. White, Karen Wight, Susan Wineberg, Phil Zaret, and, as always, Randy Samuels, "Here's to You!"

Special thanks to Ari Weinzweig for his foreword and his forward thinking. You were generous with your time and connections. We appreciate all your help, Ari.

Thanks to Jan Longone, founder and curator of the Janice Bluestein-Longone Culinary Archive (JBLCA) in the Special Collections Library, Hatcher Graduate Library, University of Michigan. Her culinary archive of over 25,000 items is one of the world's largest, and her personal cookbook collection is legendary. Jan, thanks for your kindness and incredible food knowledge. We look forward to your Culinary Historians of Ann Arbor meetings.

Susan Wineberg is an author, historian, archivist, and indispensable! Susan's books alone are a treasure trove of information, but she was also there for us from the very beginning, meeting us at libraries, and sending us updates, graphics, notes, and tips. She made herself available to us at all hours, and to that we are more grateful than words can express.

Grace Shackman did as much for us in the present as she has in the past. She certainly made herself available to us, even from thousands of miles away, but her books and countless historical articles written for the *Ann Arbor Observer* allowed us to fill in many blanks and enabled us to piece together a more complete picture of the wonderful restaurants included in this book.

Jules and Ika Van-Dyke Dobos, thanks for a lovely afternoon of coffee, cake, and reminiscing. Jules has wonderful cookbooks, recipes, and, best of all, great stories. We love Le Dog.

Monique Deschaine of Al Dente Pasta in Whitmore Lake, Michigan, thanks for all your connections. You really helped us fill in some missing puzzle pieces. And you make the best pasta!

Rob Vedro is our personal hero! The tireless co-owner of Blue Frog Books in Howell, Michigan, has outdone himself in effort and dedication, not only by processing the many graphics included herein, but by painstakingly constructing collages, transferring slide and video images (one of the many wonderful services he provides) and supervising the electronic packaging of materials. From beginning to end, he has been a tireless and greatly talented part of the team—and we think he has the best bookstore in Howell. Check it out at www.bluefrogbooksandmore.com.

INTRODUCTION

When I came here to go to school back in the mid-1970s, restaurants were the last thing on my mind. Clearly the town had plenty of them, but they played no part at all in my decision to come to Ann Arbor to attend the University of Michigan. Even while I was in school here, food was hardly front of mind. In truth, I do not really even remember a whole lot about what was on my mind. It does not sound very inspiring, but it was probably more about getting by (and something else that rhymes with that) than getting an amazing education, building a career, or carrying on the intellectual tradition of the famous academic institution of which I was one very insignificant part. Although I now write extensively about vision, the truth is that back then I had none. At least nothing very inspiring. I liked Ann Arbor well enough, but in truth I did not see all that much of it. Like most of my peers, I had no car and not much money. Which meant that eating out was a rare event. Getting downtown from campus was no small thing—walking 15 blocks when it is 15 degrees out was not my idea of a great time. Eating out was not even on my agenda. The restaurants were all there—I just did not really make use of most of them.

When I got to my junior year at U of M, I formally declared myself a history major (you have to pick something) and spent much of the following two years studying Russian history. Peter the Great, Dostoevsky, Tolstoy, Kropotkin, and the Empress Catherine were all prominent on my reading lists. And although I am not personally religious, the Russian Orthodox Church was, of course, a big part of the story. Prayer, church building, and icon painting all played prominent roles in what I was reading. Icons were one of the most interesting, and for those to whom they mattered, one of the most inspirational parts of Russian Orthodox culture. Many believed that they were inspired directly by God. Icons gave people a moment of connection with something bigger than themselves. A trigger to reflect. A setting in which solitude and community could come together in the same space. Some believed they were painted by angels.

While I do not want to say that any of the iconic restaurants in this book are acts of God, I do not think it is stretching things too much to say that for those who visited them regularly in their day, these places were very much akin to a religious, or at least near-religious, experience. They inspired. They provided a sense of security and stability. They had deeply loyal clientele who believed strongly in the business in ways that went far beyond a convenient counter at which to order breakfast or a cheeseburger. Like icons, the restaurants on this list gave comfort in times of crisis and sustenance in times of struggle. They inspired and gave their regulars a safe place in which they could study, reflect, recharge, or reconnect with friends, family, and community.

In the food world today we talk a lot now about what the French call *terroir*—it is a reference to the influence that location, soil, and climate all play in the flavor of the food that grows in it. Each plant is both influenced by and in turn influences the ecosystem of which it is a part. I like to think of business the same way. The best of them are a product of their environment, and at the same time, the environment is better for them being in it.

The chain restaurants that do not appear in the book are the opposite—they are neither iconic nor influential. Every unit in its respective chain is nearly identical to all the others; they are the same wherever anyone sets them down. Many have appeared in Ann Arbor over the decades. They come and they go, but they leave little mark on the town. The corporate offices that initiated their appearance and later pulled the plug on their presence are far more focused on financial statements and quarterly reports than they are about anyone or anything in this small Midwestern town with the big reputation. The focus on place is replaced by a near singular emphasis on profit.

In that sense, the restaurants referred to in this marvelous little book are all about Ann Arbor. And, at the same time, Ann Arbor is a lot about them. While there's a lot more to the town than its eating places, every place written up in this book has made a meaningful impact on our community. You may have eaten in many of them. You might well have even been a regular. And if you were not, your parents, your best friend, or your college roommate could have been. You might well have met your significant other, had some difficult conversations, asked for a raise, or decided to get married in one of them. Or you might, as I did, work in one. Thinking back now, it is easy to imagine that well over half of the town's most interesting business deals, new relationships, heart-to-heart conversations, and entrepreneurial ventures—at one point or another—benefitted from, or were influenced by, one of the restaurants that appear in the following pages. It is safe to say that without their culinary and community presence, Ann Arbor would not be what it is today. In fact, I am sure of it.

All of which causes me to take pause and reflect on all this Ann Arbor iconography. Little did I imagine back when I was a senior at U of M and studying Russian history that one day I would help open an icon of my own: as I write this introduction, Zingerman's is celebrating its 34th anniversary. Students at U of M still make the long trek across campus in the cold to eat. I hope that decades down the road, many will look back on memorable meals, marriages, food discoveries, and friendships made in our buildings. When someone writes the sequel to this book at some point in the future, I hope that Zingerman's is still actively engaged in this community, even if you and I are, perhaps, no longer here. Icons, after all, live on for the ages and continue to inspire, long after the people who painted them have moved on.

If you remove all of these restaurants from the history of Ann Arbor . . . it would be a very different town! And, in hindsight, so would my life. Spending the last month looking through Jon and Gail's notes, perusing old photographs, and remembering meals and meaningful moments has brought a whole range of restaurant memories back to me. Tuna subs at Pizza Bob's. Burgers at Bicycle Jim's. Beers at the Old Town. Zapatas at the Deli Rio. The salads and burgers and ribs at Maude's, the place in which I began my restaurant career and met my partners Paul Saginaw, Frank Carollo, and Maggie Bayless. Without which, and without whom, I would not be writing this introduction and there would be no Zingerman's Community of Businesses. If you have been in Ann Arbor anywhere near as long as I have, reading through this book will evoke similar memories. If you are new to town, what follows is a great way to glean some sense of what came before you, the roots of the community, and the places that were making a difference long before you arrived, but still quietly influence the conversations here every single day.

—Ari Weinzweig, 2016

One

The Legendary and the Long Forgotten

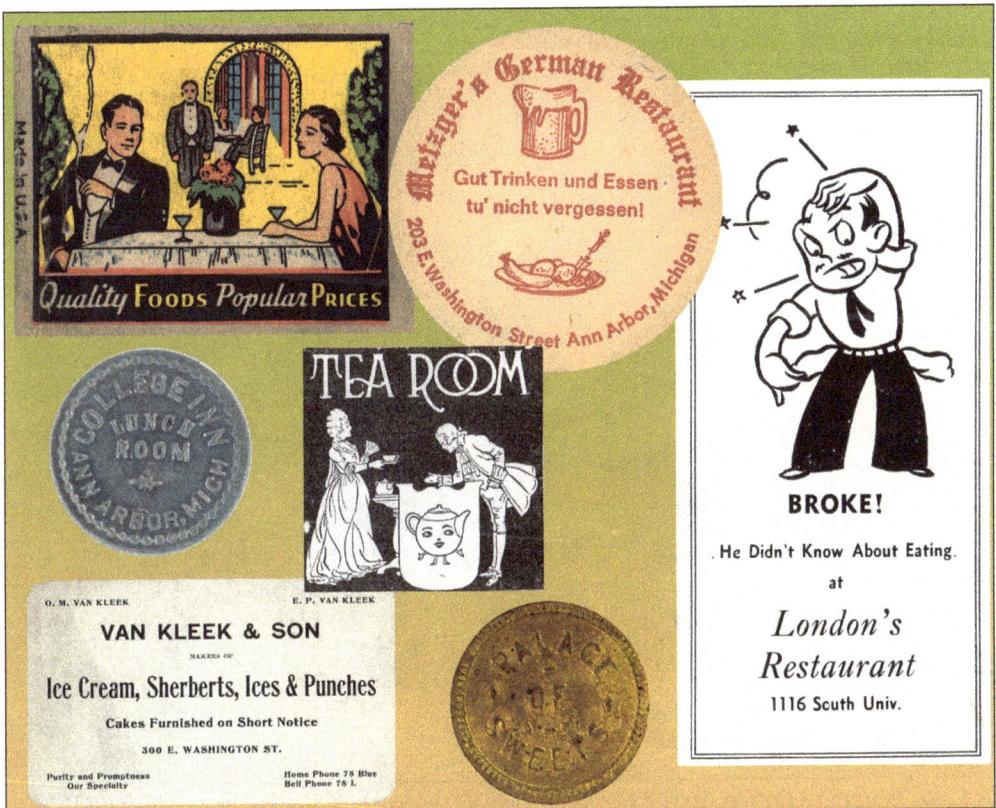

FOOD FOR THOUGHT. "Now we've all heard of Joe's and The Orient, / Where the students of old say their money was spent. / Places you swear you've heard of from days of yore / Long before Shakey Jake lived at the music store / Some are legend and others long forgot / In time replaced by another or just a parking lot / But in a hundred years or shortly thereafter, all the restaurants in this book will likely be in this chapter." (Authors' collection.)

Luncheon
Tea
Dinner

Private
Parties
Served

THE HAUNTED TAVERN 417 East Huron St.

AN OLD HAUNT. Folks looking for student haunts of the 1920s and 1930s need look no further than the Haunted Tavern, 417 East Huron Street. Hawked in the 1926 advertisement above, the tavern occupied the George Miles House (1842) after its last resident, bookseller John V. Sheehan, "crossed over" and joined the spirit world. Perhaps he waited tables! It was demolished in 1940 to make way for an A&P. (Authors' collection.)

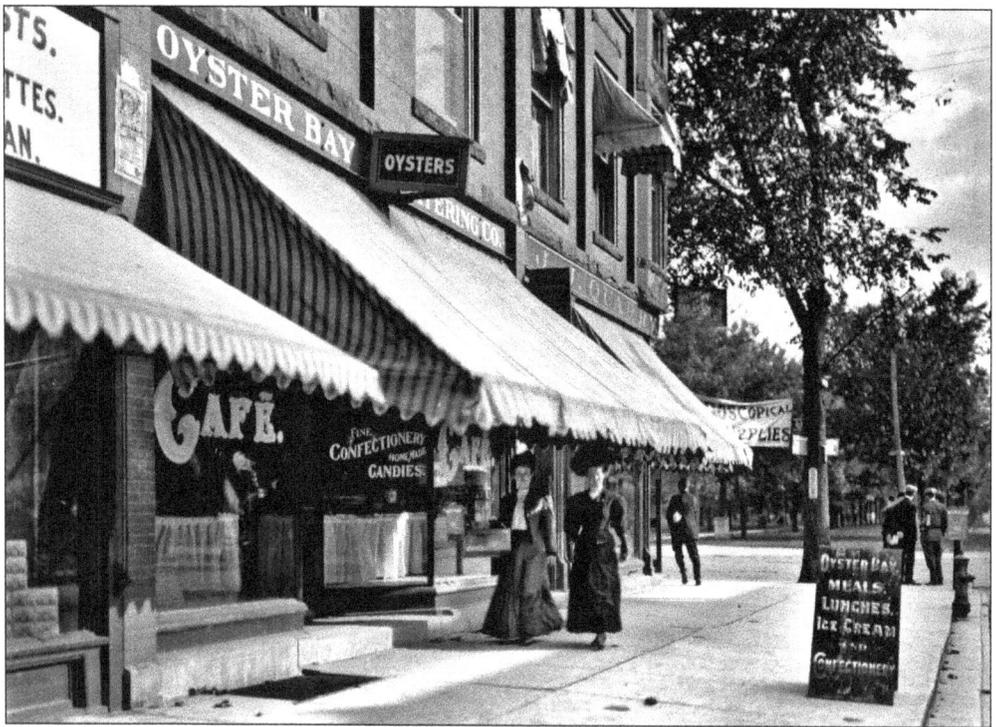

A LONG WAY FROM OYSTER BAY. After more than 100 years, the corner of State Street and North University Avenue is still recognizable—Diag is clearly visible in the background beyond the man turning the corner. David Willit's Oyster Bay Catering (above, around 1905) was located at 315 South State Street. By 1906, it was simply Willit's, though the three-digit phone number remained the same—467 (don't waste your time). Over the years, this location hosted many restaurants. Today, it is occupied by Pitaya women's apparel. (Authors' collection.)

FAWCETT HOUSE. Converting old homes into eateries seemed to be the trend in the mid-1920s, and much like the Haunted Tavern, the Fawcett House Restaurant came to occupy the Queen Anne beauty seen at right—complete with onion dome—that once stood on the northeast corner of Huron and Division Streets. Built in 1896 and originally the home of *Ann Arbor Courier* publisher John Travis, it was demolished in 1932 and replaced by a gas station. (Courtesy of Bentley Historical Library, University of Michigan.)

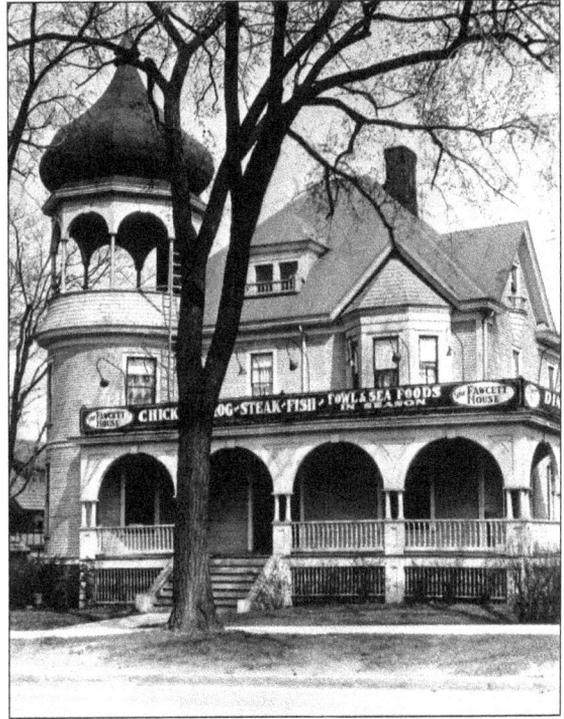

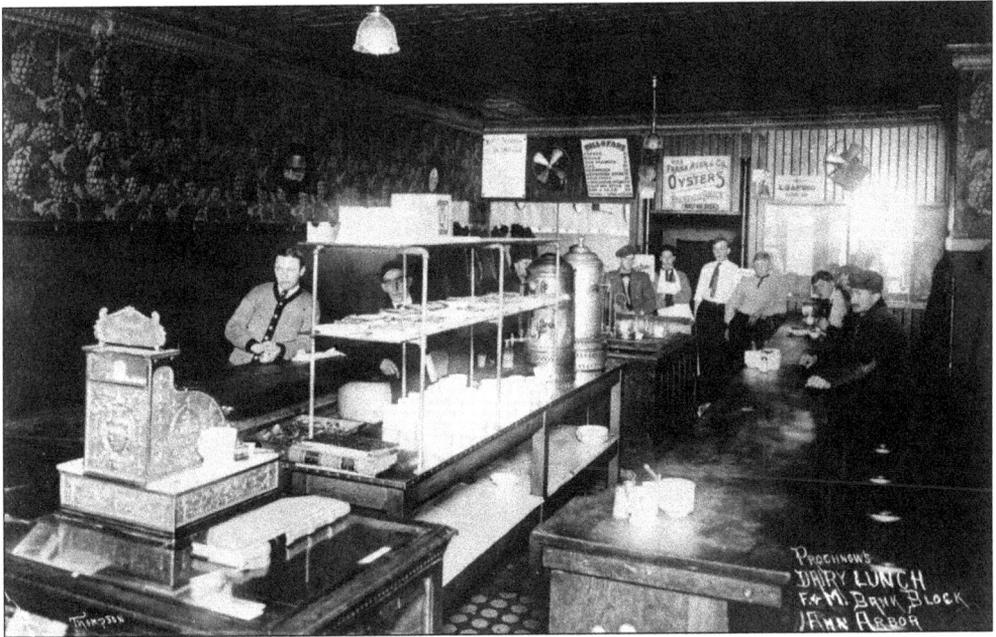

PROCHNOW'S. Theodore Prochnow opened his popular lunch counter (note the "No Loafing" sign along the back wall) at 104 East Huron Street, across from the courthouse, in 1902. It was considered a no-nonsense place for local businessmen to grab a quick lunch, but, nonsense or no, it did have its share of anecdotes. In *Ann Arbor in the 20th Century*, Grace Shackman recounts how Prochnow often cooked with a cigar butt in his mouth and it sometimes ended up in the food. (Courtesy of the David V. Tinder Collection.)

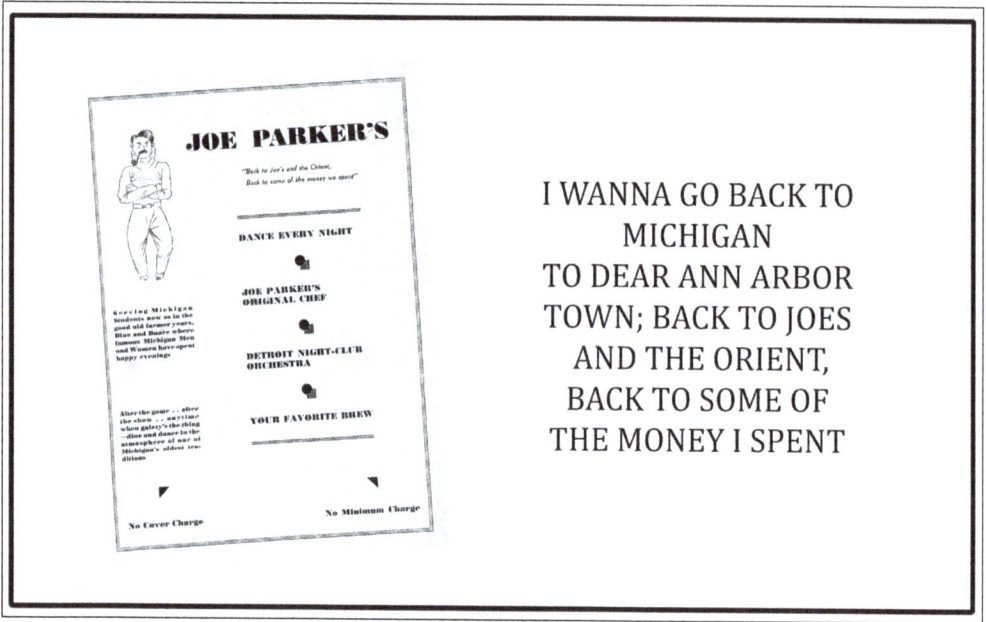

JOE PARKER'S

*"Back to Joe's and the Orient,
Back to some of the money we spent"*

DANCE EVERY NIGHT

JOE PARKER'S
ORIGINAL CHEF

DETROIT NIGHT-CLUB
ORCHESTRA

YOUR FAVORITE BREW

Serving Michigan
Students now in the
good old former years.
Blue and Bonie where
famous Michigan Men
and Women have spent
happy evenings

After the game . . . after
the show . . . anytime
when gaiety's the thing
—dine and dance in the
atmosphere of one of
Michigan's oldest tra-
ditions

No Cover Charge No Minimum Charge

I WANNA GO BACK TO MICHIGAN TO DEAR ANN ARBOR TOWN; BACK TO JOES AND THE ORIENT, BACK TO SOME OF THE MONEY I SPENT

I Wanna Go Back to Joe's. So goes the anonymously penned song from early in the 20th century, when Joe's and the Orient were favorite spots. The Orient was a barbershop and cigar store on Main Street, but Joe's (also known as Joe Parker's) was perhaps the first truly iconic eating and drinking spot in town (at least the first immortalized in song). Joe's was a popular saloon and lunch counter that originally stood at 204 South Main Street until demolished in 1912. It then moved to the Catalpa Inn, a hotel on the northeast corner of Ann Street and Fourth Avenue (currently Kaleidoscope Books), where it remained until closing around 1921. The old Catalpa Inn building still stands (below right), and the entrance to Joe's is still marked by the century-old mosaic, below left. Author and historian Susan Wineberg notes that a third Joe Parker Café briefly materialized in 1934 at 102 North Fourth Avenue but was gone by 1935. (Both, authors' collection.)

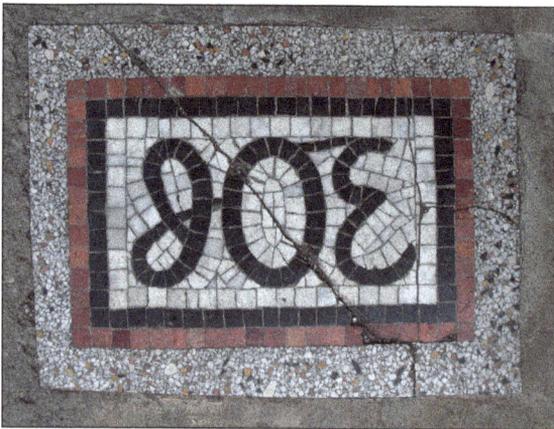

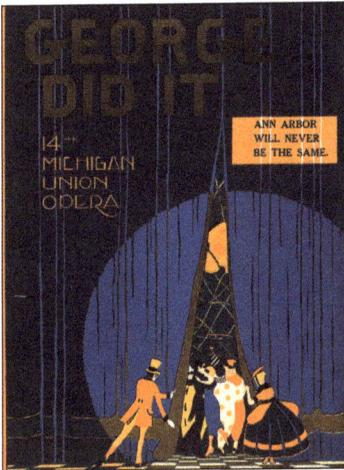

Instead of Bourbon dandy,
You try to get a jag on a bag of candy.

When daddy comes across,
Say we all "cut loose" at the Betsy Ross.

Now a-days when you've got a roll,
You "knock 'em dead" at the Sugar Bowl.

If you have some friends and want to see 'em,
Just go skating at the Coliseum.

If now you're fussing co-ed's nifty,
What's it goin' to be in 1950?

ANN ARBOR WILL NEVER BE THE SAME. In the 1920 production of *George Did It*, staged by the Mimes of the University of Michigan, songwriter George H. Roderick introduced the Prohibition-era song "Ann Arbor Will Never Be the Same." It is a wonderful send up that bids a tearful adieu to the local drinking establishments while bemoaning the fact that Prohibition has forced everyone to find their fun in local tea rooms, lunch counters, and soda fountains. It also gave Roderick an opportunity to name just about every iconic eatery in town, with lines like "Down in Foster's Tea Room, you'll find there's hardly knee room;" "To pep up for the J-Hop, had a Coca Cola at the Grey Shop;" and "If we're not drinking tea, we're drinking malted milks at the Busy Bee, Ann Arbor will never be the same!" It even included extra choruses (above). (Both, authors' collection.)

GOOD THINGS TO EAT AND DRINK

Only at the DIXIE

CAN YOU GET CHARCOAL BAR-BECUED MEAT SANDWICHES

We barbecue and baste chicken, spare-ribs, ham, pork, and beef over our charcoal oven in our display window. They are the only truly genuine barbecued meats in Ann Arbor.

The DIXIE is the nearest restaurant to the campus serving

BEER and WINE

Dancing, of course, every night from eight to two, to a red-hot colored orchestra.

Steaming hot barbecued sandwiches delivered to your door.

FREE DELIVERY

Five-Minute Service on All Orders

DIXIE BAR-B-Q

RESTAURANT

Dial 9355 207 E. Washington

DIXIE BAR-B-Q. In 1933, the Dixie made its strongest pitch (and pitcher) by claiming to be the nearest restaurant to campus serving beer and wine. With Prohibition repealed, only Division Street stood between students and a "cold one." While barbecue may still be a favorite, this vintage advertisement is cringe-worthy, reminding patrons there is dancing nightly to a red-hot "colored" orchestra. Today, the barbecue continues, as 207 East Washington Street is home to the Blue Tractor. (Authors' collection.)

BROADCASTING

The Hot Noon-Day Lunches at the BETSY ROSS SHOP. Taste our Delicious Toasted Sweet Rolls.

Hot Fudge Sundaes

Caramel Dips Butterscotch Delights
Salads Sandwiches

BETSY ROSS SHOP

13-15 Nickels Arcade

Phone 5931 Ann Arbor

We Deliver Open 7:30

"BROADCASTING" 9502

ADV. PUB. CO., ANN ARBOR, MICH.

BETSY ROSS SHOP. Maybe the ladies on the 1929 blotter above were sharing the fashionable snack of the era: chocolate cake with chocolate frosting and chocolate ice cream washed down with a chocolate malt. The Betsy Ross Shop was one of the first businesses inhabiting Nickels Arcade, a sky-lit arcade of shops (right) connecting State and Maynard Streets. This popular eatery remained a campus mainstay until the mid-1970s. (Above, authors' collection; right, courtesy of the Ivory Photo Collection, Bentley Historical Library, University of Michigan.)

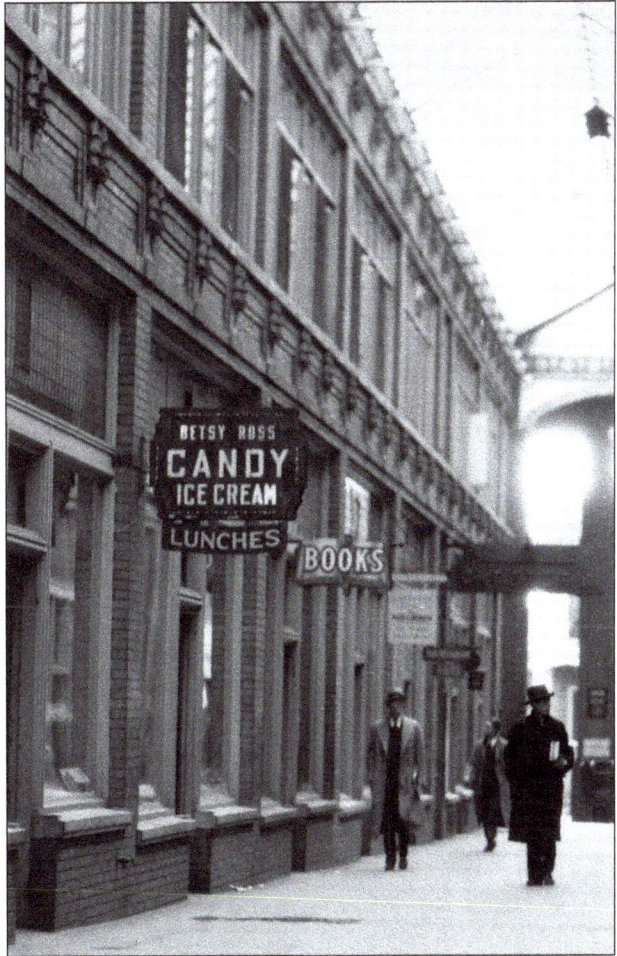

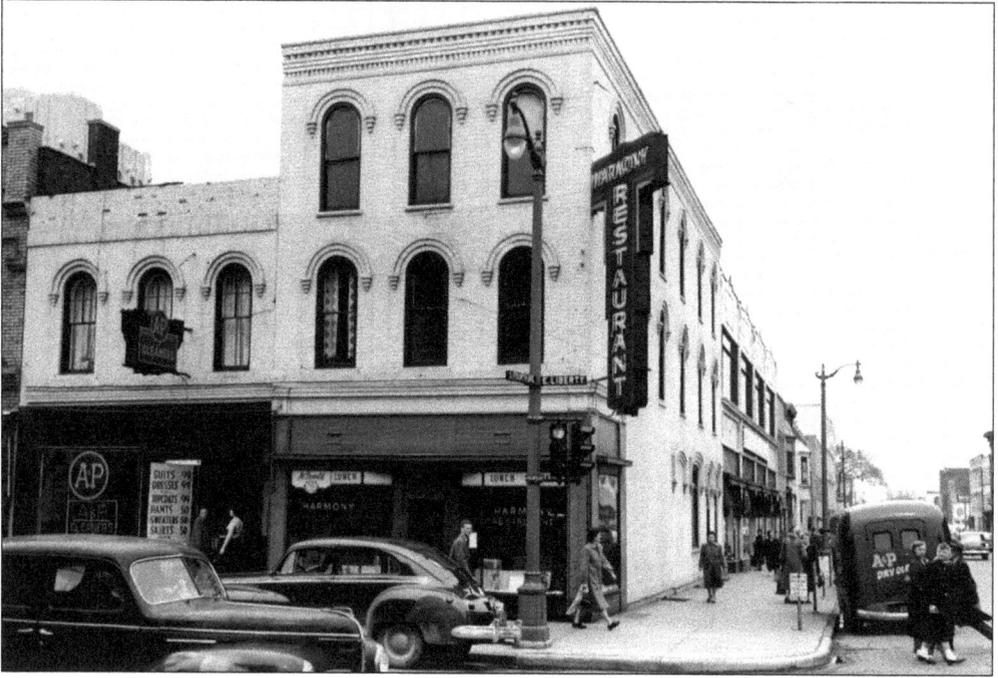

THE HARMONY. In the mid-1950s, the Harmony Restaurant (above) had the look and feel of the quintessential small-town diner. Standing on the northwest corner of Liberty Street and Fourth Avenue with its neon blade sign illuminating the night, one can almost hear the heavy, clinking Homer Laughlin crockery as locals discussed the day's adventures over the blue plate special. While the scene inside (below) seems a mite posed, what with the matronly wait staff lined up along the rear, the seemingly solitary diners seated just beyond the old register and cigarette counter look as though they came straight out of an Edward Hopper painting. If the Harmony seems unfamiliar to today's readers, it is because both the Harmony and the adjacent A&P Cleaners were lost in a major blaze sometime in the mid-1950s. Today, the corner is occupied by the single-storied building housing Running Fit, though reportedly charred evidence of the great fire still remains in the basement. (Both, authors' collection.)

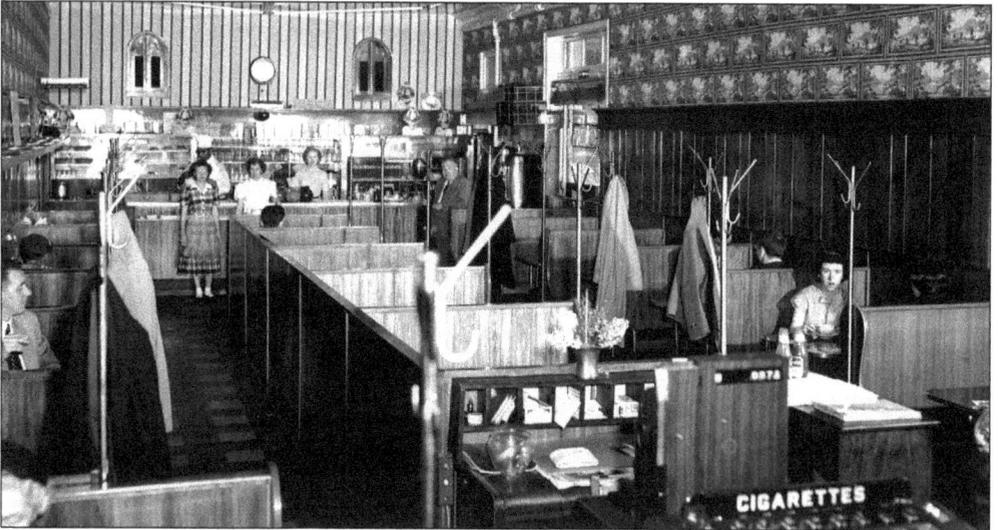

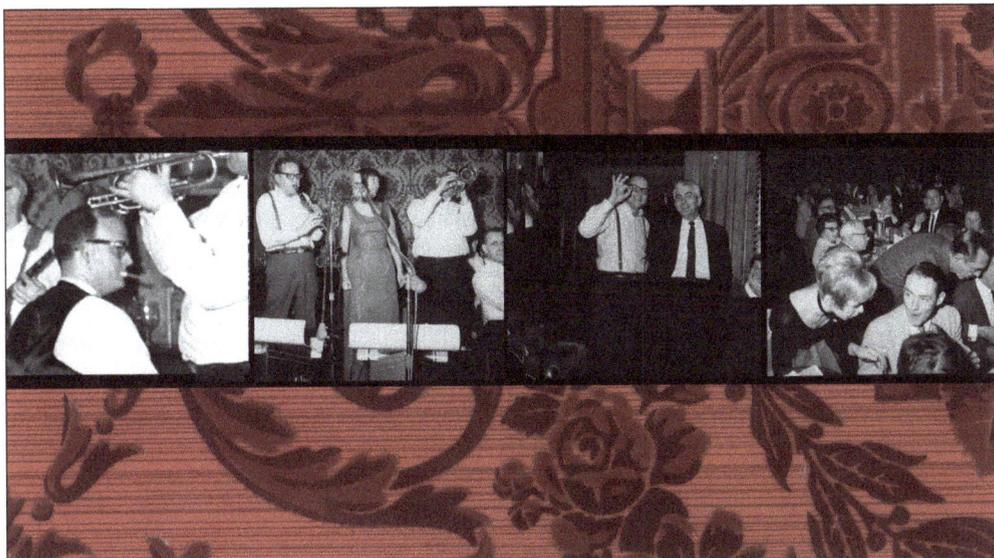

LULU'S STORYVILLE SALOON. In 1967, five advertising executives and musicians had an idea: "Let's open up a 'genuine' New Orleans venue, with hot jazz and authentic cuisine!" What could possibly go wrong? Well, for starters, none of them had any restaurant experience. Everyone contributed—artist Dick Hill created the artwork (below), musicians Walt and Mike booked the talent—stealing most of the musicians from Bimbo's around the corner—and soon, they transformed the short-lived La Seine (its flocked wallpaper fitting in perfectly with the bordello theme) into Lulu's Storyville Saloon. Ragtime Charlie & Sister Kate played opening night, and the Mother's Boys and Kerry Price even recorded an album there, but soon the crowds dried up, and some speculate the profits were walking out the back door (a common problem). By February 1968, the song had ended, and Lulu's was gone. Above are, from left to right, Mike Montgomery, Walt Gower, Kerry Price, Paul Klinger, Walt Gower, Dick Hill, unidentified, Charlie Rasch, and Eph Kelly. (Both, courtesy of Chris Hill.)

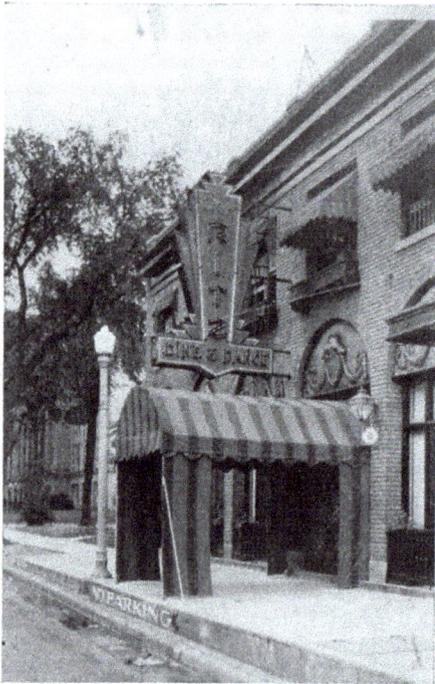

STATE STREET GOES "RITZY"
Yes, this is the Chubb House of other days

THE RITZ. The canopy and blade sign offered a jazzy appeal to folks headed for this Prohibition-era cabaret at 209 South State Street. But, in addition to food, (nonalcoholic) drink, and dance, the Ritz was a nightclub that held a secret: just behind that elaborate frontage was a peak-roofed, frame Queen Anne house. The 19th-century structure started out as a private home, but by 1902, owner George Chubb transformed it into the two-unit Chubb boardinghouse. Later, he added a restaurant and applied the cosmetic facade. It became the Ritz (left) in 1930. In later years, it was many things, including Chubb's restaurant and even a credit union. Sadly, only the facade remains. When CVS took over the site, the hidden historic home was demolished, and in an odd reversal, the facade was preserved to maintain the historic look of the block. In a small salute to history, the CVS sign was designed to mirror the Ritz's flamboyant jazz-age banner. (Left, courtesy of Bentley Historical Library, University of Michigan; below, authors' collection.)

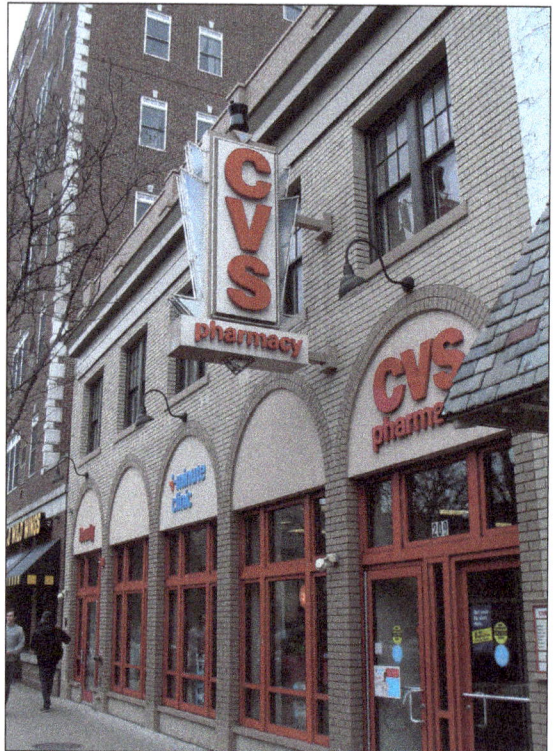

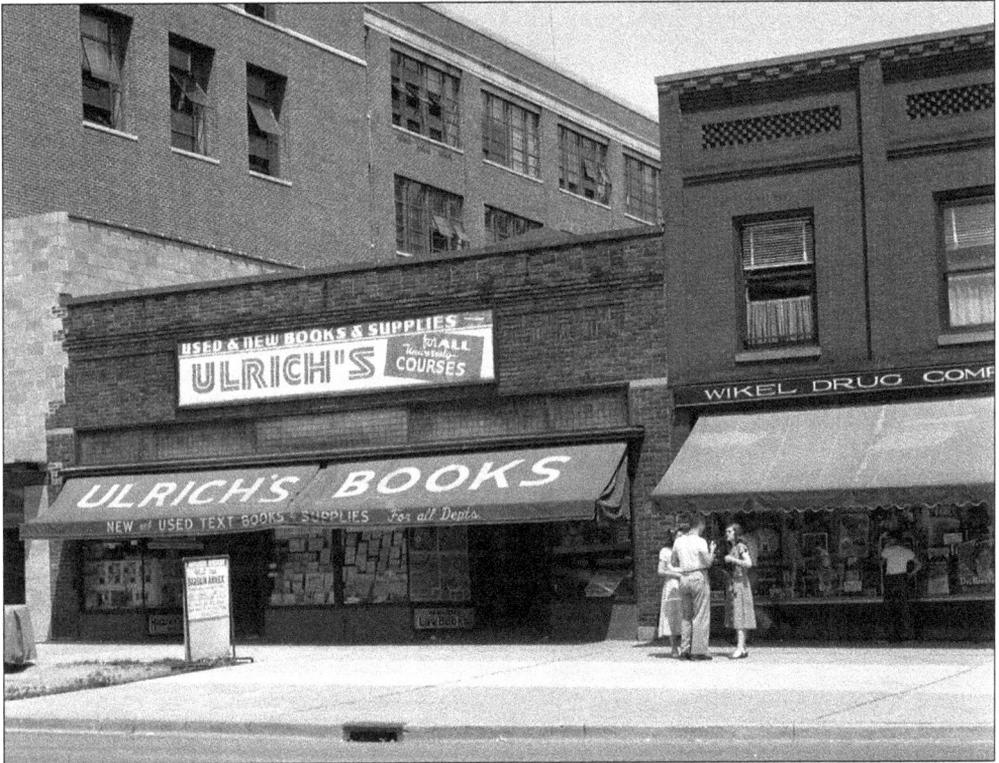

WIKEL'S. Customers could pick up more than a soda at Wikel's lunch counter, especially if Fielding Yost, a regular, just happened to be hanging around. And while pharmacist Leslie Wikel was handling the daily business, his son Howard could often be found counter-side learning Civil War history and football strategy from the master himself. According to broadcaster and author Jim Brandstatter in *Tales From Michigan Stadium*, Yost often used salt and pepper shakers, positioned along Wikel's counter, to illustrate everything from military positions to winning football plays, and Howard, among others, soaked it all in. Howard would later repay the favor of such an unparalleled education by becoming a major supporter of Michigan athletics, even cofounding a major scholarship program with Bob Ufer. For others, Wikel's was a just great place to grab a snack between classes, and many remember it still. The building remains along South University Avenue next to Ulrich's, behind the refaced entrance to Espresso Royale. (Both, courtesy of the Charles Rasch Collection, Bentley Historical Library, University of Michigan.)

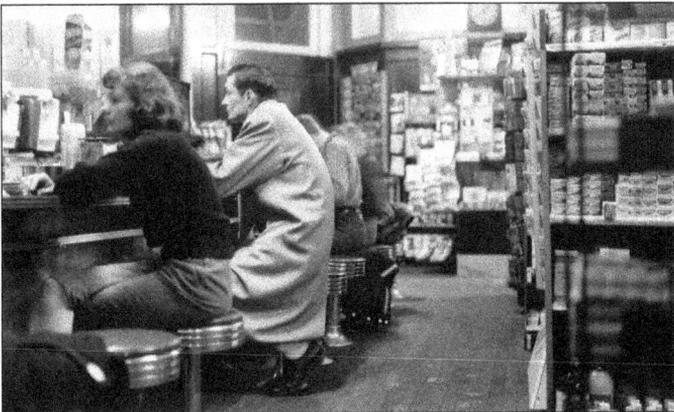

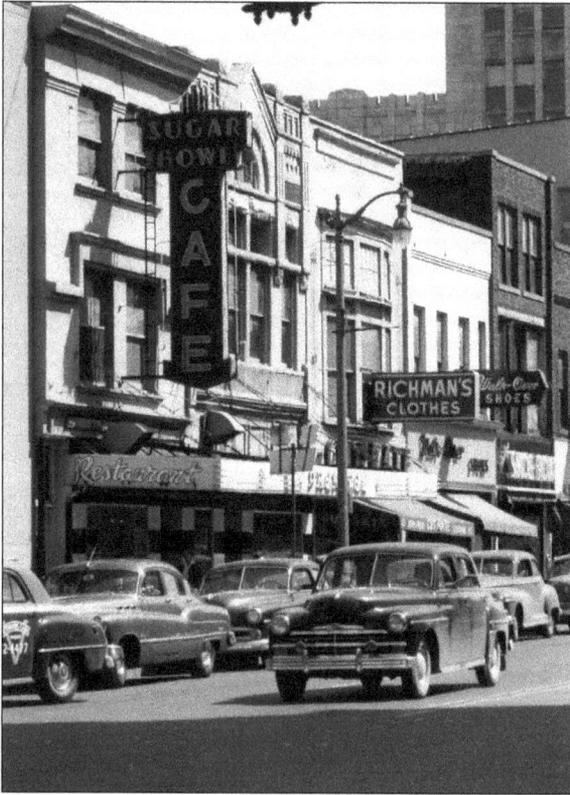

THE SUGAR BOWL. In 1910, the four Preketes brothers, Charles, Paul, Frank, and Anthony, left Megalopolis, Greece, and settled in Ann Arbor. Following a hopeful path to new opportunity, the boys opened a penny candy and ice cream emporium in a storefront at 109 South Main Street. The family lived upstairs, where they made all the ice cream and chocolates sold in the store. It was called the Sugar Bowl, and it became an Ann Arbor favorite, operating for 55 years. Over the years, the Sugar Bowl logged its fair share of local firsts, including the distinction of erecting the first electric sign along Main Street. (Both, courtesy of the Ivory Photo Collection, Bentley Historical Library, University of Michigan.)

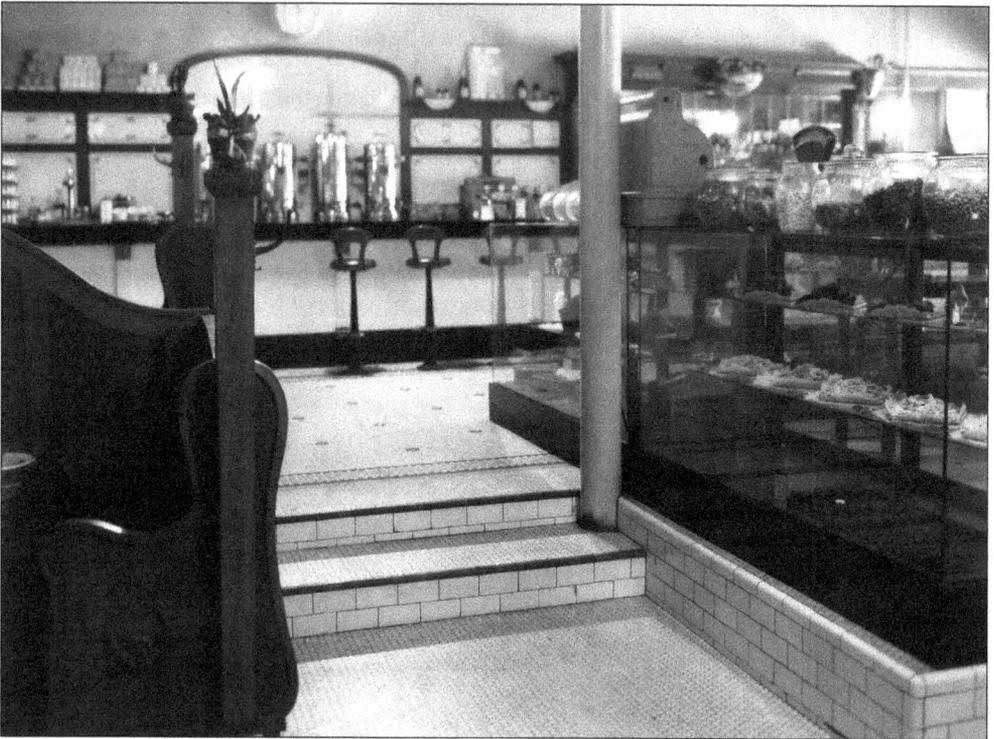

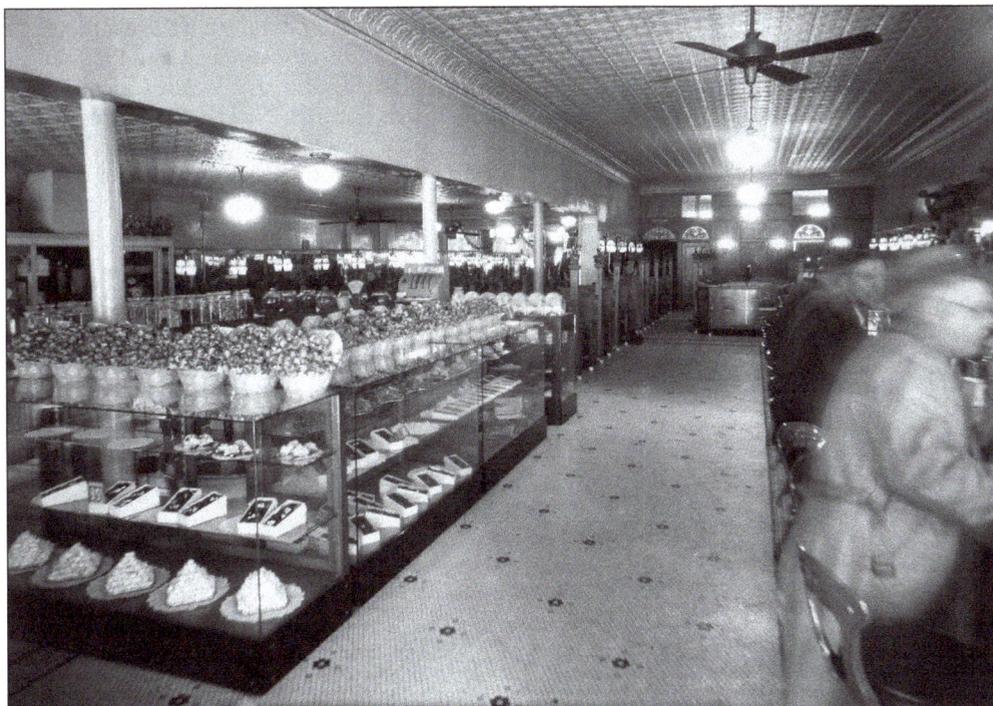

SWEETER STILL. There were many confectionery establishments in town at the time. Justin Trubey's Ice Cream Parlor was down the street at 116 Main Street, and La Casa offered lunches, sodas, and ice cream at the corner of Liberty and Main Streets, but Preketes Sugar Bowl remained the popular choice with its long glass counters filled with confectionery delights and the always-busy soda fountain (above). Business was briefly halted in 1941 when a fire caused considerable damage, but the Preketes saw it as an opportunity to update and streamline the place, as illustrated in the color postcard below. In 1961, the Sugar Bowl was remodeled once again, reinventing itself as a full-service restaurant and cocktail lounge. It closed forever in 1966, when the brothers decided 55 years were enough. It was soon replaced by the short-lived and upscale restaurant La Seine. (Above, courtesy of the Ivory Photo Collection, Bentley Historical Library, University of Michigan; below, authors' collection.)

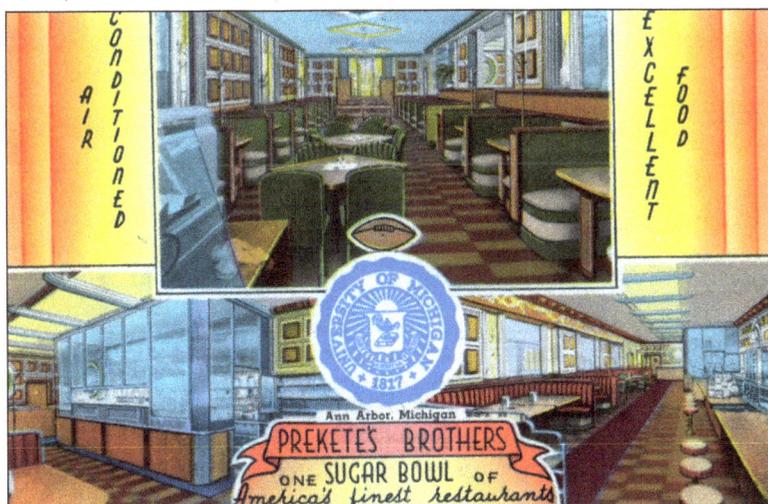

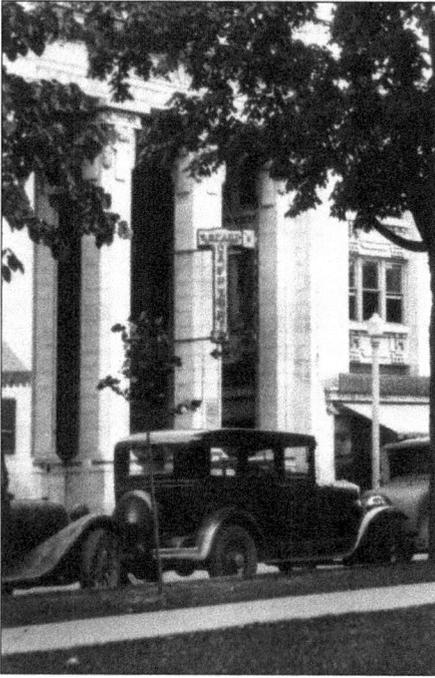

ARCADE CAFETERIA. Looking a bit like a prop from the set of *Elmer Gantry*, this late-1920s-era neon restaurant sign for the Arcade Cafeteria proudly stands out from Nickels Arcade, inviting passersby to "come on up and dine." The Arcade Cafeteria was located on the second floor of the arcade, and it secretly utilized an old brick building (or garage) located between the arcade and the adjacent Delta Kappa Epsilon (DKE) Chapel, on William Street, as its kitchen. (Courtesy of the Ivory Photo Collection, Bentley Historical Library, University of Michigan.)

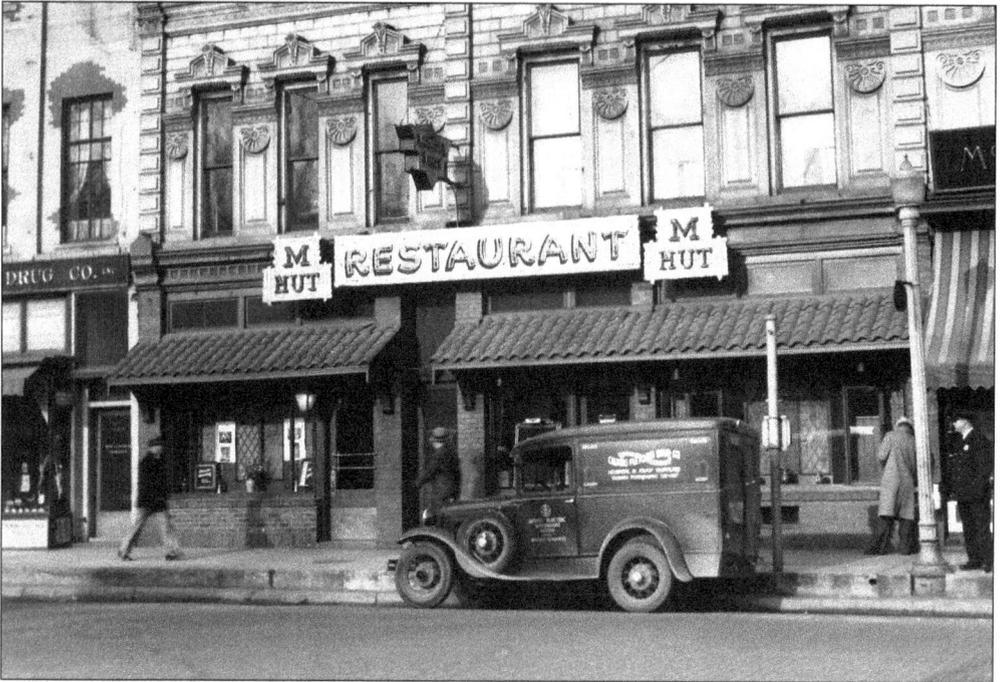

THE M HUT. Before there was an M Den, there was the M Hut (above, around 1929). Located along South State Street and run by Clarence Fingerle, it offered food, (nonalcoholic) drinks, and dancing. With or without Prohibition, it would be a long time before alcohol would come to State Street. Though repeal brought beer and wine back to Ann Arbor, Division Street remained the dry cutoff line for alcoholic beverages near the university until 1960. (Courtesy of the Ivory Photo Collection, Bentley Historical Library, University of Michigan.)

FOR RESERVATIONS, PHONE: 662-1414

La Seine

109 South Main Ann Arbor

FRENCH LESSON. An authentic French restaurant with nine co-owners who knew little about running it—what could go wrong? La Seine is the stuff that legends—and cautionary tales—are made of. Converting the Sugar Bowl took more than $200,000 back in 1966. Crystal chandeliers, Limoges china, and a grand piano set the mood. So did chef Alexander Gens, who trained under the creator of crêpes suzette. Service was intimate and hushed, and the wait staff spoke French. Ruth Reichl worked here, and although her salary was $1 an hour, she would take home around $26 in tips. This menu, from 1967, has classics like duckling a l'orange and chateaubriand for two. This special salad was made tableside, along with flambé desserts. It was hard to have a meal in under three hours, but those who had the time, loved it. High prices, mismanagement, culinary tantrums, and an old, leaky building all led to *la mort* for La Seine. Ambitious but delicious, La Seine closed a year and two weeks after opening. (Both, courtesy of the JBLCA, Hatcher Library, Special Collections, University of Michigan.)

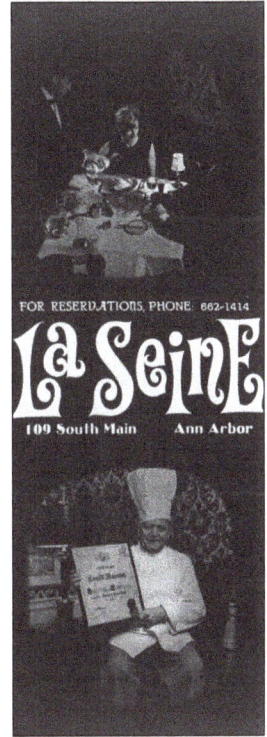

D'AGOSTINO AND LOMA LINDA. Out of the googie world came D'Agostino's (above), at 990 Broadway Street. With its turquoise-and-gold color scheme, vaulted ceilings, and fountain centerpiece, it was the largest addition to the city's restaurant scene following approval of a liquor-by-the-glass measure in 1959. Established by Dominic and Louise D'Agostino in 1965, it was a bookend to their popular restaurant in Bridgeman (near Lake Michigan). The Ann Arbor location was near the University Motel and shared the parking lot. While the Bridgeman site remains, the Broadway location closed around 1970, making way for a taste of Mexico in the form of Loma Linda (Spanish for "pretty hill"), which is seen below. Briefly popular, the restaurant's location became problematic when the college bought the motel to utilize the property. Loma Linda closed soon after, leaving behind *un edificio abandonado*—Spanish for "abandoned building." (Above, authors' collection; below, courtesy of the Ann Arbor District Library.)

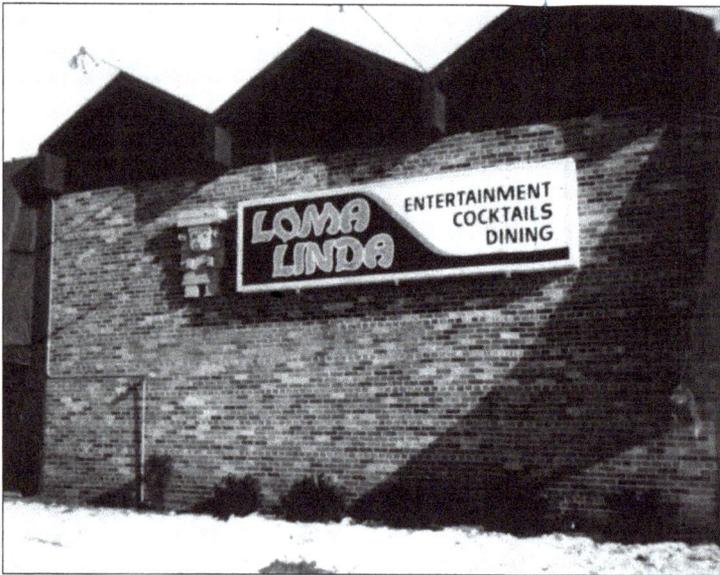

Two

LOCAL FAVORITES AND STUDENT STANDBYS

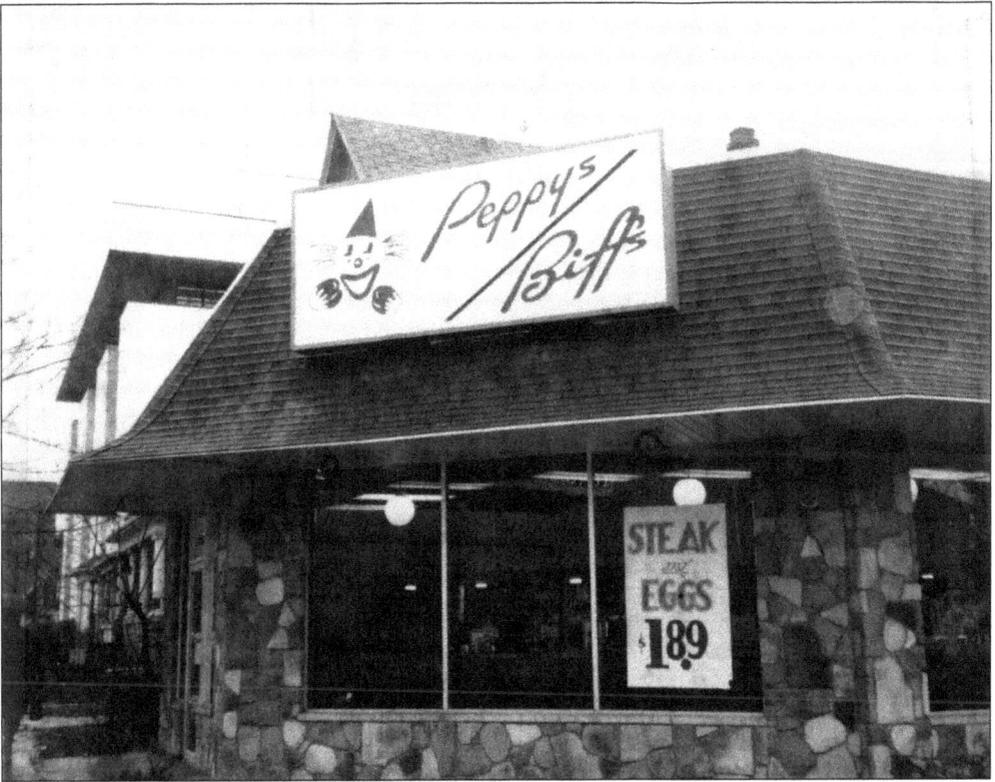

CLEAN, WELL-LIGHTED PLACES. In every corner, cul-de-sac, and nook and cranny, one is sure to find local favorites and student standbys—places that were around for years and many that are still here. Some are a never-ending party; others are warm and cozy places where customers can get a quick snack or perhaps breakfast at 2:00 a.m. Still others are the quiet and solitary type, places where folks can be anonymous for an hour or two, nursing a cup of coffee, doctoring grits, and listening to trains passing in the night. Peppy's/Biff's (above) was a quiet and popular all-nighter best known for its cheap breakfast specials. Biff's hamburger secret was a pat of butter on the bun. It stood at the corner of East William and Thompson Streets and later became a succession of Korean restaurants. (Courtesy of the Ann Arbor District Library.)

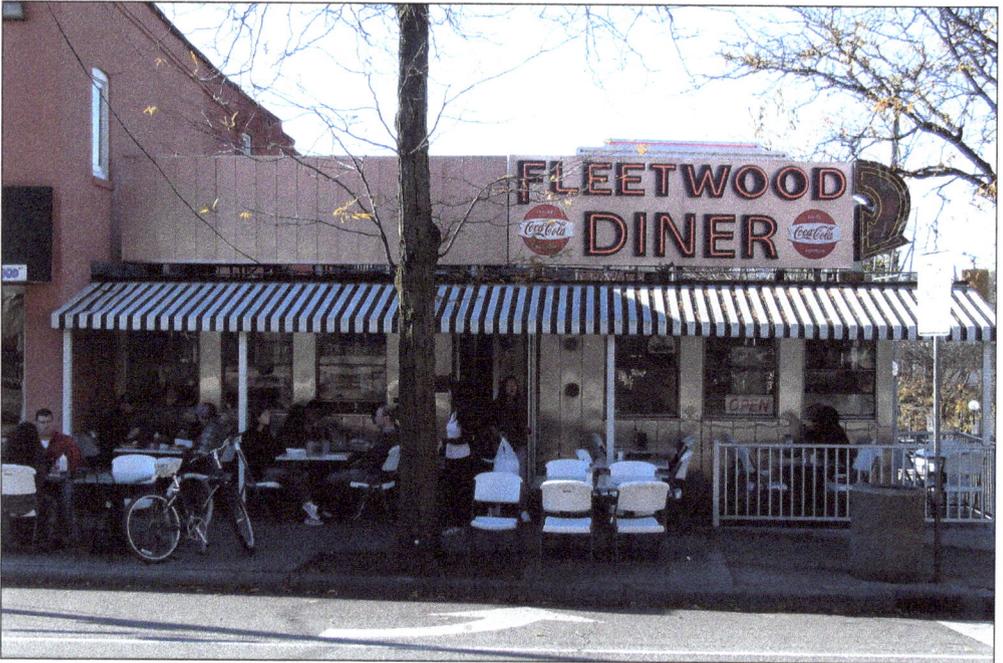

NIGHTHAWKS. They can be found at this diner, but morning people are welcome, too. In fact, all kinds of people hang out here. The Fleetwood is still there serving hippie hash (hash browns covered in vegetables and topped with feta). The Fleetwood began as the Dag-wood Diner, named for the Toledo company that made the building kit that owner Donald Reid constructed the diner from in 1949. It was also Ann Arbor's first sidewalk café. Mark Hodesh bought it in 1971 and renamed it the Fleetwood. It has had several owners and several closings, but at this time, it thrives, as current owners have added Greek food to the burgers, sandwiches, and the two greatest words in the English language, "breakfast anytime." The last of Ann Arbor's 24-hour diners lives on. (Both, authors' collection.)

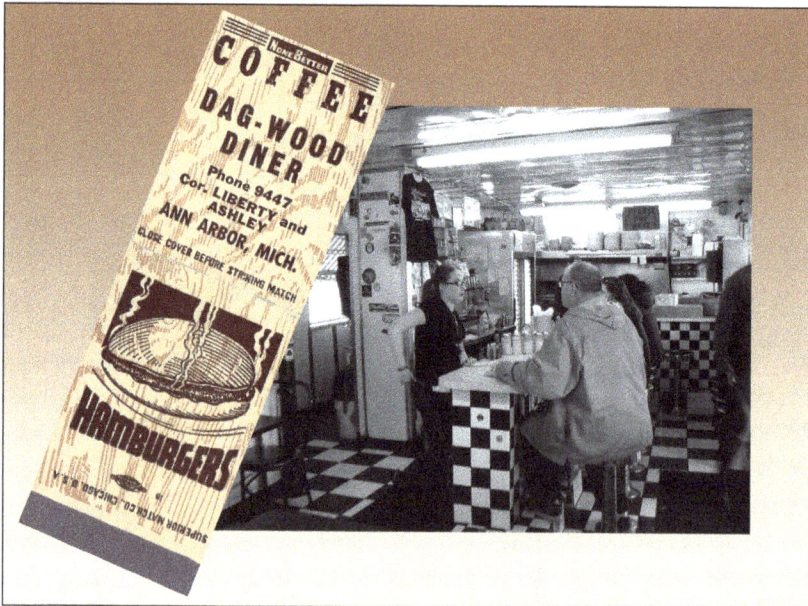

ALWAYS A PARTY. Every day was pretty much a celebration at Mr. Flood's. Twenty-five-year-old Ned Duke opened it in 1969, and there was almost always a line to get into this Tiffany-lamped West Side bar. A great jukebox and frequent free drinks were also a draw. Johnny Winter played there, Alan Ginsberg read poetry there, and Bonnie Raitt hung out there. Even the bartender was famous: John Leslie was an adult film star and director. Duke opened Leopold Bloom's restaurant next door, but the party was over in 1980. (Courtesy of the Ann Arbor District Library.)

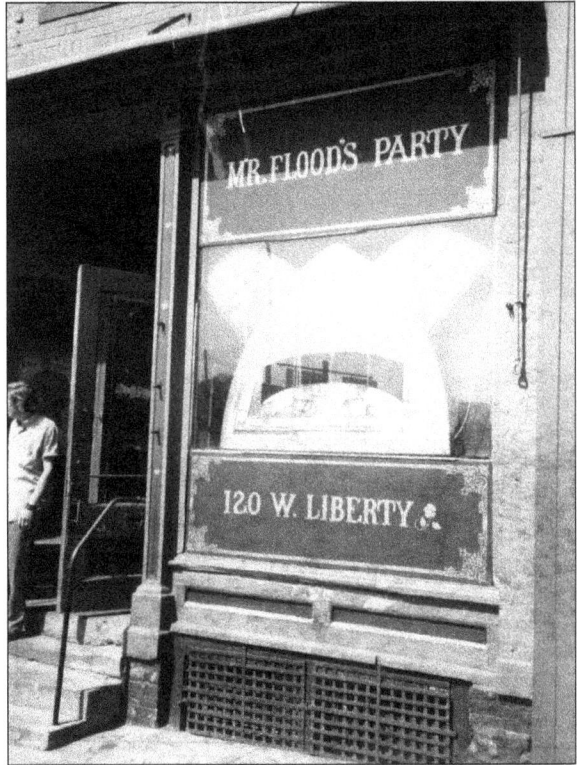

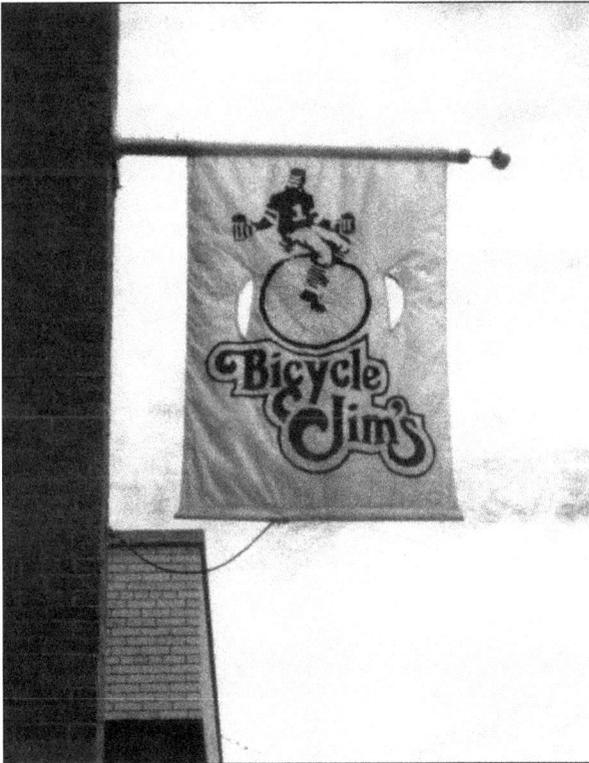

ENJOY THE RIDE. Look up at the corner of Forest and South University Avenues. If it is the late 1970s, there is a man on a unicycle, wearing a jersey and holding a beer. Not only could folks get a frosty one or a hummer at Bicycle Jim's, they could munch unique sandwiches like the hot damn and the gobbler. The fried mushrooms were craveable. Former Bicycle Jim's cook Frank Corollo remembers cooking them at lunch, running off to class, then getting admiring sniffs from nearby students. (Courtesy of the Ann Arbor District Library.)

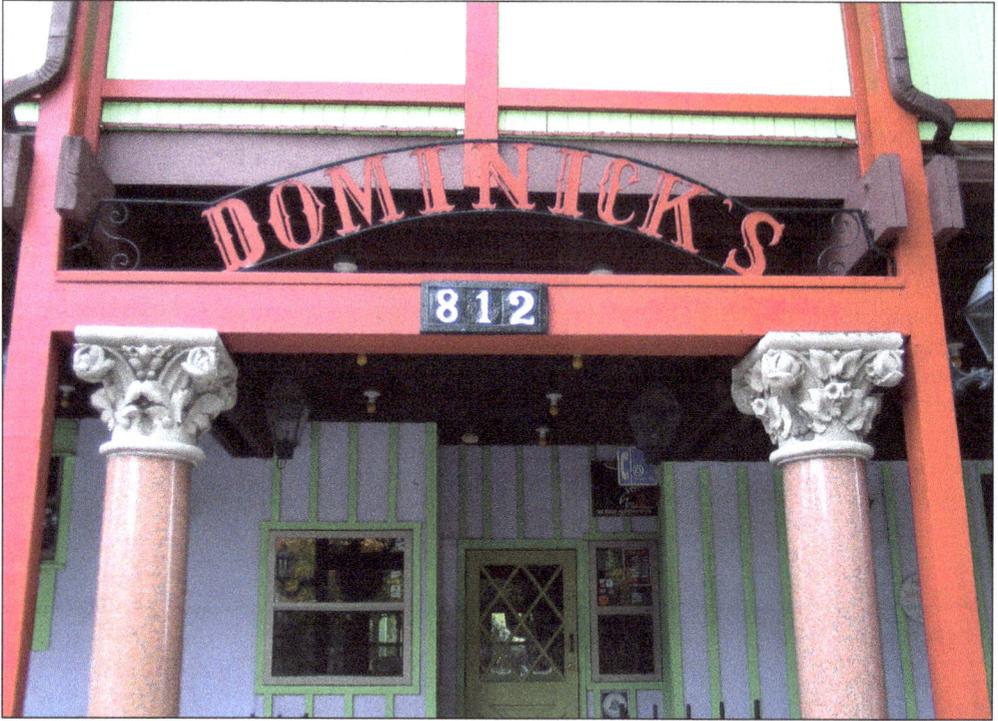

THE BIRDS, THE BEES, AND . . . For many locals, spring starts when Casa Dominicks opens. Since 1960, this charming hangout started by Dominick DeVarti comes to life the Monday after U of M's spring break and closes after the last home football game. Many a student has spent long sunny afternoons sipping homemade sangria or beer from a mason jar—before mason jars were trendy. The outdoor courtyard, an Italian garden complete with cherub fountain, is filled with picnic tables and happy chatter. Admire the Oxford-like Law Quad from the balcony while eating an Italian sub. Inside, there is a wonderful collection of vintage Ann Arbor Film Festival posters. Upstairs is a hidden gem: original 1879 etched glass rescued from the Capitol Building Dome in Lansing during renovations. All in all, second-generation owner Richard DeVarti does not change things up too much. And for that, everyone is grateful. (Both, authors' collection.)

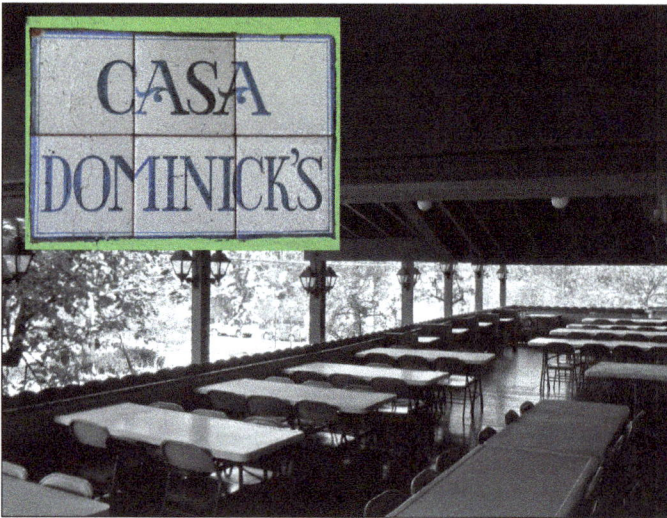

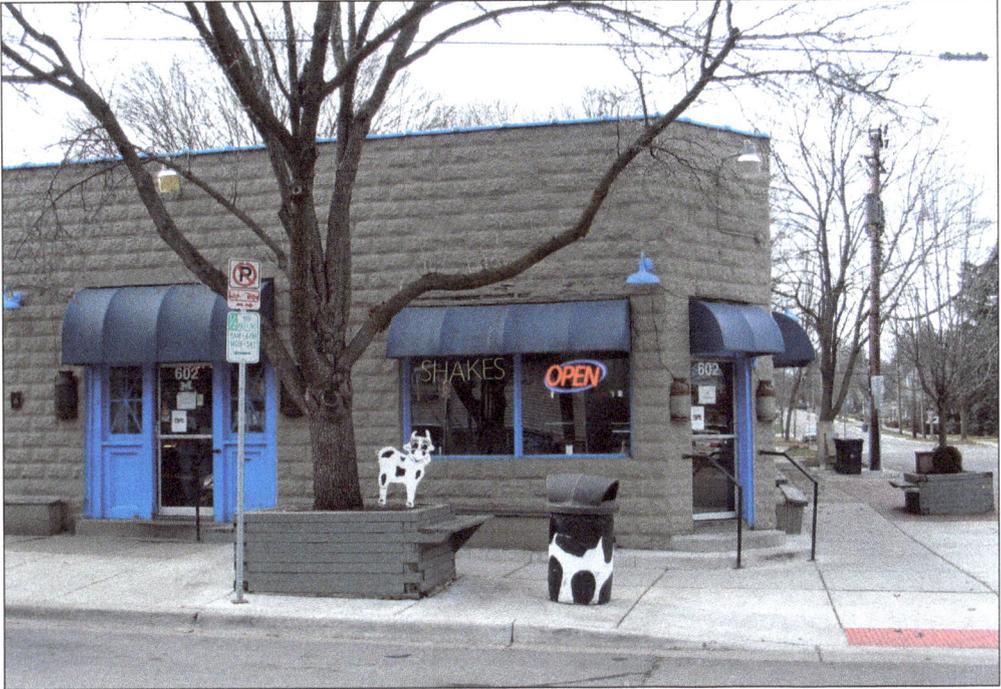

MILK AND MORE. Mornings taste better with coffee and donuts at Washtenaw Dairy. Groups of regulars make it their ritual, with a special fondness for maple-glazed and chocolate. The Washtenaw Dairy no longer makes its own ice cream, but it sells a lot of it (the best-selling flavor is vanilla). It also still runs two commercial delivery trucks a day and stocks a fine selection of dairy products. Opened as a grocery store with a soda fountain in 1934, it still looks much the same, complete with original floor. Over the years, everyone from Bo Schembechler to Clint Eastwood (okay, his assistant) has stopped by for a hand-dipped cone. The Washtenaw Dairy also donates ice cream to many charity events. (Both, authors' collection.)

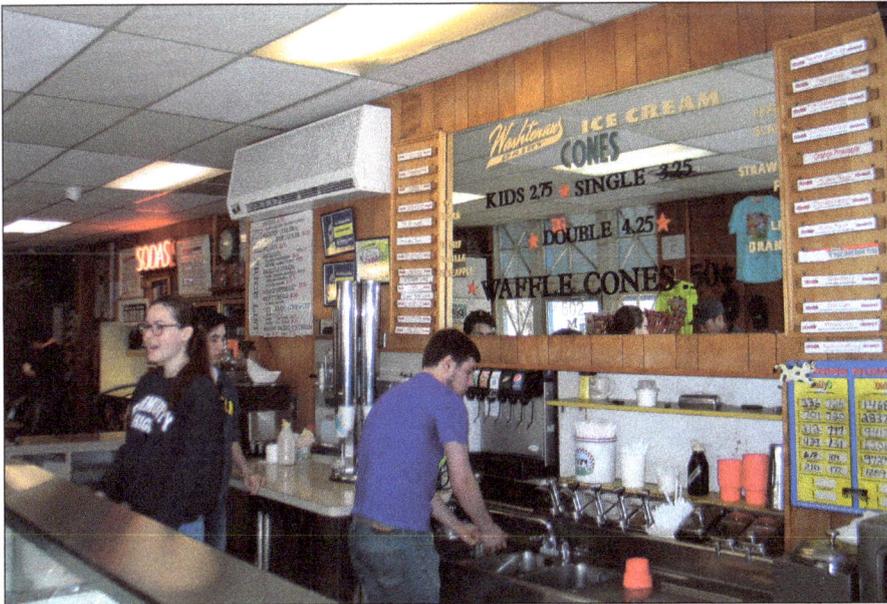

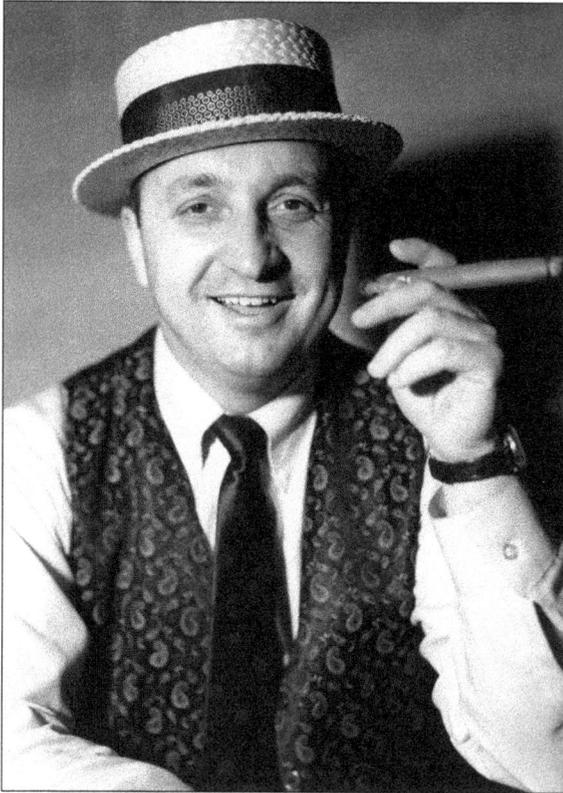

BIMBO'S. He was often billed as "The Friendly Yugoslav," while others called him "Bimbo," a nickname he acquired in his youth, but in any case, Matt Chutich (left) was one of Ann Arbor's most celebrated "Founders of Fun." Chutich was trained as a barber and attended the University of Minnesota before starting up the first of a series of popular pizza emporiums. By 1962, he had already experienced several successes and failures when he opened Bimbo's in Ann Arbor and that big striped awning first appeared over the entrance of 114 East Washington Avenue (now the Ann Arbor Brewing Company). Inside, there were long tables; "Keep Cool with Coolidge" signs; big photographs of Laurel and Hardy, Charlie Chaplin, and Harold Lloyd; peanuts shells on the floor; plenty of pizza; and lots of beer and Faygo by the pitcher to wash it all down. (Left, courtesy of Kerry Price; below, courtesy of the Bentley Historical Library, University of Michigan.)

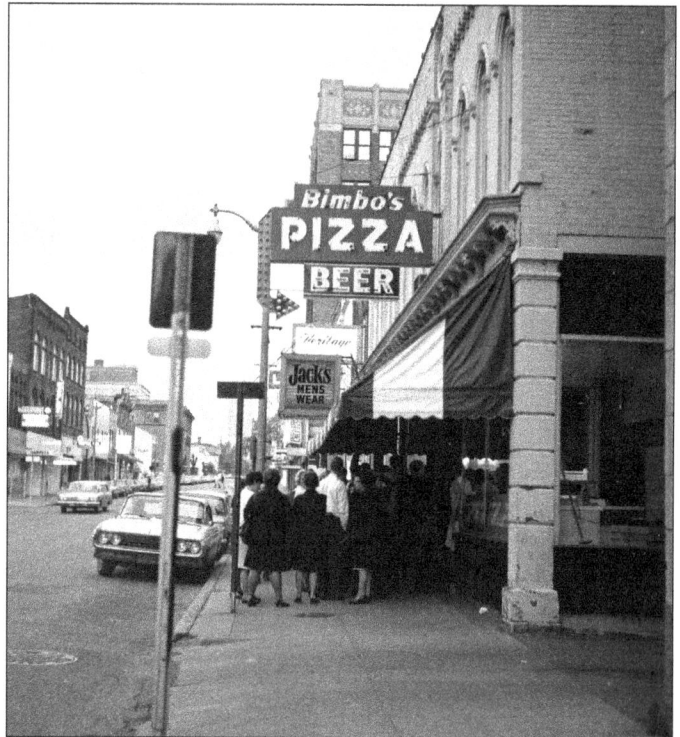

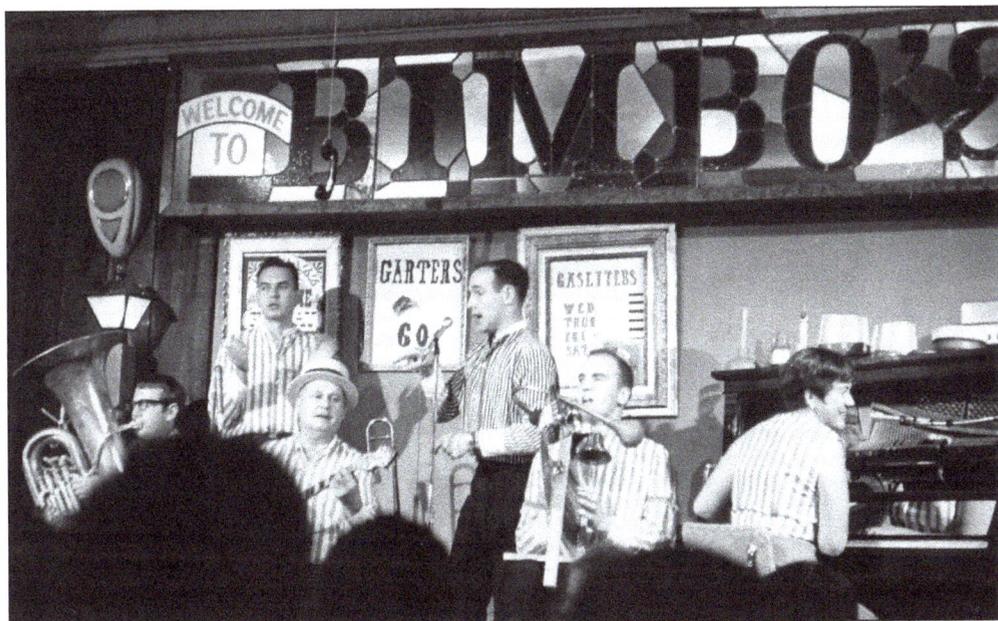

AND THE BANDS PLAYED ON. After any Michigan sports victory, everyone at Bimbo's would literally rock the place, raising their glasses and singing "The Victors," led on by the evening's entertainment. It was where one could hear Mike Montgomery and the Boll Weevils, Kerry Price and The Mother's Boys, Ragtime Charlie & Sister Kate, the Gaslighters, and more. Pictured around 1968 are, from left to right, Brent Herald, Don Dygert, Pat DeLoughery, Rich Bloch, Dennis Huntley, and Kerry Price at the piano. (Courtesy of the Charles Rasch Collection, Bentley Historical Library, University of Michigan.)

VILLAGE INN AND BIMBO'S ON THE HILL. Springboarding off the success of the Ann Arbor Bimbo's, Chutich opened a second Bimbo's along Washtenaw Avenue. It was ready-made for him, as it had recently been vacated by a pizza parlor chain known as the Village Inn. Known as Bimbo's On the Hill, it immediately became a popular place for the nearby Eastern Michigan University crowd. Today, it is home to Paesano's. (Courtesy of the Charles Rasch Collection, Bentley Historical Library, University of Michigan.)

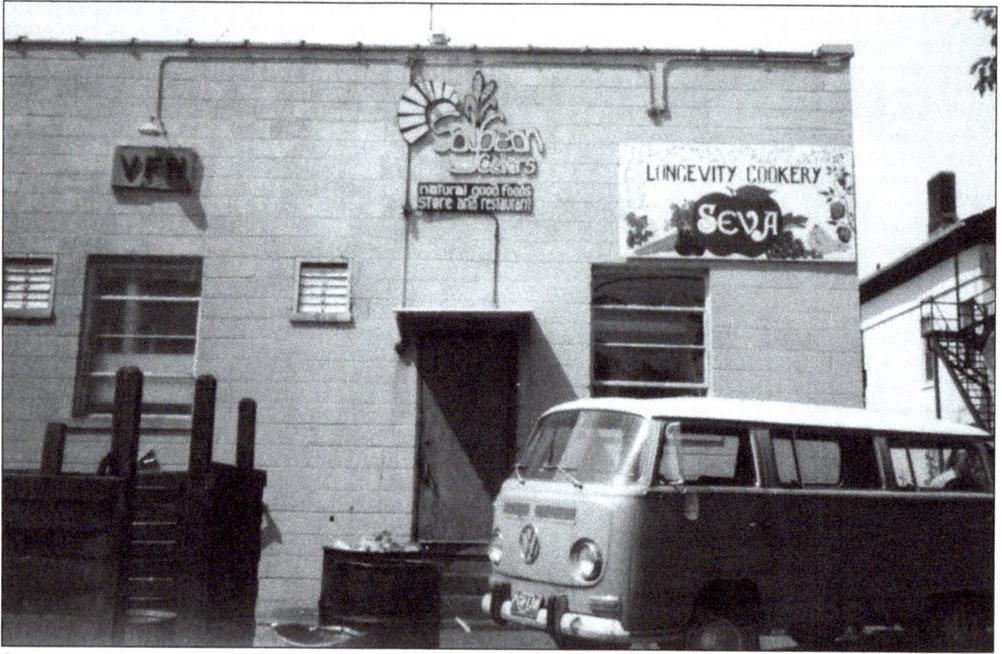

SAY WHAT? Since the dawn of sprouts, Seva has been serving up creative vegetarian food. Housed in a former VFW post (above) on Liberty Street that also contained Birkenstock shoes, The Wild Weft, and Wazoo Records, Seva was formerly the Soybean Cellars restaurant and natural foods grocery. In 1973, Steve Bellock bought and renamed it Seva Longevity Cookery. Depending on who one asks, the name is a variation on the French phrase *ça va*, Sanskrit for "satisfaction," or just a word that means "black bean and sweet potato quesadillas," a menu favorite for almost 40 years. The Jackson family, who bought Seva in 1997, moved it, complete with some of the original stained-glass pieces, to the west side of town in 2014 (below). Happily, Seva is still one of the top vegetarian destinations in the Midwest. (Above, courtesy of the Ann Arbor District Library; below, authors' collection.)

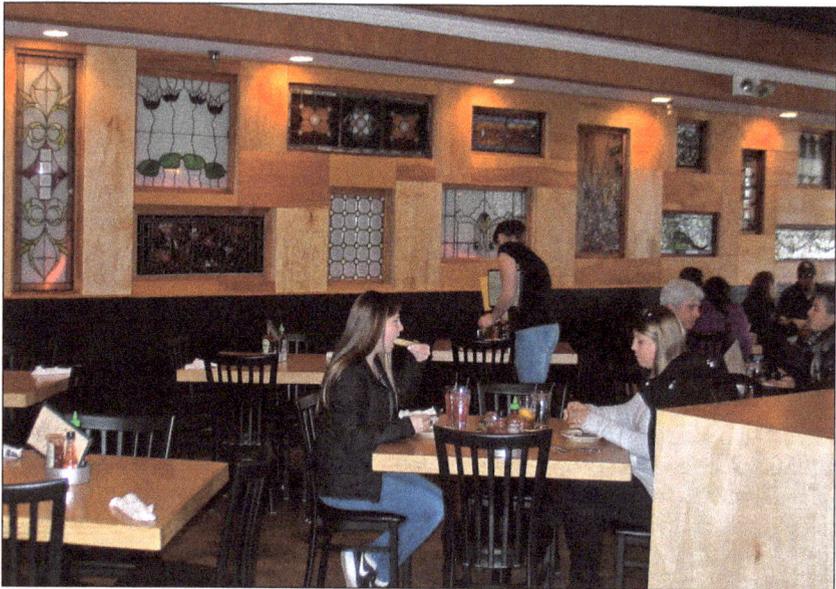

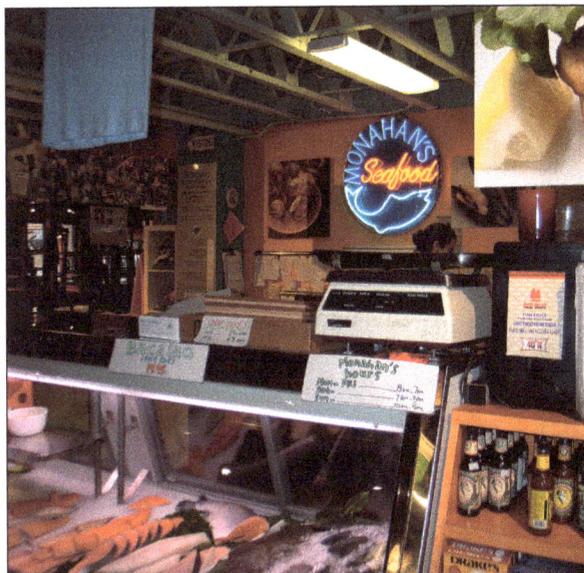

FISHED OUR WISH. From a retail case in Real Seafood to what *Saveur* magazine called "The fish market we wish were next door," Monahan's Seafood is the real deal. Moving to Kerrytown in the 1970s, Mike Monahan is the reason people who did not know they liked fish actually love fish. From the Bernie's chowder (named after a longtime employee) to bluefish teriyaki and fresh oysters, customers can eat there or have the kind (and patient) Monahan tell them how to cook it at home. In his spare time, Monahan also fishes. (Authors' collection.)

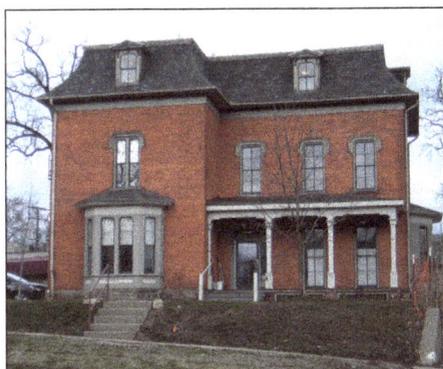

A MOVEABLE FEAST. Chef Dan Huntsbarger and his wife, Carol, assumed ownership of the Moveable Feast, a small restaurant and catering business, in 1996. Transforming the historic home at 326 West Liberty Street (above left) into the award-winning Daniel's On Liberty, they managed their much-heralded catering business from the same location. Over time, Dan's cooking won many accolades from *Zagat*, *Gourmet Magazine*, and even Paul Newman and Elizabeth Taylor. Preferring to focus solely on catering, Dan and Carol closed Daniel's in 2005 and now operate out of nearby Manchester. (Authors' collection.)

WHERE NIGHT OWLS PERCHED. The Pantree, on Liberty Street above Community Newscenter, was one of the few 24-hour downtown melting pots. A favorite of bar and restaurant staff after their shifts, nurses, students pulling all-nighters, and anybody with spare change, the Pantree was big on breakfast anytime. Some craved their nachos, and they even made a good gazpacho. Eventually they trimmed their hours, then closed their doors in the late 1980s. (Authors' collection.)

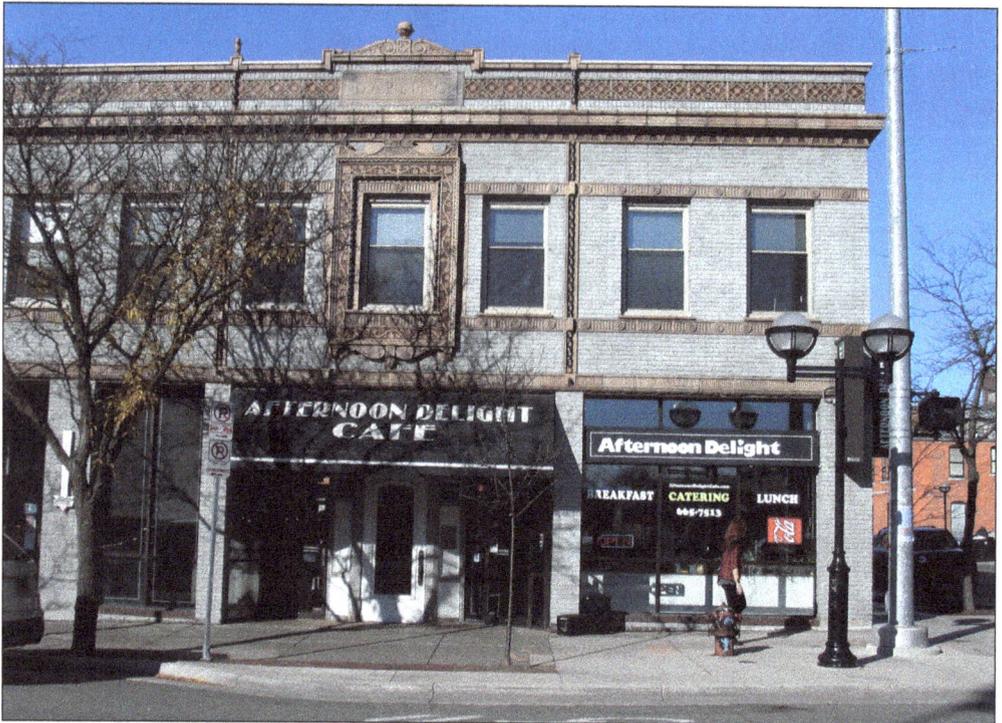

MUFFIN MAN. Though named after a one-hit wonder, the staying power of Afternoon Delight is delightful. Tom Hackett opened it in the former Fisher Pharmacy in 1978 with unique salads (a salad bar was added in the 1980s), sandwiches, and omelets. And if a bran muffin was ever beloved, this is the one. There is almost always a line full of patient people. Families now bring their kids and grandkids to enjoy Afternoon Delight. Hackett added partner Joanne Williams and catering in 2000, and now he says he is "down to working just 7 days a week."

SUMMERS OF LOVE. "Nothing from a can" was one of the mottos at Indian Summer, and folks could taste that care and love. Everything was made from scratch, even the yogurt. In 1971, natural food pioneers Rick Peshkin and Ken King (of Frog Holler Farm fame) opened this State Street spot (formerly the Virginian). The communally-run kitchen dished out favorites like miso soup, vegetable tempura, and a healthy but wicked deep-dish pizza. Being close to the Diag, Indian Summer was an especially popular munchie must during the Hash Bash. (Authors' collection.)

FROM WAKES TO BAKES. Few know that this building began as Dolph's Funeral Home ("Finest Funeral Furnishings") in 1891. A birthday celebration alternative to the Pretzel Bell, Dooley's was a noisy, jock-filled bar with surprisingly good pizza—like the Troll and the Fungus Amungus. Madonna cooked that pizza and waited tables here in the mid-1970s. It was also known for Monday night dime beer. And yes, Shakey Jake ate here. Now Scorekeepers, it still smells like beer; the embalming continues! (Courtesy of the Ann Arbor District Library.)

THE BLIND PIG

208 S. First St. Ann Arbor

HOURS

WEEKDAYS	SATURDAY	SUNDAY
10 AM-2AM	11 AM-2AM	NOON-2AM

TRUE BLUES. A cozy cavern known for world-class blues, Tom Isaia and Jerry Delguidice (who spent time in Europe as exchange students) birthed the Pig in 1971. It was named for a slang term for speakeasies during Prohibition. Many people tried their first cappuccino or espresso there in what was Ann Arbor's first coffee house. The food had a European flair, like crostini sandwiches, spinach soup, cheese plates, and biscotti. It all traveled down a dumbwaiter to the basement, where blues greats like Koko Taylor and Boogie Woogie Red played through dense smoke. Amazingly, these dishes came out of a kitchen that consisted of only hot plates and a toaster oven! The bar served only top-shelf liquor, unusual wines, and beers like Guinness on tap. In the 1980s, the Pig became a rock nightclub. In the 1990s, Nirvana gave it a shout-out on MTV, calling it their favorite place to play ever. In the Ann Arbor food continuum, Tom Isaia owns Coffee Express, and former manager Monique Deschaine started Al Dente pasta in nearby Whitmore Lake. (Both, Tom Isaia.)

ON DRAUGHT
	GLASS	PITCHER
Hamm's	.30	2.50
Bass Ale	.55	4.25
Guinness	.55	4.25
Half & Half	.75	3.50
Black & Tan	.65	4.25

HOUSE WINES
	GLASS	½ LITRE	LITRE
Red	.65	1.50	3.00
White or Rosé	.65	1.50	3.00
Sangria		2.50	4.00

WINE BY THE GLASS

Red (Dry)
Bordeaux	1.10
Beaujolais	1.15
Burgundy	1.10
Lambrusco (Semi-Sweet)	.85
Spanish Burgundy (Dry)	.85

Rosé
Anjou	(Semi-Sweet)	1.05
Mateus		1.15
Rodilys		.90

White
Retsina (Dry, flavored)	.90
Sauternes (Sweet)	1.15
Spanish Chablis (Dry)	.85
Liebfraumilch (Semi-Sweet)	.85
Moselblumchen	.85
Maywine (Semi-Sweet flavored)	.85
Vouvray (Semi-Sweet)	1.10
Orvieto	1.20

Specialty Wines
Plum Wine (Sweet)	.95	Mead (Sweet) .85
Cherry/Blackberry		Sake - Hot or with Ice - .95
Hijaki (Sweet)	.90	

SPARKLING WINE
Asti Spumanti	6.50
Sparkling Anjou Rosé	8.50
Korbel Brut	10.00
Lacrima Christi	
Mumm's Extra Dry	18.00

FORTIFIED WINES
Harvey's Bristol Cream Sherry	2.00
Dry Sack Sherry (Dry)	1.15
Koppe Ruby Port	1.50
Madeira (Rainwater)	.85
Marsala (Sweet)	.85
Punt-e-Mes (Bitter-Sweet)	1.00
Tokay (Sweet)	1.10
Vermouth	.85

POURING AN OUNCE & A HALF OF THE BEST, SINCE 1975.
$2 (INCLUDES MIX OR WASH.)

SPIRITS
Remy Martin (Brandy)
Wild Turkey (Bourbon)
Glenfiddich (Scotch)
Bombay Gin
José Cuervo Gold (Tequila)
Don Quixote Gold (Rum)
Bushmills Irish Whiskey

MIXES
All Mixes Included in Price of Drink
Coca-Cola · Beer · Orange Juice
Schweppes Tonic · Lemonade
Sparkling Soda · Papaya Juice

LIQUEURS $2.00
Drambuie
Sambucca
Amaretto
Tia Maria
Benedictine

YOUR CHOICE OF LIQUOR OR LIQUEUR IN A MUG OF CAPPUCINO TOPPED WITH REAL WHIPPED CREAM **$2** EXCEPT COGNAC $2.50

Three

HAMBURGERS, HOT DOGS, PIZZA, POPCORN, AND SODAS

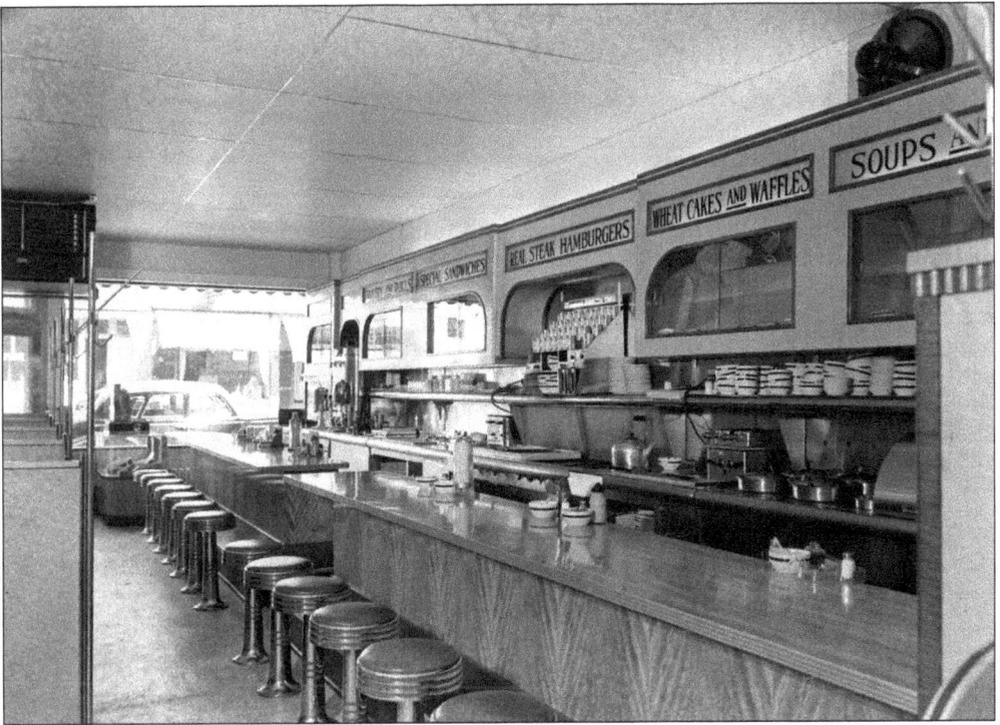

COUNTER SERVICE AND CARRY OUT. Ann Arbor is not a chain sort of place. Many have come; most have gone. Even when it comes to the simplest form of food on the run, folks around here ascribe to Emily Dickinson's craving for a "liquor never brewed"—or at least one they can only get around here. So, if one is seeking something unique amid the usual fare, this is likely the place to find it. Gourmet soups prepared daily and dispensed from an old popcorn stand or award-winning hamburgers prepared and sold at a counter requiring patrons to follow specific rules for ordering—even when it comes to soup and a sandwich, the Ann Arbor experience can be a long way from the ordinary. The fabulously named Hillbilly Hamburgers (above) is still recalled fondly by a few. Located on South University Avenue, between Forest Avenue and Church Street, it was highly regarded for its delicious 5¢ hamburgers during the Great Depression. (Courtesy of Bentley Historical Library, University of Michigan.)

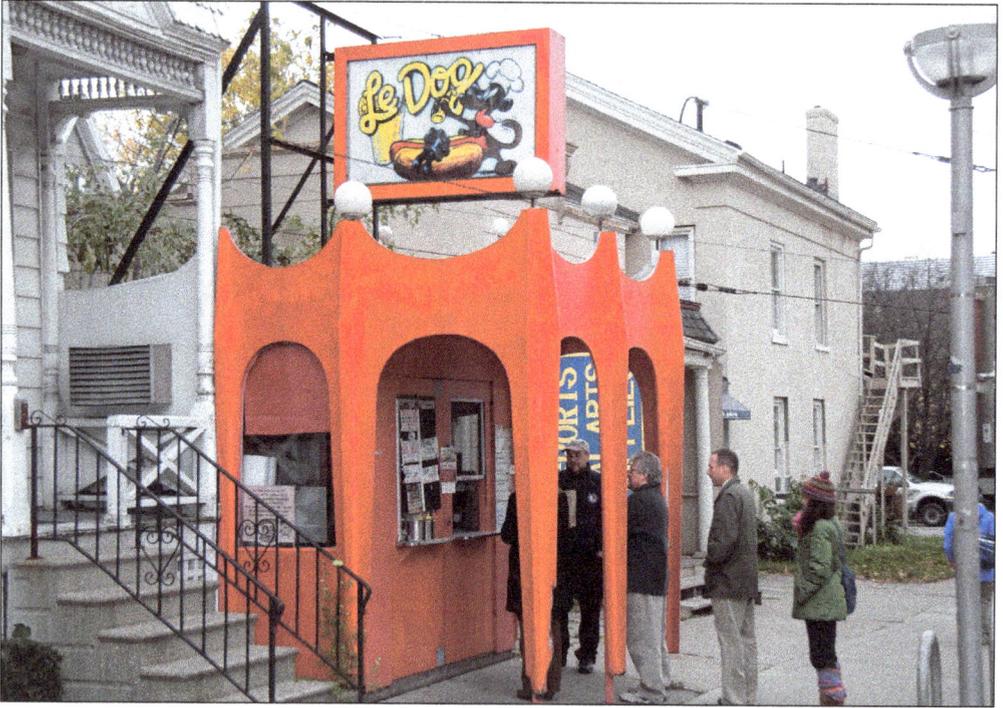

FANTASZTIKUS ETELEK. What started as Karamel Korn Kastle turned into one of Ann Arbor's sweetest success stories. In 1979, Jules Van Dyck-Dobos (below) bought the former garage turned bright red stand on Liberty Street and renamed it Le Dog (above) for the lemonade and hot dogs he planned to sell. Van Dyck-Dobos, who apprenticed under Hungarian chef Louis Szathmary of famed Chicago restaurant The Bakery, then became its manager, yearned for his own creative spot. So he started with a hot dog cart. Then a Michigan winter came, and he thought soup—not just average soup, but mushroom with wild rice, chicken tortilla, and the legendary lobster bisque (people have been known to play rock, paper, scissors for the last bowl). Soon to follow were entrees like roast duck and pheasant under not glass but Styrofoam, all from a 200-square-foot space. A cult (and line) soon formed and continues to this day. (Both, courtesy of Jules Van Dyck-Dobos.)

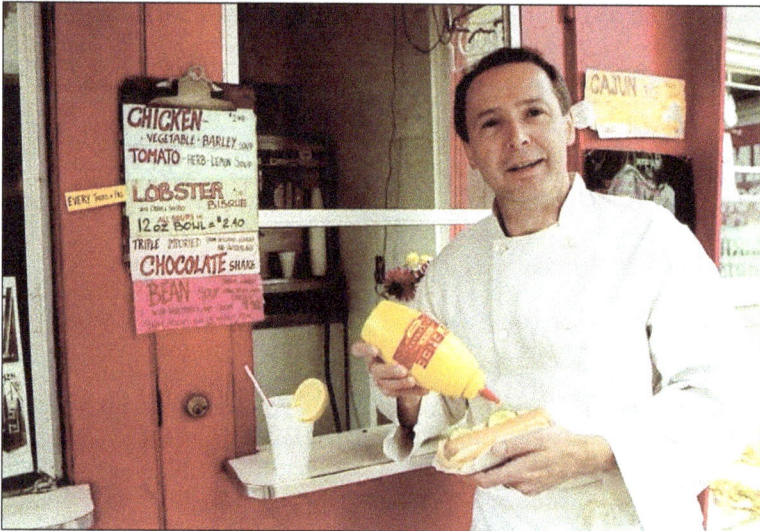

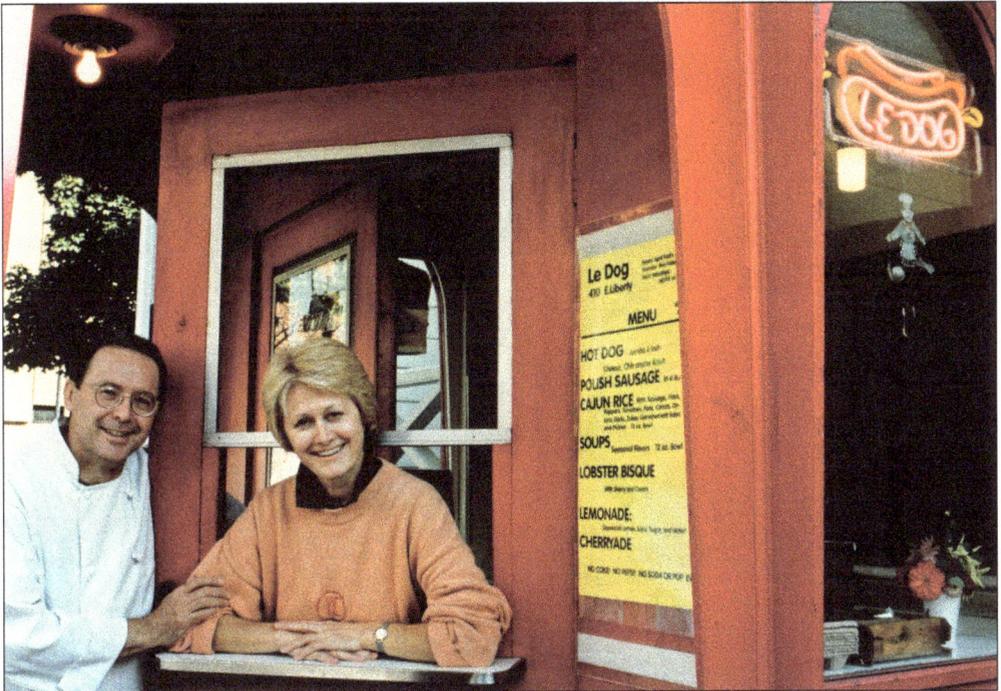

WORTH WAITING FOR. People do not mind waiting. Jules Van Dyck-Dobos cooks what comes into season and what comes into his head. And just when customers think they have a favorite soup, he creates a new one. He has a code of conduct, too: no cell phones while ordering, no website, and the famous sign "No Coke. No Pepsi. No Pop or Soda. Ever!" In the early 1980s, during the Art Fair, the beverage delivery guys refused to brave the busy streets. So Van Dyck-Dobos kicked their equipment out, never to return. For a while, Van Dyck-Dobos stayed on Liberty Street, and his wife, Ika (they met as kids, then married years later), ran an outpost with a bigger kitchen on Main Street. But years of schlepping soups uptown took its toll, and in 2014, they closed the Liberty Street location. Now with their son Miki (below) carrying on the tradition, they are on Main Street to stay. And with over 428 different soups a year, their customers are not going anywhere either. (Both, courtesy of Jules Van Dyck-Dobos.)

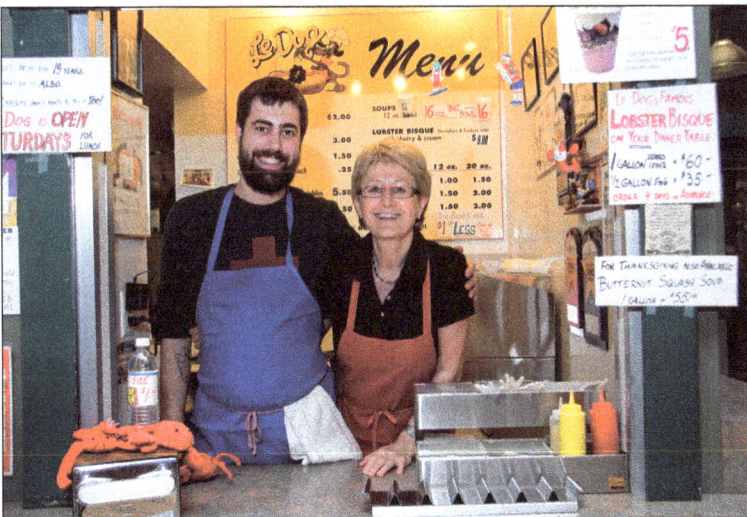

HOW TO MAKE IT HAPPEN:
LISTEN TO THE QUESTIONS
ANSWER JUST THE QUESTION

HOW TO ORDER A BLIMPYBURGER

- # OF PATTIES (THERE A 1/8 ID. TO A Lb.)
- WHAT KIND OF BUN REGULAR (INCLUDED) ONION, KAISER OR PUMPERNICKEL EXTRA
- ANY GRILLED ITEMS
 ↳ BACON, EGG, ONIONS, MUSHROOMS, SALAMI, PEPPERS

X CHEESE AND CONDIMENT CHOICES
WILL COME LATER !!!/!!\!!\

THANK YOU FOR BEING HERE AND
AND PARTICIPATING IN THE PROCESS
ENJOY YOUR BLIMPY

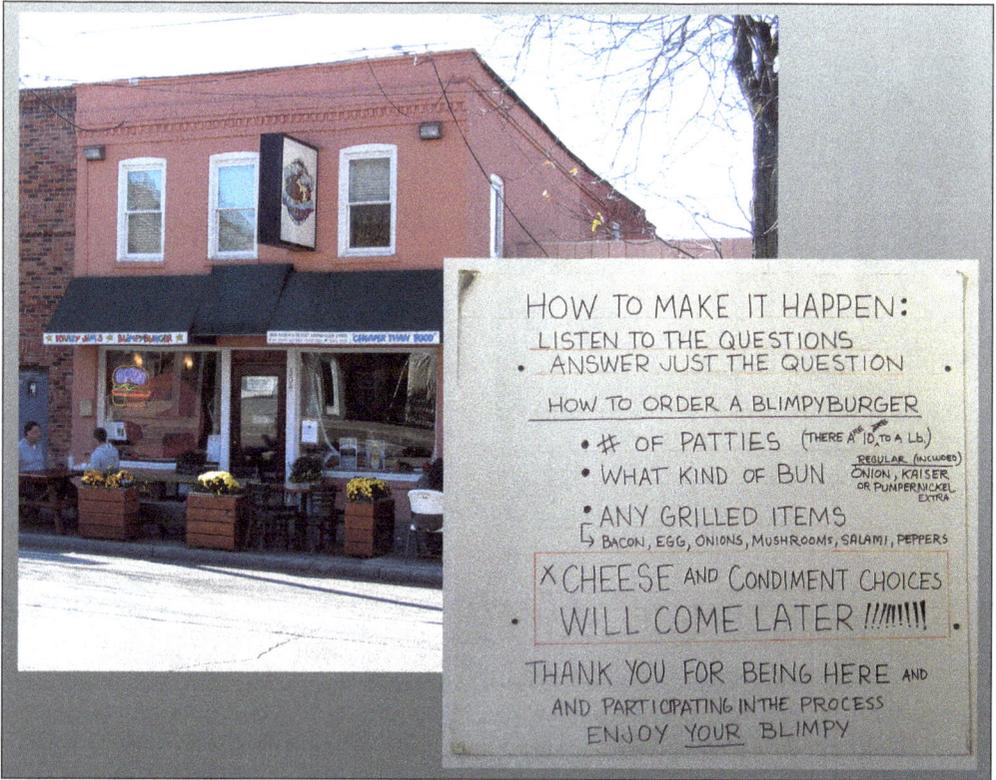

CHEAPER THAN FOOD. For such a free-form joint, Krazy Jim's Blimpy Burger has a particular set of rules for ordering. These involve when to order patties, fryer food, and condiments, among others. That is all part of the charm. Hemming, hawing, and ordering out of order brands one as a rookie. Get it right and get one of the juiciest burgers in town (with toppings like eggs and salami) and a side of crunchy fried vegetables. Sassy service, snow bear sculptures outside in the winter, and the slogan "Cheaper than food" are also hallmarks. Opened in 1953 by Jim Shafer, it nestled among dorms on South Division Street. Rich Magner, the owner since 1992, moved it to its current location on Ashley Street. It is a Food Network favorite, too. Guy Fieri featured Blimpy Burger on his *Diners, Drive-Ins and Dives.* He got it right. (Both, authors' collection.)

KRAZY JIM'S
BLIMPY BURGER
(CHEAPER THAN FOOD)

BLIMPY B. DOUBLE MEAT 35¢
FRENCH FRIES 15¢
COFFEE—2nd CUP FREE 10¢

WE GRIND OUR OWN BEEF
COR. DIVISION & PACKARD
NO 3-4590

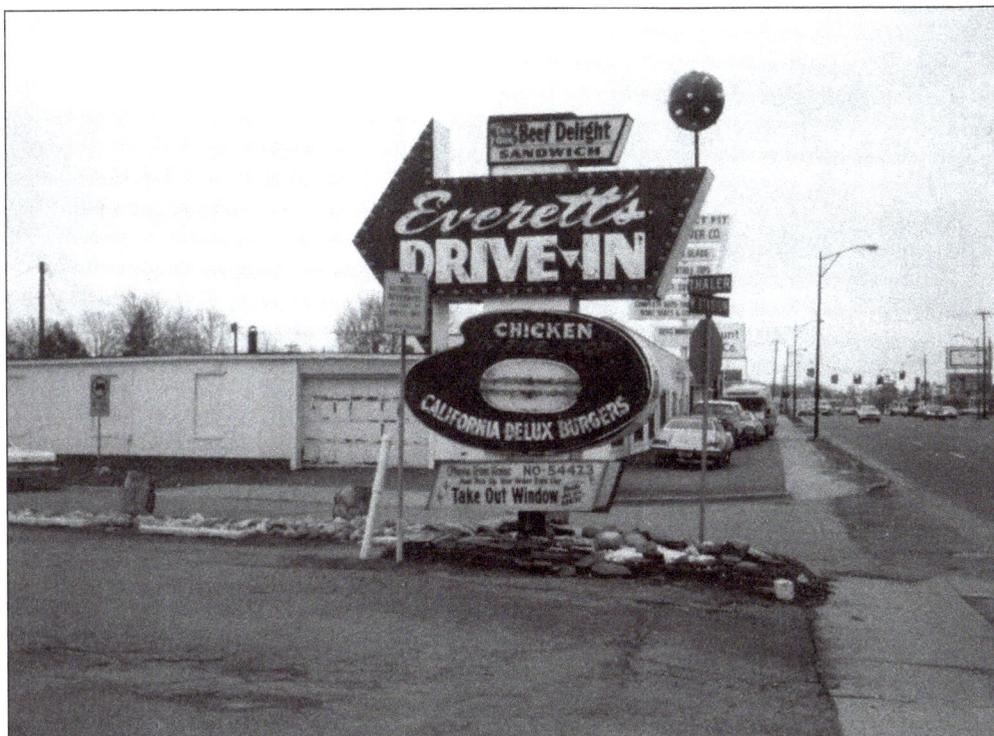

EVERETT'S DRIVE-IN. According to the late Wystan Stevens, Everett's was owned by Everett Williams, who also ran the Milk Maid on Washtenaw Avenue. From the 1950s through 1980, Everett's stood at West Stadium Boulevard and Thaler Avenue, where it became a popular favorite for its trademark California deluxe burger, beef delight sandwich, and "chicken in the coop." Although Everett's is long gone, it still lives on in the fond memories of many who no doubt shed a silent tear as they pass the Taco Bell that ultimately replaced it. (Courtesy of the Ann Arbor District Library.)

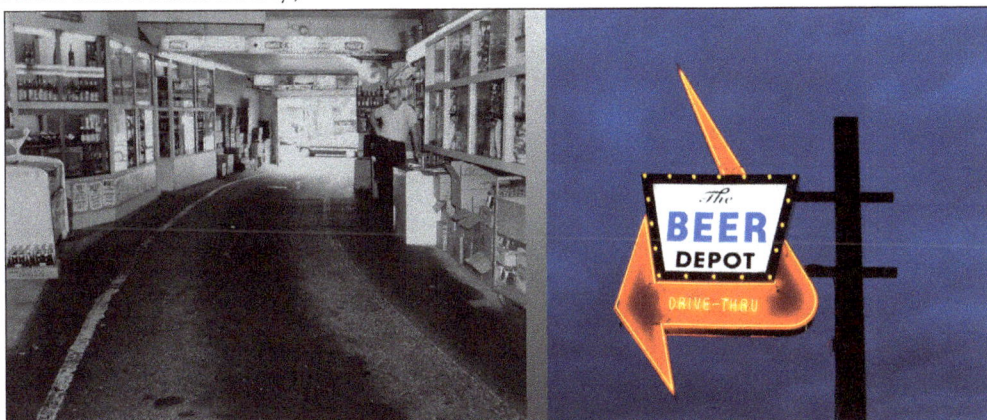

BIER HER. With its iconic sign downtown, the Beer Depot still beckons. An addition to the 1875 Eberbach house, it was built in 1938 as an expansion to Harris Tire. But many remember it as the drive-through Beer Depot. Many a party was stocked by driving through and having cases of beer put directly in the car. That service stopped in 2005 due to regulations. Still, it is a great place to buy craft beer, home brew supplies, and even pizza. (Courtesy of Bentley Historical Library, University of Michigan.)

41

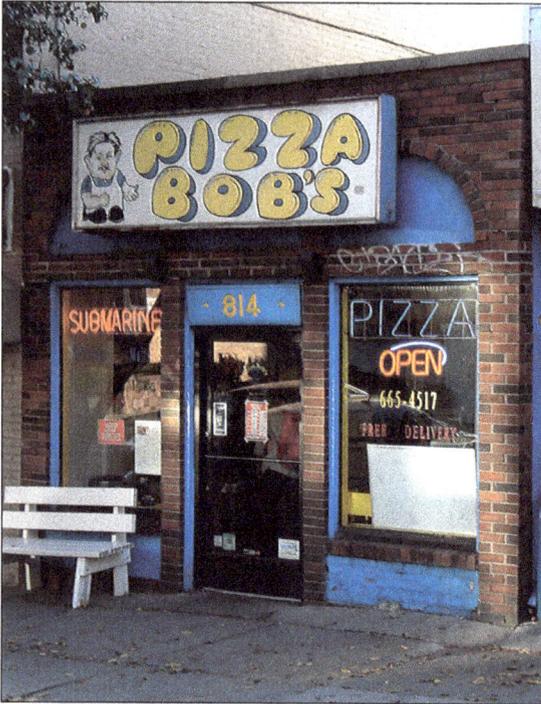

THE BOBS. It started as Pizza Loy Dairy Joy. But since the 1960s, the small storefront now known as Pizza Bob's has been bringing joy in the form of chipatis, thick milkshakes, and subs in addition to pizza. It was renamed for taxicab driver turned cook Bob Marsh (who cooked alongside his wife, "Pizza Babe"). A visit to Pizza Bob's (left) is a late-night and game-day tradition. In fact, on a football Saturday, they will sell over 400 signature chipatis (pocket bread with chopped vegetables and a tangy orange sauce). There have been at least three other locations over the years, including Pizza Bob's Uptown two doors down (below). (Left, authors' collection; below, courtesy of the Ann Arbor District Library.)

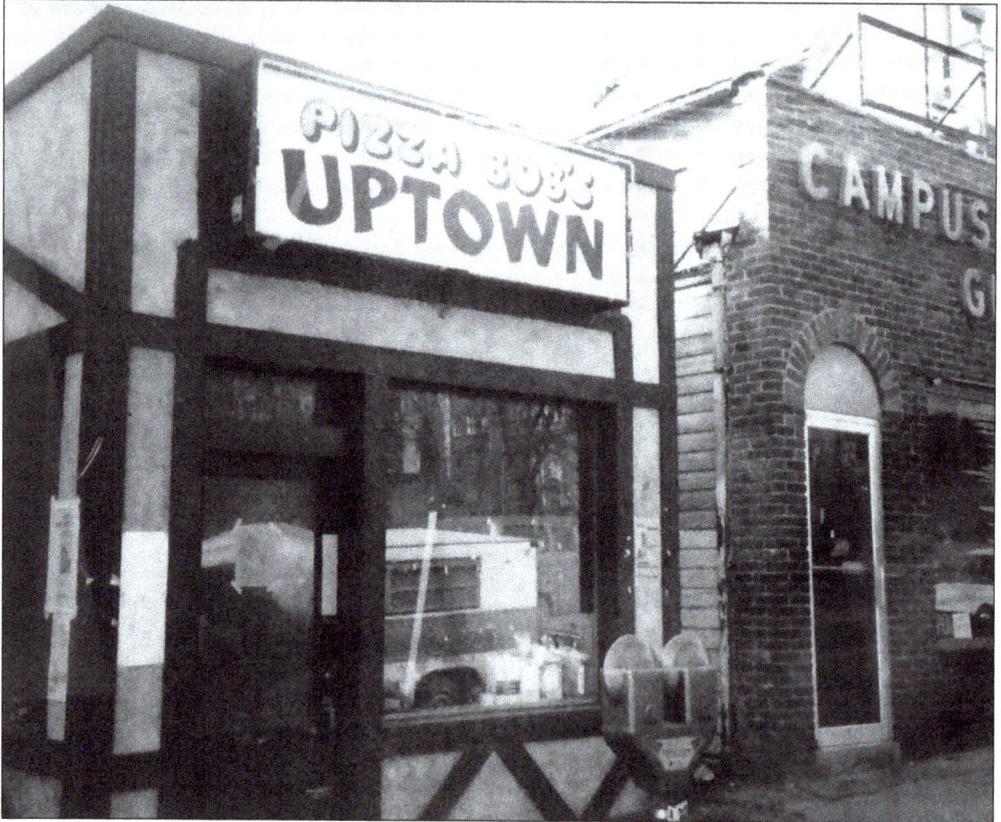

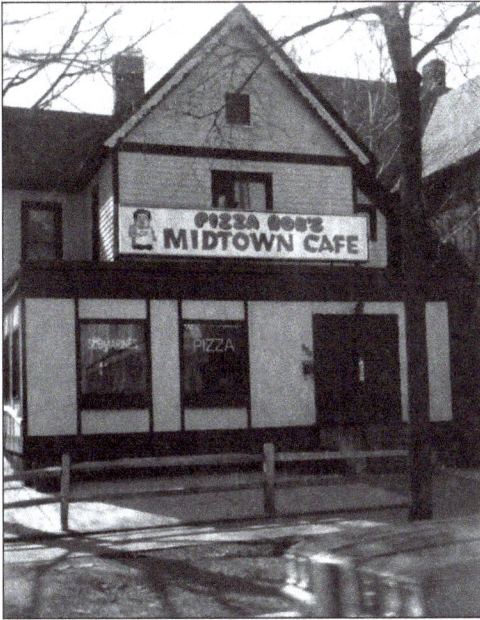

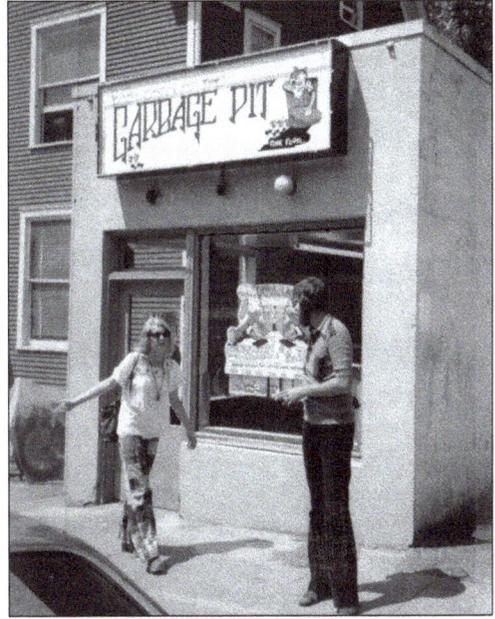

WHAT ABOUT THE REST OF THE BOB'S? There was a Pizza Bob's Mid-Town (above left) on Church Street, a Taco Bob's, and even the Garbage Pit (above right), which later became Pizza Bob's Uptown. Longtime customers Terry and Pam Pietryga have owned Pizza Bob's since 2001, and their son Nathan is carrying on the tradition. Although Pizza Bob himself is long gone (an obit read "All of Ann Arbor grieved when rotund and cherubic Pizza Bob passed away" in August 1971), his likeness can be seen on T-shirts all over the world. (Both, courtesy of Ann Arbor District Library.)

YOU CAN CALL IT RAY'S. It is also known as Chicago Dog House. But do not call it Red Hot Lovers, due to a lawsuit. On East University Avenue, under various names, Ray's has been dishing out dogs since 1983. Also known for its cheese waffle fries, this was the only place to get a real Chicago hot dog. Open until 2:00 a.m. on weekends, Ray's Red Hots is still the perfect place to cure or prevent hangovers. (Authors' collection.)

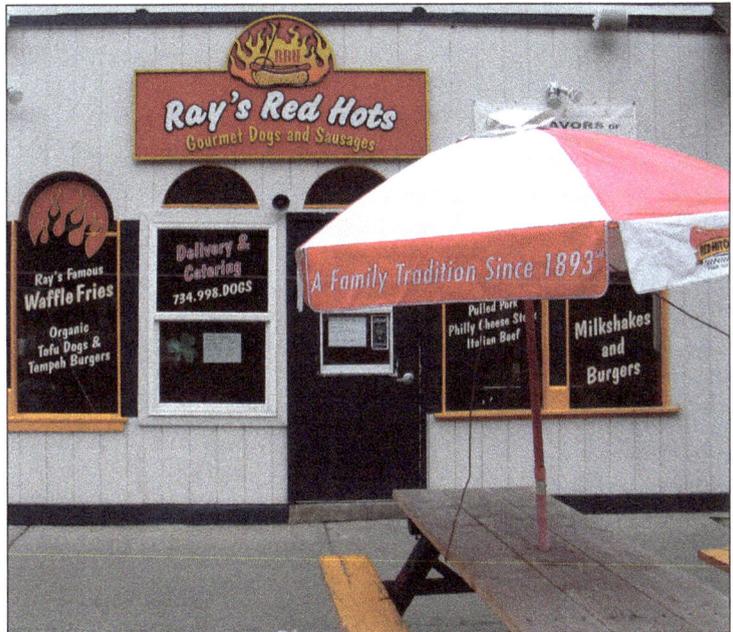

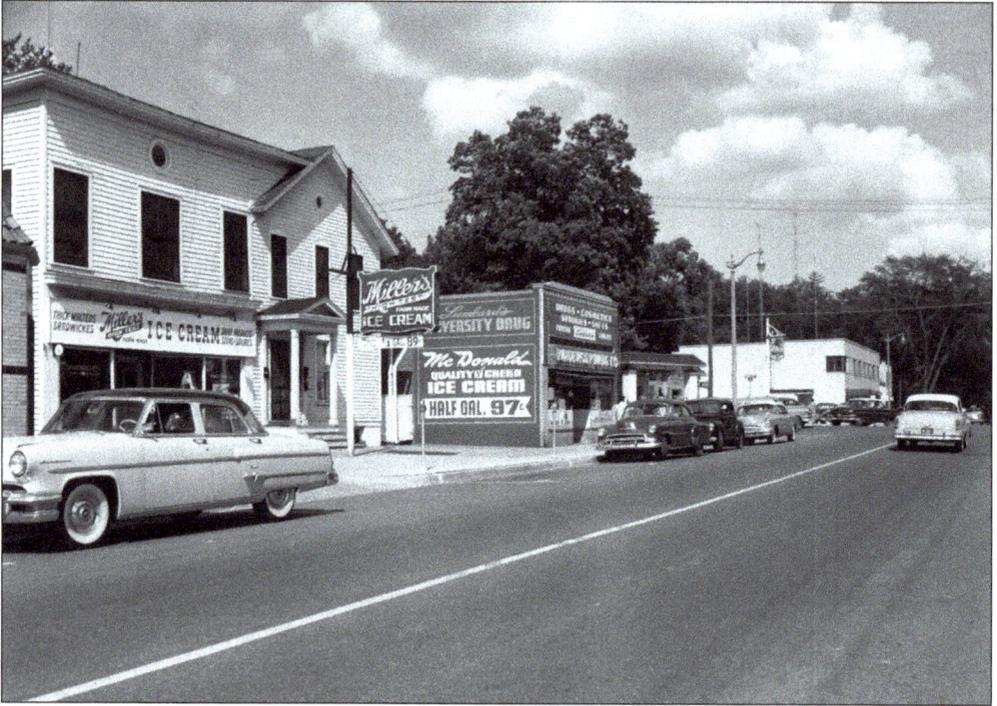

FARM MADE. Miller's Farm Dairy started in Eaton Rapids in 1896 and sold ice cream throughout Michigan. Ann Arbor had three stores on Main Street, Liberty Street, and South University Avenue. Great marketers, they had unusual flavors like dill pickle and gave away Mexican jumping beans. Many remember their massive "Wyatt Burp" sundae. Founder Dennis Miller ate a pint of his own ice cream every day for over 50 years and lived to be 83. Ken Burns says he once took Abbie Hoffman and Jerry Rubin to Miller's on South University Avenue for a cone. Miller's always had unusual names for sundaes. Looking at this Miller's menu from the 1930s (below), perhaps the Queen Mary was named for the new luxury liner. Dolly Varden was a Dickens character. Miller's kept it topical, too. In 1969, they had a man-on-the-moon menu, featuring a Sea of Tranquility float. (Above, courtesy of Bentley Historical Library, University of Michigan; below, courtesy of the Ypsilanti Historical Society.)

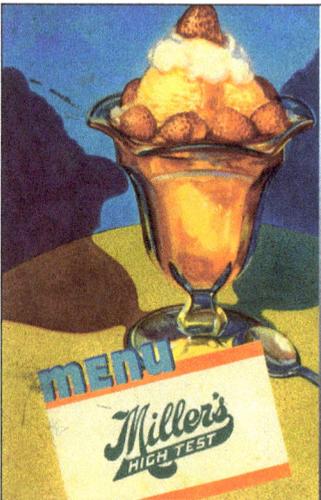

BRICK HOUSE. The debate over the best pizza in Ann Arbor rages on. Since 1986, Pizza House throws down a mighty pizza and delivers until 4:00 a.m. They have as many as 40 delivery drivers at a time. Pasta and "big as a house" burgers are other reasons this place is frequently packed. U of M basketball, football, and hockey coaches do their radio shows from here, so folks are bound to see athletes and their fans. (Authors' collection.)

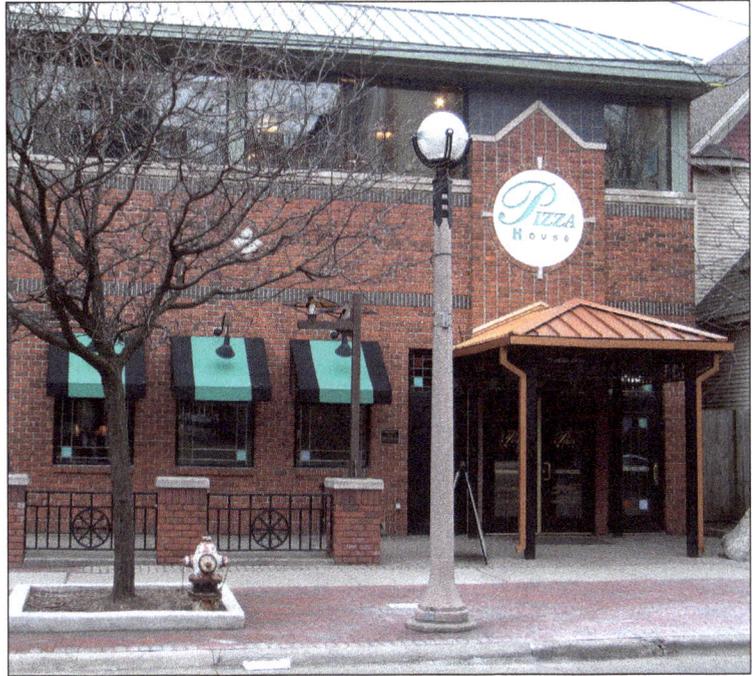

FRAGEL CRAVINGS? This so–Ann Arbor treat was the star attraction at the Bagel Factory on South University Avenue. Picture a deep-fried raisin bagel, rolled in cinnamon sugar—chewy on the inside and crunchy on the outside. A carb lover's destination for over 40 years, this Bagel Factory location closed in 2001, but a version of this unique pastry can be found at Bagel Fragel on Plymouth Road. (Authors' collection.)

45

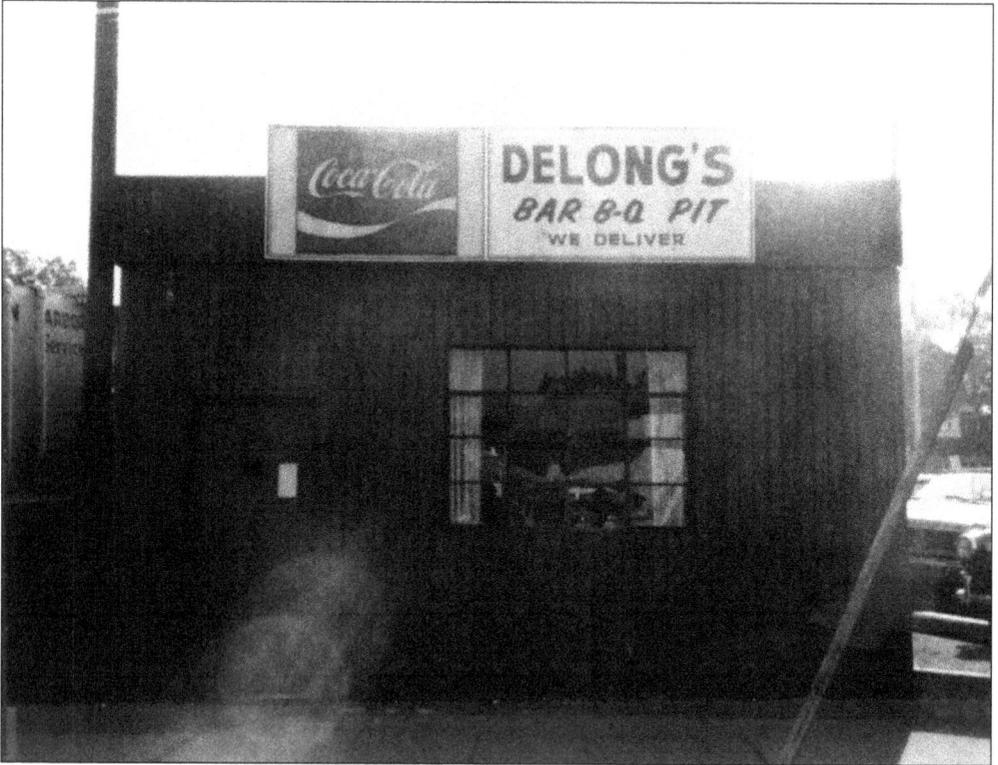

The tastiest in town!
REAL BAR-B-Q

DeLong's delectable, mouthwatering
Ribs - Chicken
Shrimp & Seafood

Dinners • Sandwiches • Side Orders
Carry-Outs • Deliveries • Party Trays

314 Detroit Street *(opposite Farmer's*
665-2266 *Market)*

Mon-Wed-Thur-Sun 11:00 am to 2:00 am
Fri-Sat 11:00 am to 3:00 am
Closed every Tuesday

CLASSIC 'Q. Wafting through the Farmers Market, the soulful smoke of DeLong's Bar-B-Q Pit drew hungry shoppers willing to throw vegetables aside for some tangy ribs. Cooking on a huge old-fashioned grill, DeLong's delivered barbecued chicken, trout sandwiches, and other meaty treats through the wee hours. Lots of sauce and lots of napkins were used. And there was great sweet potato pie. DeLong's was founded by Robert and Adeline Thompson in 1964, shortly after they relocated from Mississippi, and it quickly became the place for authentic barbecue! It was also one of Ann Arbor's most successful African American–owned restaurants with a popular run exceeding 37 years—briefly and ironically, it became a vegetarian Indian restaurant before finally closing its doors in 2002. Over the years, Ann Arbor has proven to be a fertile environment for African American startup restaurant businesses, and while DeLong's is the most notable, many still fondly remember Johnnie's Diner on Huron Street, run by John Eddins. It later became the Rose Bowl, owned by peace activist Rose Martin. And many still recall Ike's Snack Shack on Catherine Street, owned by Ike and Racine Hunter. (Above, courtesy of the AADL; left, authors' collection.)

Four

AROUND THE WORLD, JUST UP THE BLOCK

WHERE IN THE WORLD. When it comes to international fare in Ann Arbor, one can pretty much go anywhere in the world and never leave town. The multicultural pull of the university has made it possible for locals to sample foods from every corner (and curve) of the world. The German restaurants got here first, but, since most folks around here were German, it would hardly have been called exotic or even foreign. In time, there was something for everyone from just about everywhere. And what there is not, there soon may well be. Bon appetit! (Courtesy of the JBLCA.)

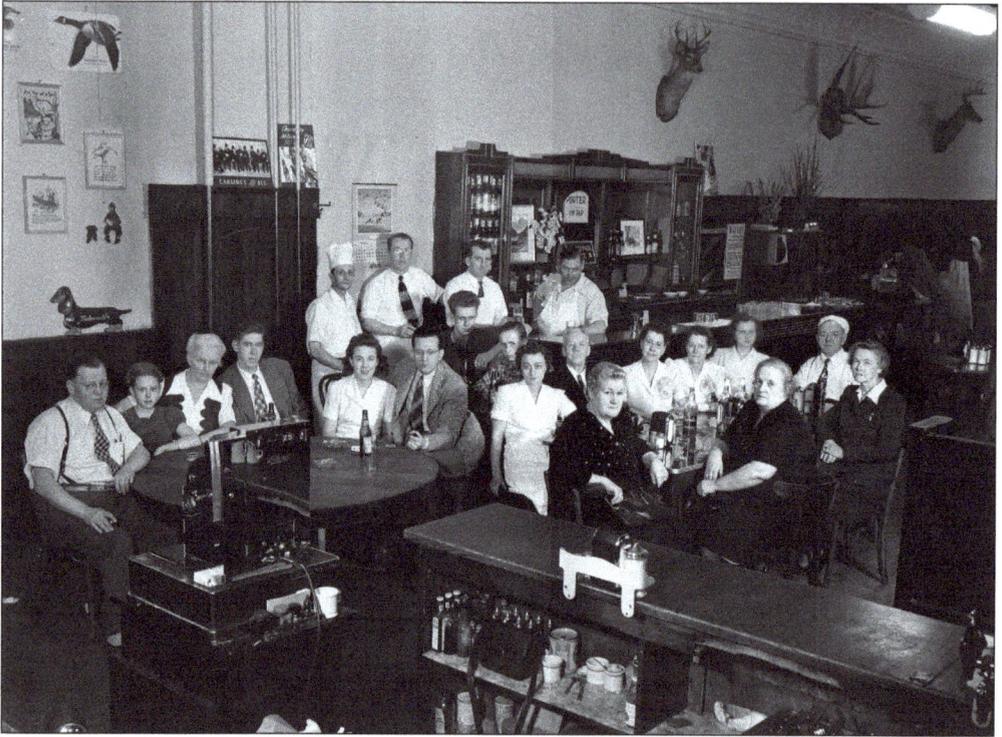

DAS FOOD! Migrating from Germany in the 1920s, the three Metzger brothers set out to corner the market in fine German food. Third-generation owner John Metzger explains that his grandfather Wilhelm, accompanied by brothers Fritz and Gottfried, decided that Ann Arbor, with its predominantly German population, was the perfect place to offer their old-country food specialties. Wilhelm opened his full-service restaurant, Metzger's, in 1928 near the corner of Ashley and Washington Streets, where he served traditional favorites like sauerbraten, rouladen, schnitzel, and a wide variety of German beers. In 1936, Metzger's moved just east of Fourth Avenue (above), where ownership eventually passed to Wilhelm's son Walter until closing in 1999. Since 2001, John Metzger and his sister Heidi have held court in Metzger's new location (below) on the west side of town at Zeeb Road, just north of I-94. (Above, courtesy of the Bentley Historical Library; below, authors' collection.)

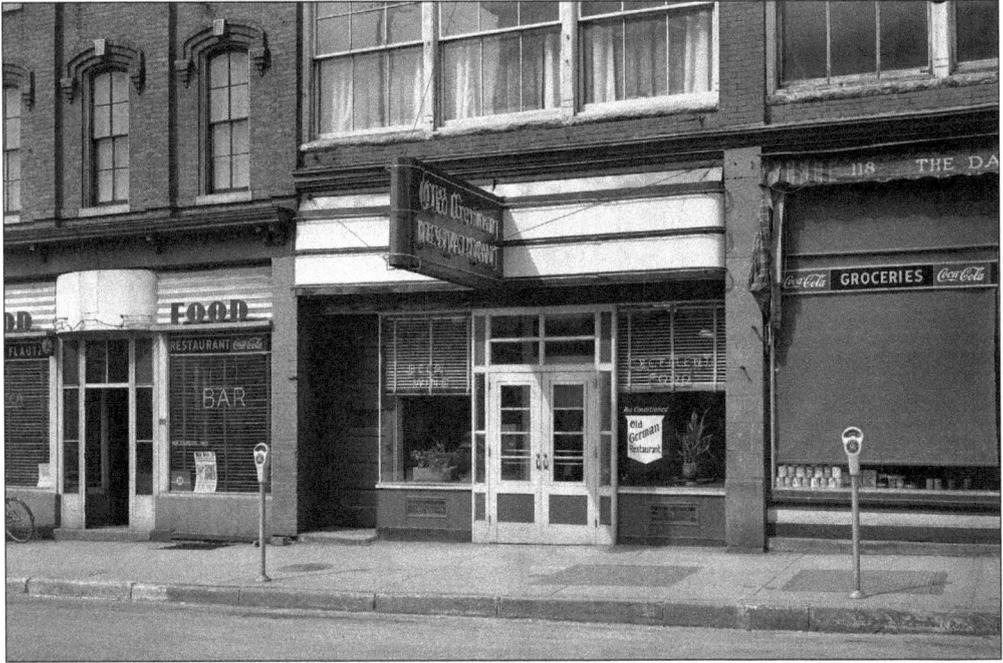

YOUNG AND OLD GERMANS. Following the lead of his brother Wilhelm, Fritz Metzger also went into the restaurant trade, opening an establishment in nearby Ypsilanti and later running another in Ann Arbor. Although all three Metzger brothers had been bakers back in Germany, only Gottfried stayed true to the original trade, opening the Deluxe Bakery at Washington Street and Fourth Avenue. In 1946, Fritz bought the Old German (above), a restaurant that had stood adjacent to Metzger's at 120 West Washington Street for many years. Below, a group of Marines poses in front of the Old German during the postwar years, a happy alternative to the World War II period when the family had to endure false rumors linking them to the German war effort. They ultimately defended themselves and were cleared through the efforts of the *Ann Arbor News*. While the original Old German closed in 1995, it was reopened 18 years later and now resides just below Grizzly Peak. (Both, courtesy of Bentley Historical Library, University of Michigan.)

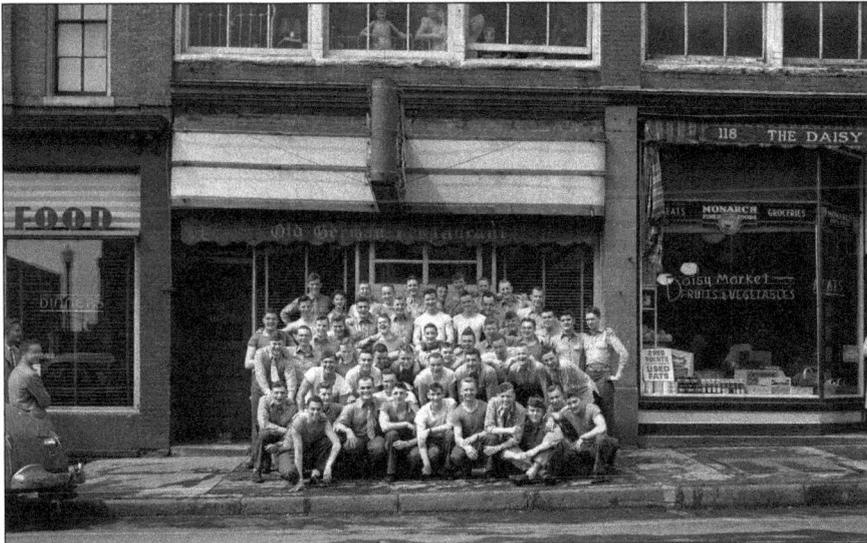

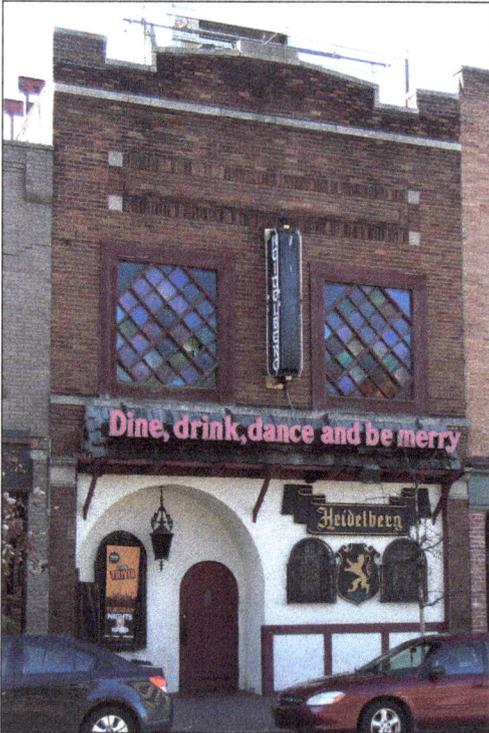

HEIDELBERG. The "Berg" has been offering dining, drinking, dancing, and music diversions for more than 50 years. Opened in 1961, the Heidelberg (left) at 215 North Main Street has always featured traditional Bavarian-style dishes, but in recent years, it has expanded its menu to include "continental favorites" (it even offers quesadillas), as well as contemporary *Neue Deutsche* cuisine. The new owners have restored the Bavarian murals, and the main floor Alpine dining room still retains its old-country family dining feel, while downstairs, the Rathskeller continues to exude its after-hours, party flavor, offering a wide variety of German and local brews and the famous glass boot of beer. Never short on entertainment, the Heidelberg has offered musical acts from Ragtime Charlie & Sister Kate to the Barons at the Heidelberg (below). In recent years, the Heidelberg has introduced the Club Above on the second floor for alternative and electronic dance music aficionados. (Left, authors' collection; below, courtesy of Bonnie Ross.)

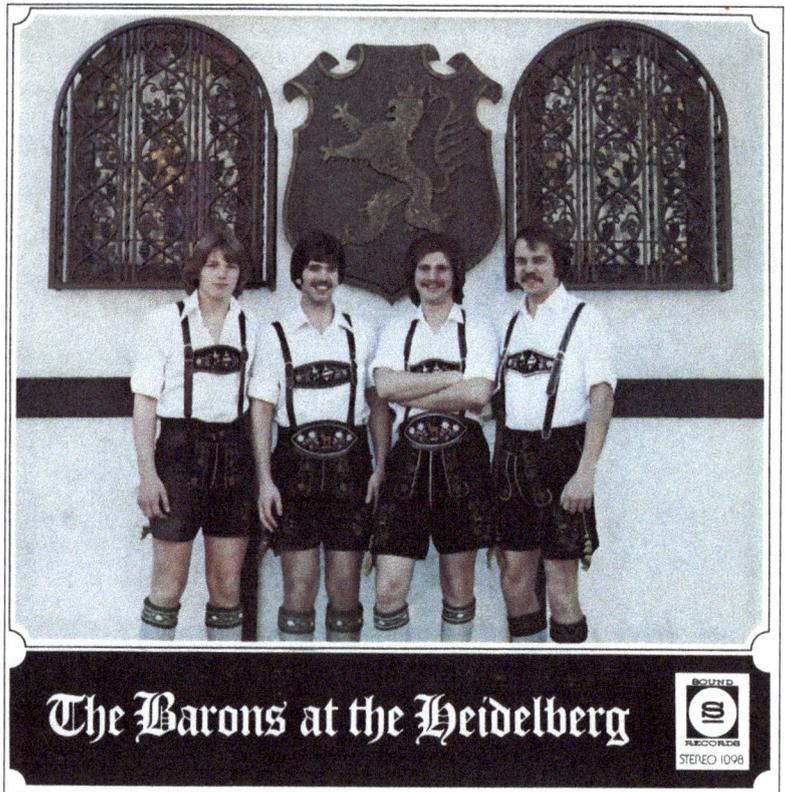

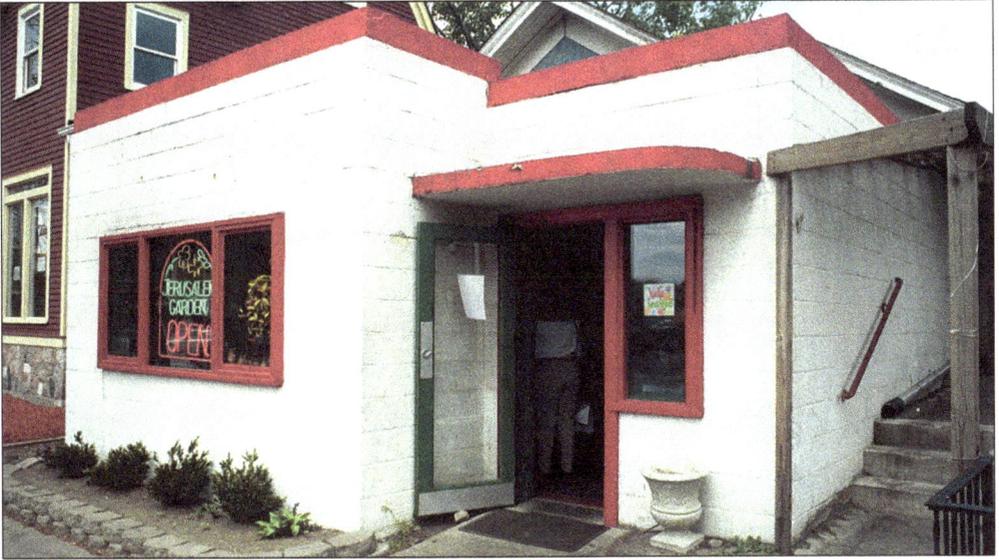

AT THE CORNER OF PALESTINE AND THE MIDWEST. As cozy and comforting as a bowl of its lentil soup, the original Jerusalem Garden was 350 square feet. But for falafel this delicious, diners were happy to crowd in. Ribhi Ramlawi started the Jerusalem Garden in 1987. His son Ali continues in a bigger space in the former Seva on Liberty Street. Ali thinks he has made at least 100 tons of hummus so far. (Photograph by Jim Rees.)

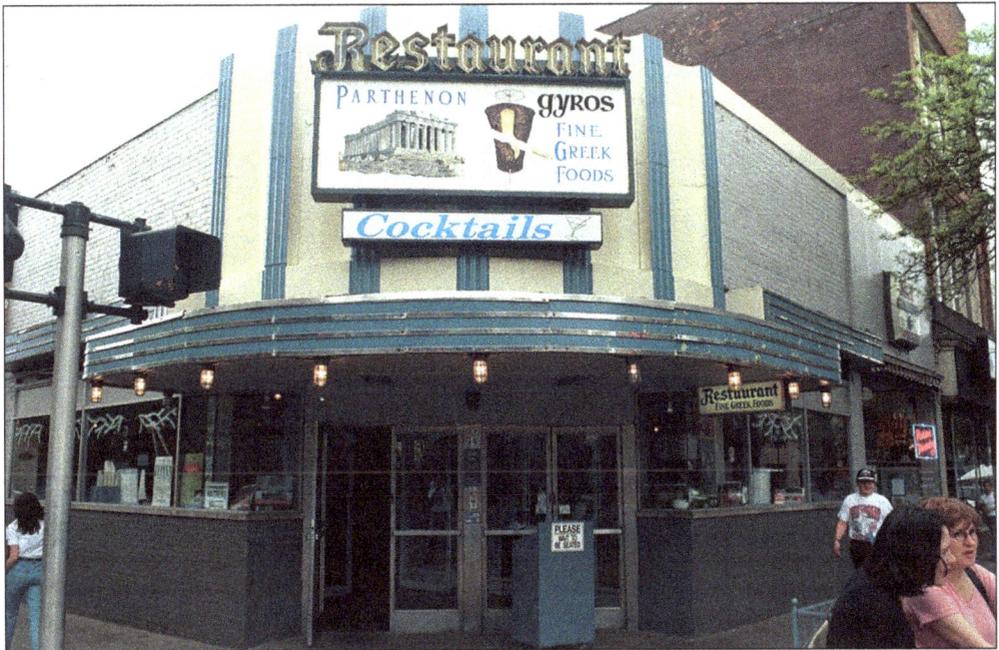

OPA! Grilled lamb and beef slices, with tomatoes, onions, and tzatziki sauce, nestled in pita bread—from 1975 to 2012, countless fans wolfed down these gyros at the corner of Liberty and Main Streets at the Parthenon. Starting as a cafeteria with sparkly red vinyl booths then a full-service restaurant, stomachs (and hair!) were warmed by *sagnaki*—kasseri cheese set aflame with a hearty "Opa!" Brothers Tom and Steve Gavas made this former Cunningham's drugstore a late-night Greek haven. (Photograph by Jim Rees.)

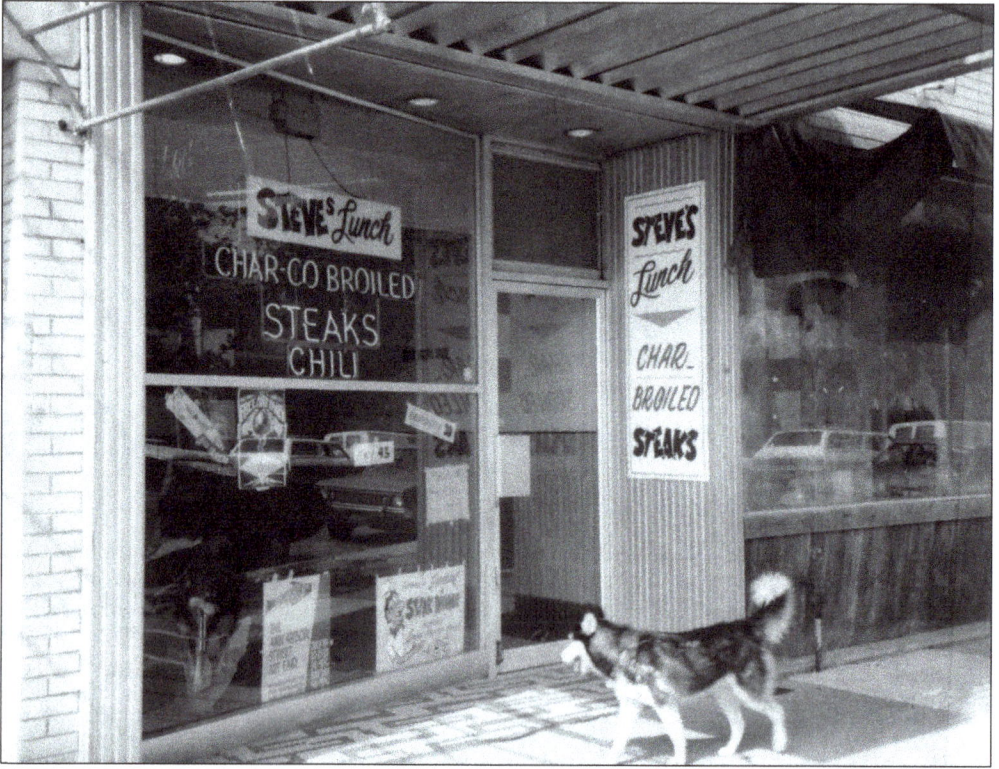

STEVE'S—YOU KNOW, THAT KOREAN PLACE. Steve's Lunch is not the name one would expect serving beansprout omelets, kimchi, and bi bim bap, especially back in the 1970s. Many would stand in line to revolve on one of the red stools at this counter-only treasure. Korean-born scientists Wan Youl and Goom Sook Lee bought it from Steve Vaniadis in 1972. Many had their first and still favorite taste of Korean food at this diner. (Courtesy of the Ann Arbor District Library.)

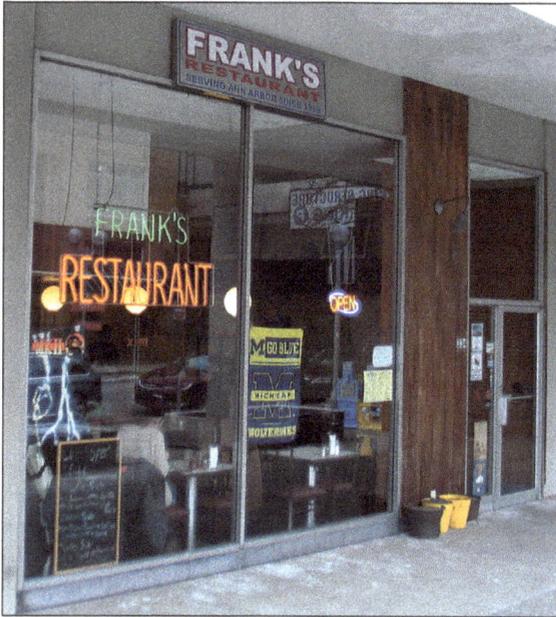

CLASSIC GREEK. As longtime Frank's patrons enjoy their crispy French toast and hash browns, they try to picture Pete Poulos at the grill. Now retired, Poulos owned, managed, and cooked for over 30 years at this Maynard Street icon (he also did a stint at the Delta on Packard Street). New owner Tony Zervogiannis has thankfully kept things much the same. But please, do not linger with a laptop. It is just not done. (Authors' collection.)

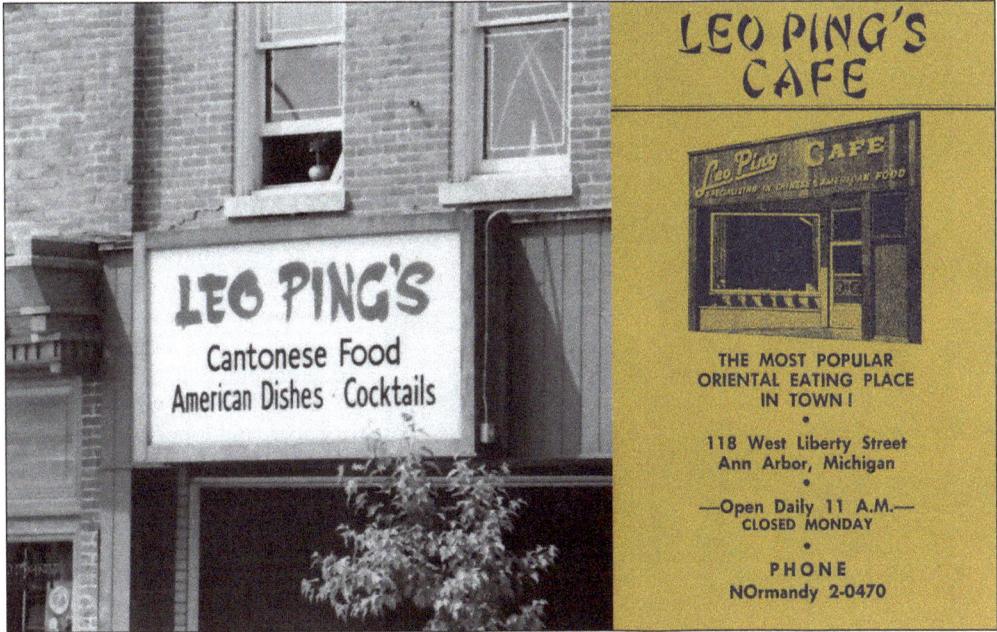

SWEET AND SOUR. Purely Cantonese, Leo Ping's was Ann Arbor's first Chinese restaurant, or as the menu proclaims, "The most popular Oriental eating place in town." The Lum family, who also had restaurants in Detroit's Chinatown, started out upstairs on Main Street, then moved to West Liberty Street. Pressed duck, chop suey, and Cantonese shrimp with eggs were some favorite dishes, but there was a lot of love for their good old American fried chicken, too. (Both, courtesy of the JBLCA.)

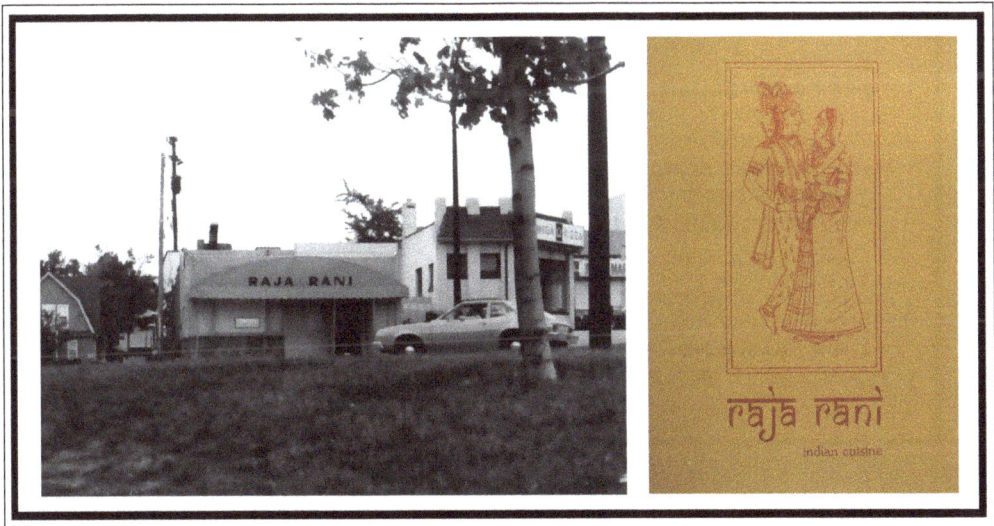

REGAL CUISINE. One of the first Indian restaurants in Ann Arbor, Raja Rani opened in the early 1970s in a little spot on Huron Street that later became Kana. The tandoor oven was a taste of home for many students. In 1976, it moved to a Victorian house on Division Street, where many had their first taste of aloo gobi, tandoori chicken, and naan. Raja Rani means "king and queen" in Sanskrit, and in tribute to the original name, long may it reign. (Both, courtesy of the JBLCA.)

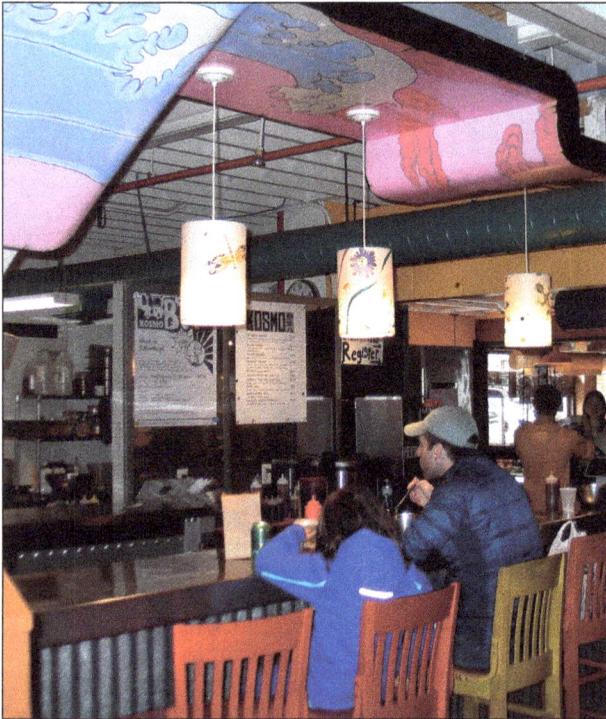

BOP OVER. Community High's patron saint of quick tastiness has always been Kosmo's in Kerrytown. Original owner Henry Park introduced Korean specialties like bulgogi and chop chae noodles back in the late 1970s. He also made a mean egg roll. But the vegetable tempura was the star. Don Kwon, owner since 2001, doubled the café space and has added bi bim bop and fusion food like hot dogs wrapped in bacon and topped with kimchi. (Authors' collection.)

HAPPY BIRTHDAY. The small and serene Kana was on Huron Street near the U of M hospital, replacing Raja Rani in 1982. Byung and Kun Ko made a special ginger tea to go with their spicy meals, like the tak bokum with chewy rice cakes. Kana moved to Liberty Street in 1995 (where the Round Table used to be) and continued until 2000. The next chapter was written by son Y.B. and partner Duc Tang, who expanded the menu into the creative pan-Asian restaurant Pacific Rim. (Courtesy of the JBLCA.)

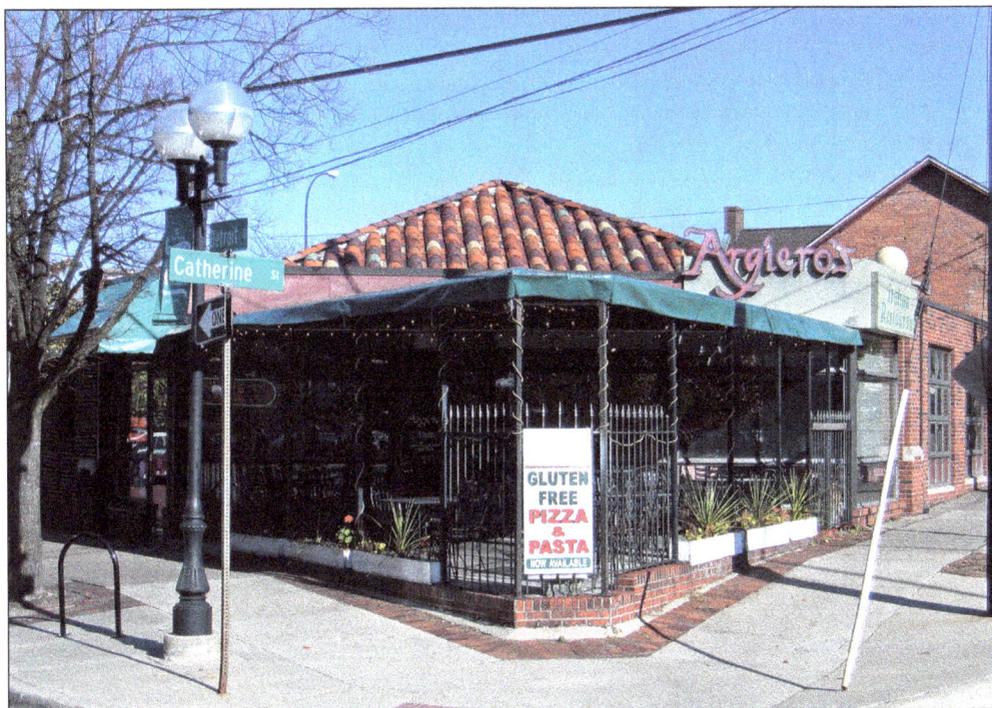

TERRA-COTTA AND RICOTTA. There is history and great Italian food under the old terra-cotta roof at 300 Detroit Street, part of the Kerrytown district and home since 1977 to Argiero's—"the only Italian Restaurant in town, still run by an Italian family." Housed in what was around 1936 a historic, cooperative gas station, Argiero's was founded by Rosa and her husband, Tony (Tony's father asked for train tickets to Benton Harbor, and the stationmaster heard Ann Arbor). Today, it is run by their sons. Many loyal customers enjoy dishes like spaghetti with eggplant sauce and pasta di giorno with lots of garlic, either in a relaxed inside atmosphere or on the covered outside patio. Take the cannoli (it is homemade). (Authors' collection.)

WINNER DINNER. Named for a yearly horse race in Siena, Palio's has dished up Italian country cooking since 1991. The former Quality Bakery (then Quality Bar) became Ann Arbor's first rooftop restaurant, called Palio Del Sole. Both upstairs and downstairs serve favorites like asiago al forno, pasta with rustic Bolognese sauce, and tiramisu. It is all made in Palio's *cucina*, which is a challenge when making lasagna for an Art Fair crowd, as one chef described. It is a great spot to watch the world below. (Authors' collection.)

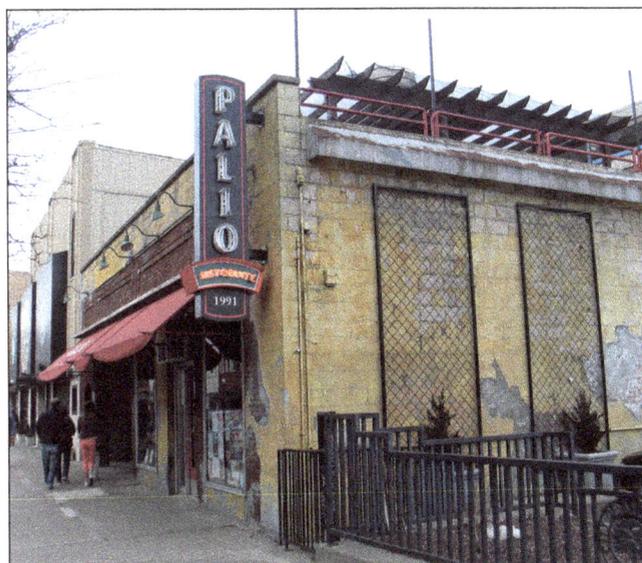

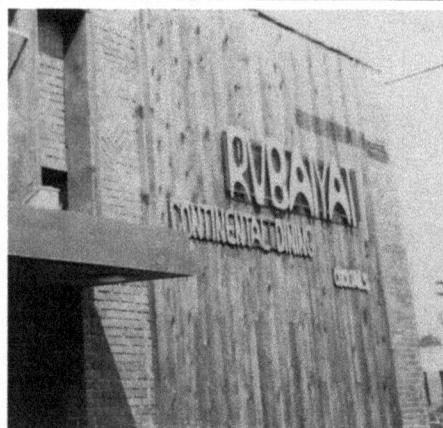

A JUG OF WINE, A LOAF OF BREAD, AND SOME WOO DIP HARR. The Rubaiyat's "enchanting atmosphere of Continental dining" was not the only way it ultimately widened horizons. Opened in 1960 as a dining and dance club by Greg Fenerli, it served up to 300 guests exotic dishes like Hawaiian chicken and sukiyaki. But it ran into eye-raising legal snags in the early 1970s when same-sex couples attempted to dance together. In time, the Rubaiyat became one of the first clubs to establish a dedicated gay night, and still later, it became one of the most important clubs of the disco era. Just ask Madonna. (Above left, courtesy of the AADL; above right, authors' collection.)

CORNER CUISINE. There has been quite a menu of owners at 1232 Packard Street. In 1968, novelist Kingsley Amis's ex-wife, Hilly, opened an authentic British fish and chips shop. It was later run by Constance Bassil, who put up signs like "Tax and poison included." Many remember China on the Run (which later Diamond Head Café in Kerrytown) for its Hawaiian influence. The mid-1990s brought Bev's Caribbean Kitchen and delicious jerk chicken. Here's hoping Real Baked Goods succeeds with its from-scratch cinnamon rolls. (Authors' collection.)

Five

I SURE MISS

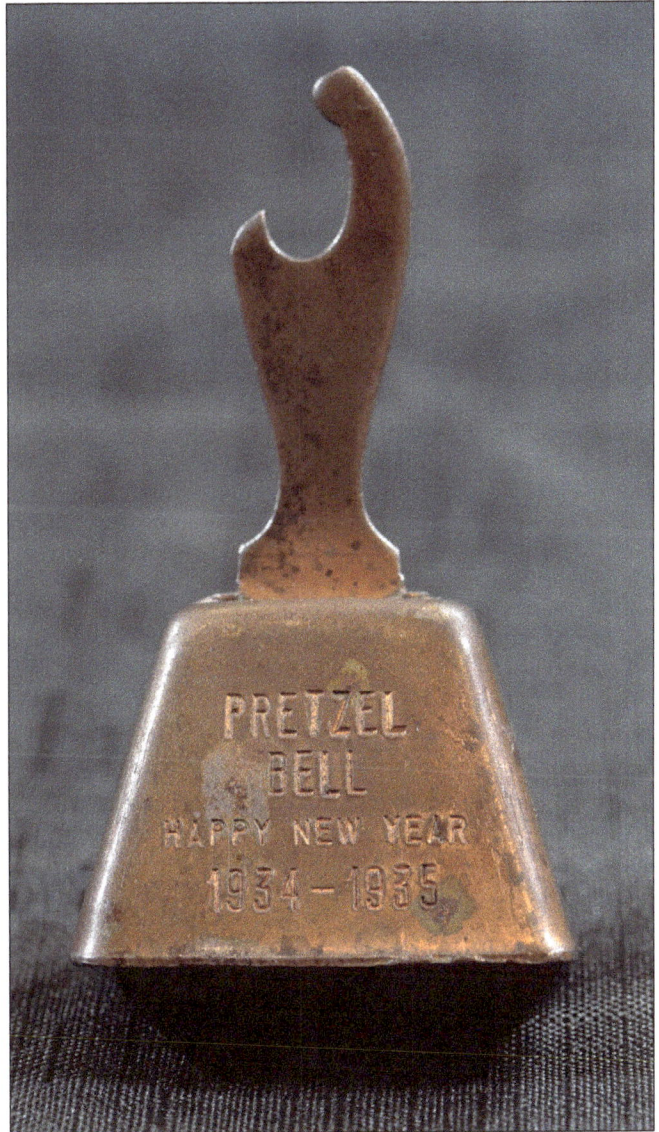

ALL OVER BUT THE
SHOUTING. When people
heard about this book
on iconic Ann Arbor
restaurants, the common
response was, "Is the Pretzel
Bell going to be in it?"
Drake's was a close second.
Sadly, the originals are gone,
as are many others. But here
is a chance to briefly cry
in beers and limeades and
fondly remember those places
frequented not so long ago.
The combination bell and
bottle opener (right) was
a Pretzel Bell party favor
on New Year's Eve 1934.
(Authors' collection.)

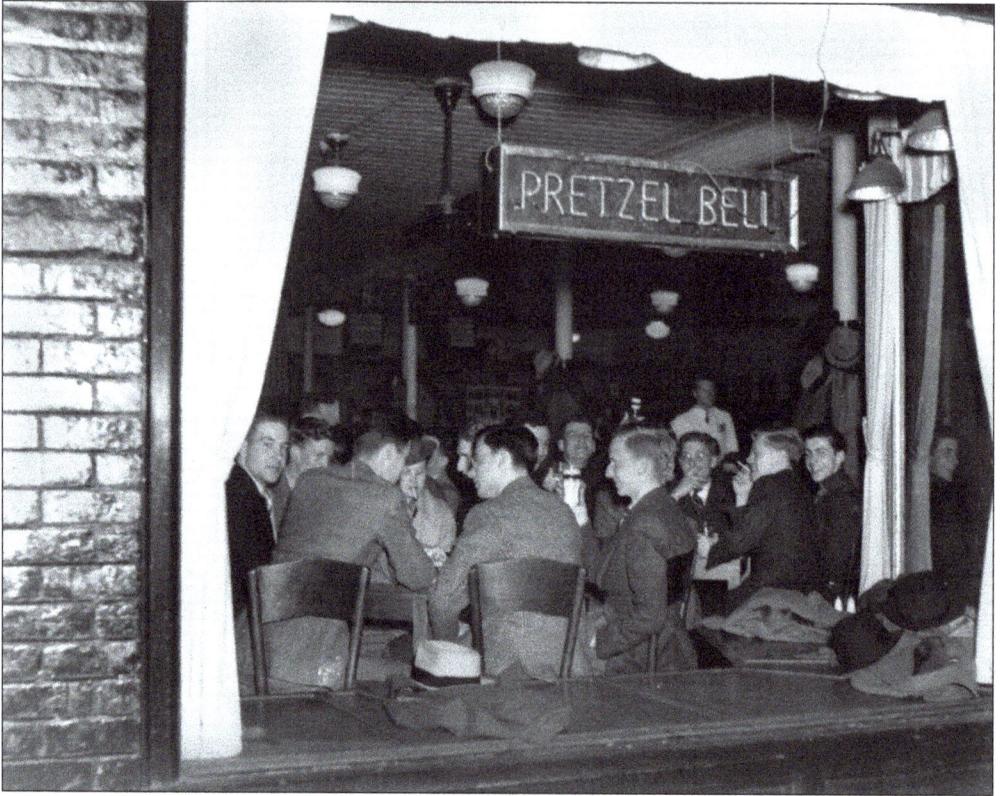

STILL RINGING. Clint Castor Sr. opened the Pretzel Bell in 1934, shortly after the repeal of Prohibition. And from that moment on, the restaurant at 120 East Liberty Street became synonymous with the Michigan "Go Blue" spirit. The Pretzel Bell seemed to celebrate everything Ann Arbor—its past, its present, and, above all, the University of Michigan Wolverines. It was a veritable Ann Arbor museum, featuring the original bar from Joe Parker's Saloon and the richly lacquered (and heavily carved) tables from the Orient. The dinner bell that alerted folks to phone calls once rang for athletic events at Ferry Field; the larger bell that heralded Michigan victories, parties, and milestones was a gift of Alpha Delta Phi. More than 500 photographs, many one-of-a-kind Michigan team photographs dating back to 1883, lined the walls. It was the place to be, and to be seen, from Fielding Yost to Pres. Gerald R. Ford, Charlie Gehringer, Ethel Barrymore, and Artur Rubenstein. Both color snapshots below are from Pretzel Bell in the mid-1970s. (Above, courtesy of Bentley Historical Library, University of Michigan; below, courtesy of a private collection.)

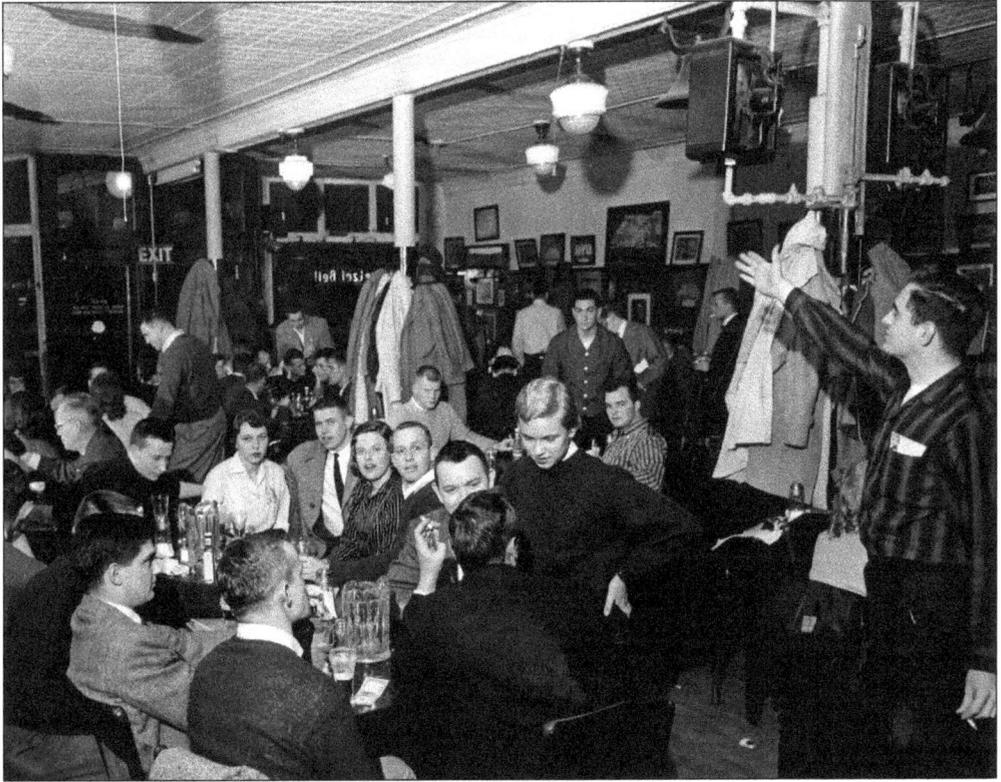

LAST OF THE BELL. Going to the P-Bell was an Ann Arbor rite of passage. It was the place to go to celebrate a Michigan victory—bells ringing, beers raised, and a deafening din, intermittently overshadowed by a chorus of the victors. It was yet another place where Fielding Yost would use plates, glasses, shakers, and utensils to transform his table into a football-oriented variation of a chessboard and challenge students to out-strategize him. In 1936, Leopold Stokowski stood on a chair and led revelers through "The Victors" and "I Want to Go Back to Michigan." It was that kind of place—a party with good food and good beer and lots of Michigan spirit. In time, Clint Castor Jr. (pictured on the right of Clint Sr.) took the helm, and he also opened a short-lived place along South University Avenue known as the Village Bell. The Bells rang up their last sale in 1984, when the Pretzel Bell went dark, and the party was over. (Above, courtesy of Bentley Historical Library, University of Michigan; right, authors' collection.)

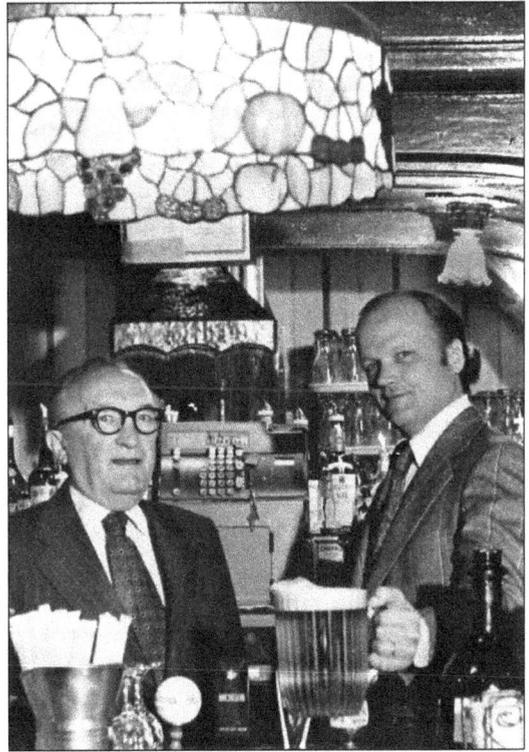

59

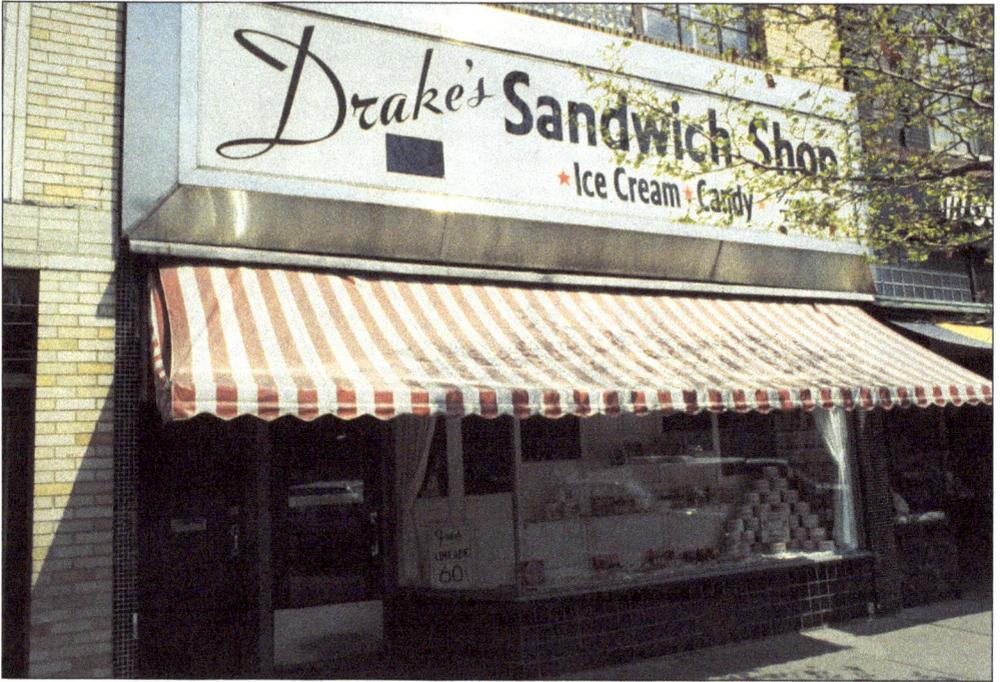

HITS THE SPOT. Drake's gets more wistful looks than just about any Ann Arbor spot. For over 60 years, Truman and Mildred Tibbals perched on stools and held court in this charming candy, sandwich, and tea shop. The hospital-green walls were lined with hundreds of candy-filled glass jars ready to be scooped into iconic red-and-white striped bags by smock-wearing helpers. Chocolate cordials were a favorite, and Drake's was the first to have gummi bears. Many still drool over its fresh-squeezed limeade and pecan rolls grilled in butter or unusual sandwiches like peanut butter and bacon along with a pot of Ty-Phoo tea. Customers ordered by writing on a green pad with a tiny attached pencil. The window displays were also a treat: "electrified" chickens picking at candy corn, and, in the fall, miniature maize and blue footballs. (Both, photograph by Jim Rees.)

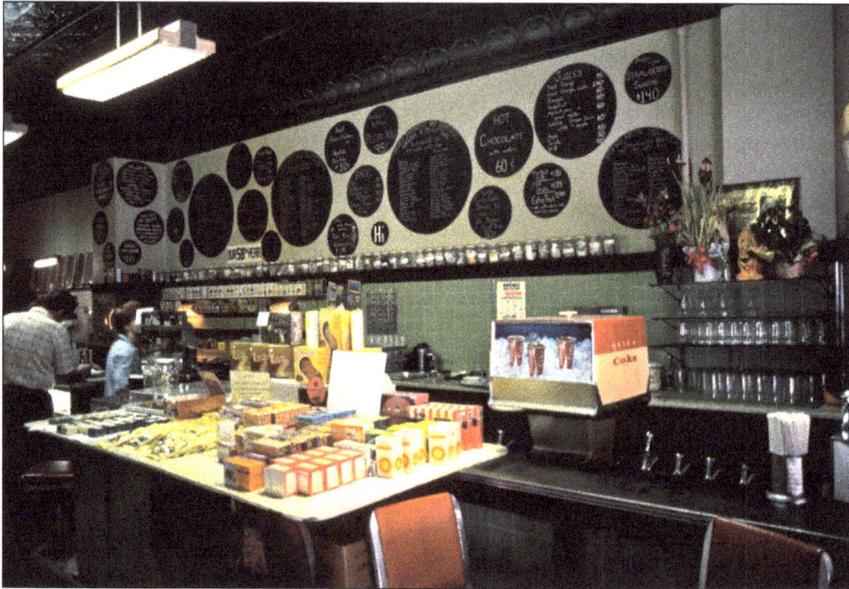

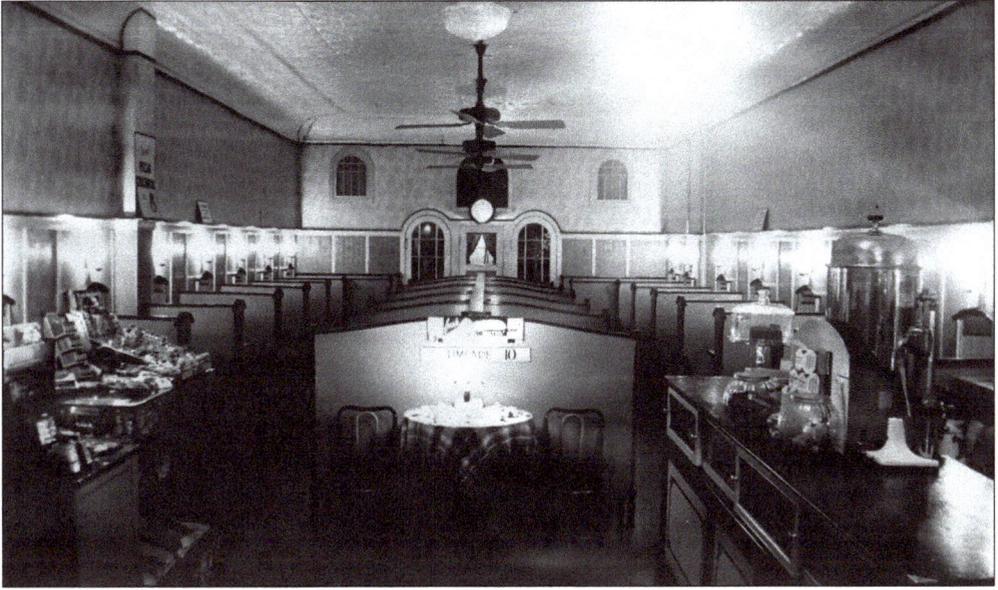

SECRET RECIPE. Drake's upstairs was the Martian Room (formerly the Walnut Room) for dancing in the 1940s, and later, it was a cozy spot for dates to perhaps share a black and white sundae (marshmallow and hot fudge) in one of the high-walled booths. The Stanford sandwich was also popular. Here is the recipe: grind green olives in a meat grinder, drain the olives and add a bit of Hellman's mayonnaise, slather cream cheese on a bagel (or bread), and put the olive mix on top. Drake's was also a hangout for local cops. While working at night, Truman Tibbals would leave the back door open so they could come in and get themselves a piece of pie or a sundae. It was known to dispatchers as a "709"—the address at Drake's. This comfort food classic closed in 1993, but there's no shortage of great food memories. (Above and below left, courtesy of the Bentley Historical Library, University of Michigan; below right, authors' collection.)

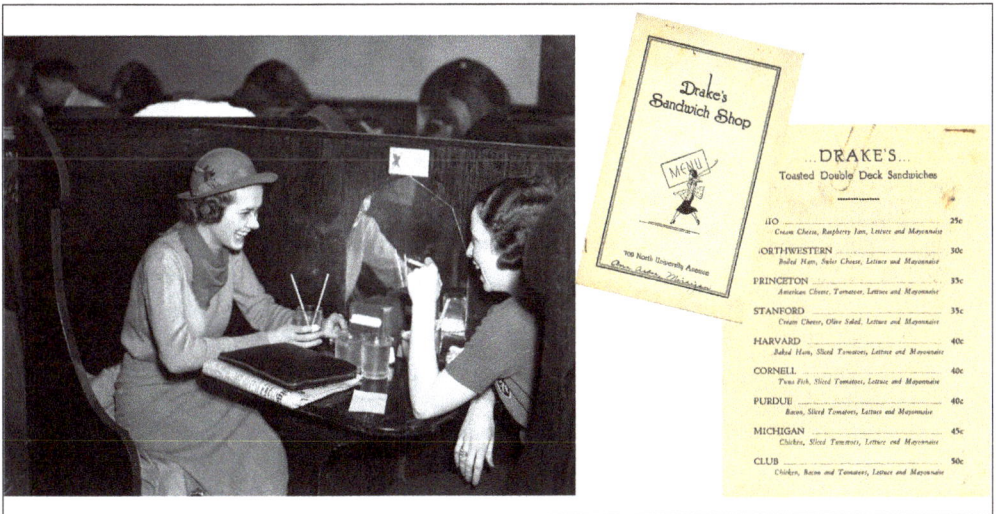

Drake's
Sandwich Shop

MENU

700 North University Avenue
Ann Arbor, Michigan

...DRAKE'S...
Toasted Double Deck Sandwiches

ILO	25c
Cream Cheese, Raspberry Jam, Lettuce and Mayonnaise	
NORTHWESTERN	30c
Boiled Ham, Swiss Cheese, Lettuce and Mayonnaise	
PRINCETON	35c
American Cheese, Tomatoes, Lettuce and Mayonnaise	
STANFORD	35c
Cream Cheese, Olive Salad, Lettuce and Mayonnaise	
HARVARD	40c
Baked Ham, Sliced Tomatoes, Lettuce and Mayonnaise	
CORNELL	40c
Tuna Fish, Sliced Tomatoes, Lettuce and Mayonnaise	
PURDUE	40c
Bacon, Sliced Tomatoes, Lettuce and Mayonnaise	
MICHIGAN	45c
Chicken, Sliced Tomatoes, Lettuce and Mayonnaise	
CLUB	50c
Chicken, Bacon and Tomatoes, Lettuce and Mayonnaise	

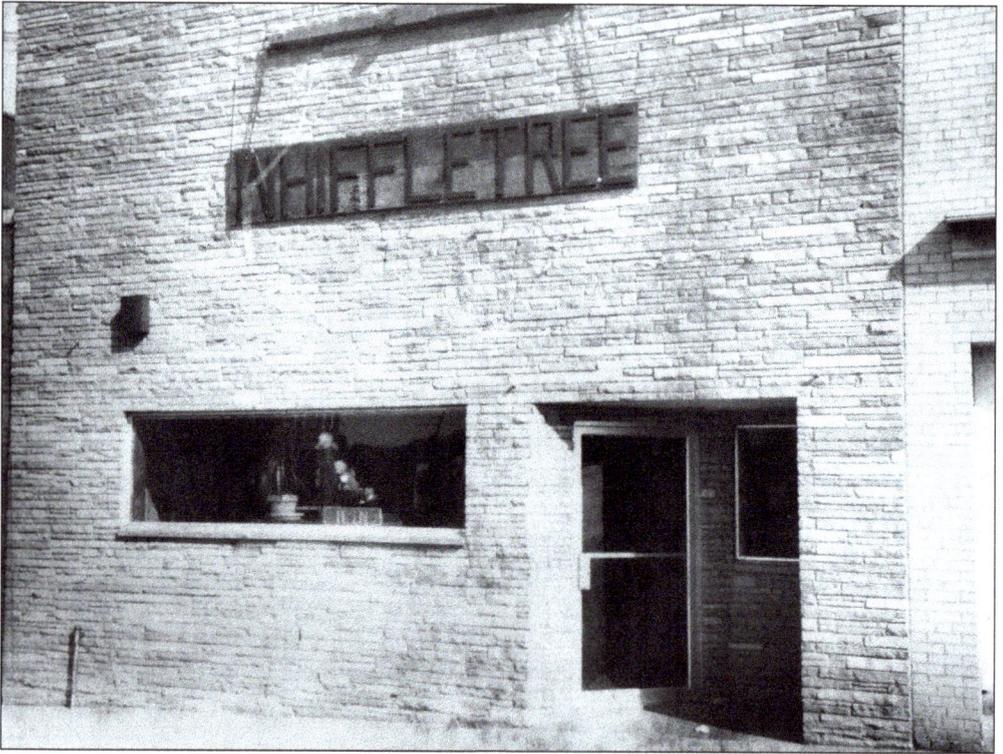

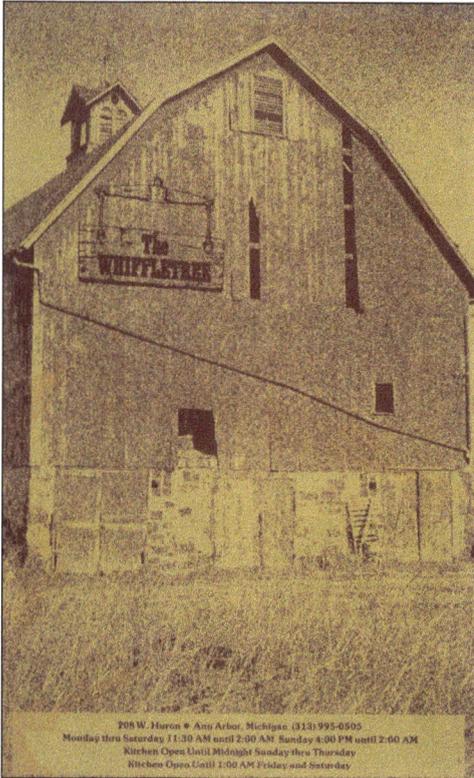

THE WHATCHACALLIT. It was almost called the Whippletree or the Singletree. But the Whiffletree won out, and the former monument company, then the Century bar, was decorated with many of the steering devices that attach to a horse's harness. In fact, the interior was wood from a barn torn down by owners Robbie Babcock and Andy Gulzevan. The Whiffletree on Huron Street was an eclectic place that drew just about everyone from townies to out-of-towners. Successful from its opening in 1973, the menu ranged from affordable sandwiches (the Yosemite Sam burger) to affordable luxuries (Dover sole and other fresh fish flown in daily). Former acolytes can rattle off their favorites, like mushroom caps, king crab legs, and especially the fries. The Wednesday night buffets were legendary—they even included prime rib. Luckily, seating increased from 100 to 340. (Above, courtesy of the Ann Arbor District Library; left, courtesy of the JBLCA.)

LET THE WHISKEY FLOW. Robbie Babcock, who became sole owner after three years (and also owned Robbie's at the Icehouse) remembers one football Saturday where the line to get in was so long that it crossed the street and merged with the line to get into the Old German. The Whiffletree had its share of celebrities, too. Arthur Miller was such a fan that he brought his acting troupe there every time he was in town. Jimmy Stewart, Vincent Price, and Fleetwood Mac ate here, as well as U of M sports legends like Desmond Howard. Even after dinner, there were special touches, like Robbie's mom's angel food cake and their famous Irish coffee. In fact, in an average week, they went through four cases of Irish whiskey—a record in Washtenaw County. Sadly, one summer night in 1987, a fire a few doors down spread and collapsed the roof of the Whiffletree. It was never rebuilt. Almost 30 years later, many still mourn. (Both, courtesy of the JBLCA.)

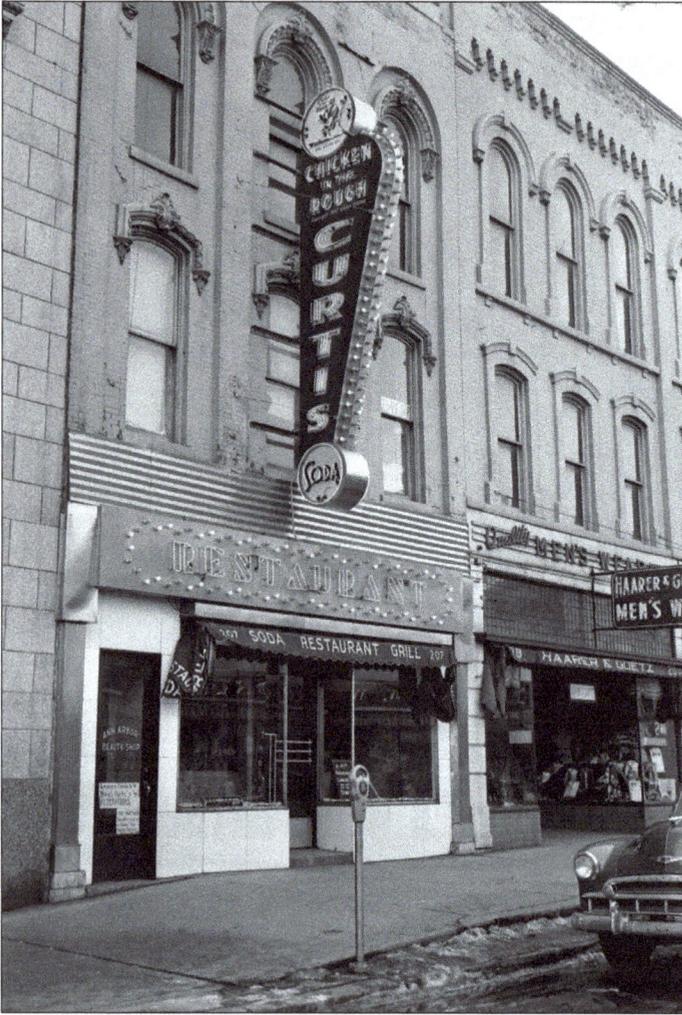

ROUGH START. Chicken in the Rough was one of the first restaurant franchises in the country. Started in 1936 by a Dustbowl couple looking to rebound from the Depression, a Chicken in the Rough dinner was described as "A half fried chicken, served unjointed without silverware, with shoestring fried potatoes, hot biscuits and honey." Along with the meal came a hand towel and a handy (and colorful) Chicken in the Rough finger bowl (below), brought to the table full of sudsy water for easy clean-up. The concept was a big and tasty hit. Over time, it grew to 235 outlets worldwide. Ann Arbor's most notable outpost was the Curtis Restaurant (left), founded in 1947 by George Curtis, who lived above it. (Left, courtesy of Bentley Historical Library, University of Michigan; below, authors' collection.)

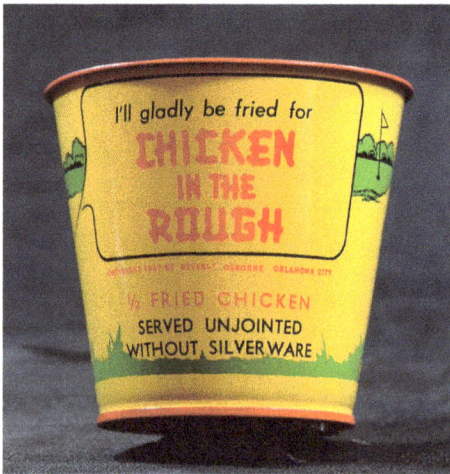

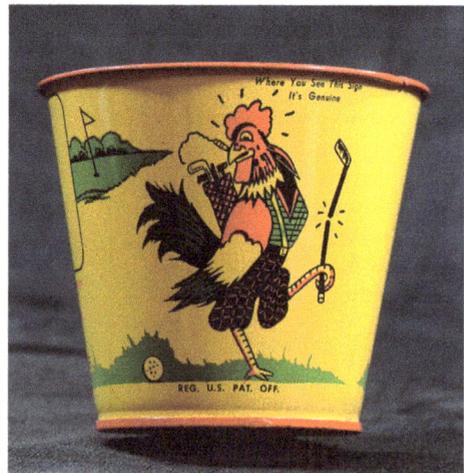

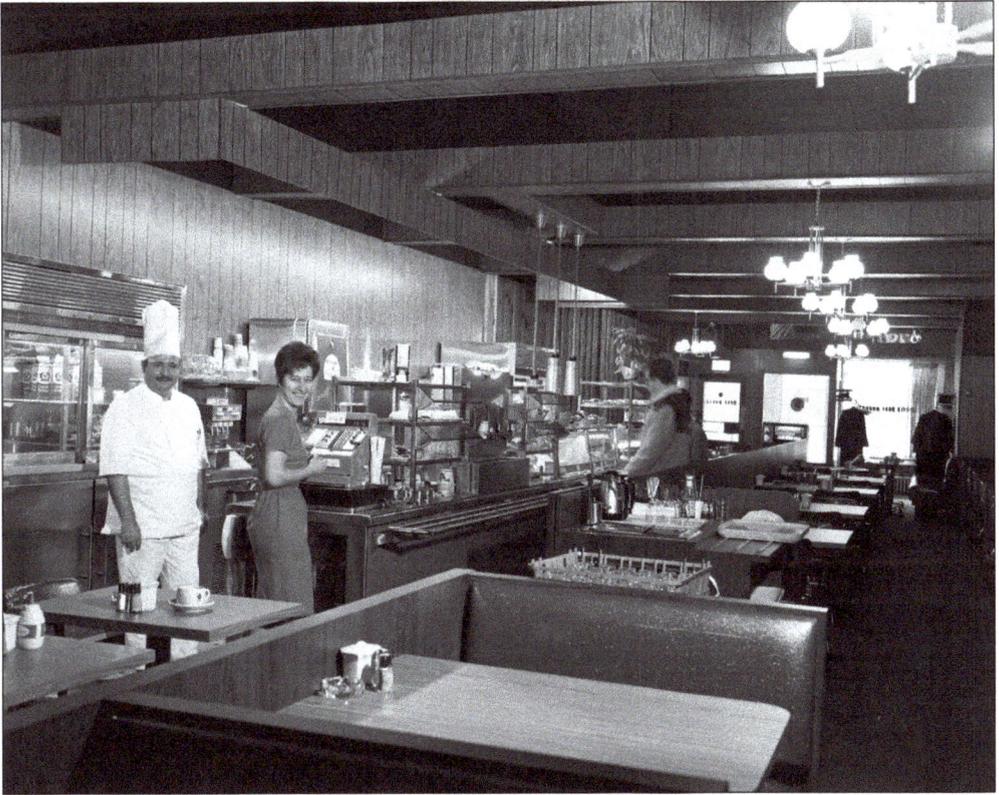

LATE NIGHT BITES. Curtis was one of the first restaurants in town to stay open until 2:00 a.m. Later, it became Curtis Beef Buffet, then the Full Moon Café, and now it is the Ravens Club. To try Chicken in the Rough, head to the Palms Krystal Bar in Port Huron, Michigan—the last US location. It is worth the trip. At one time, Metzger's (below) also featured Chicken in the Rough, and they still display the old sign in their dining room. (Above, courtesy of Bentley Historical Library, University of Michigan; below, authors' collection.)

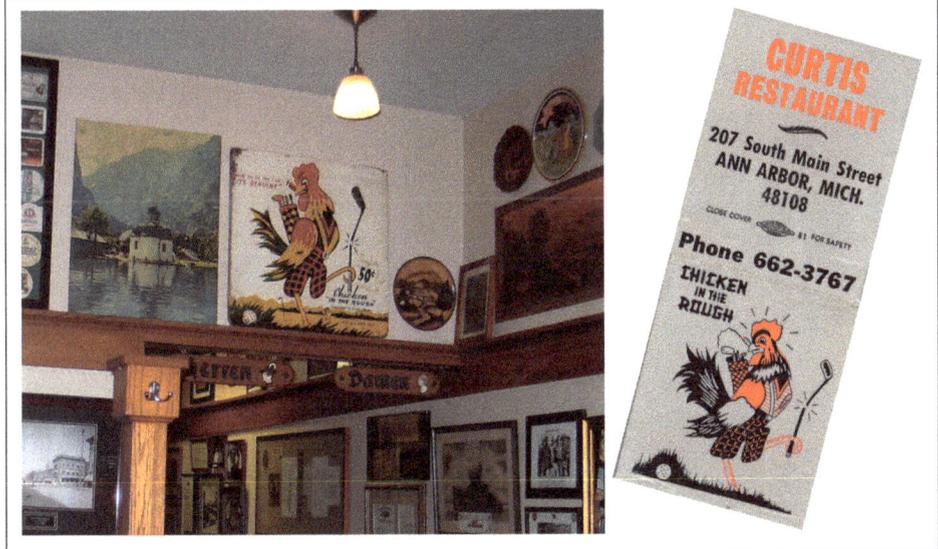

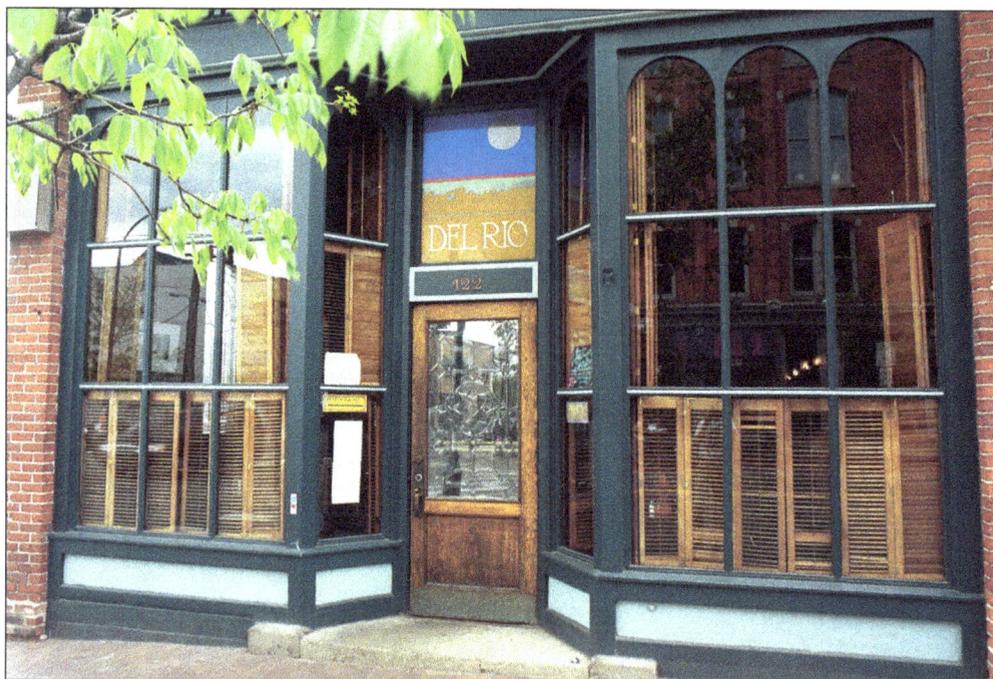

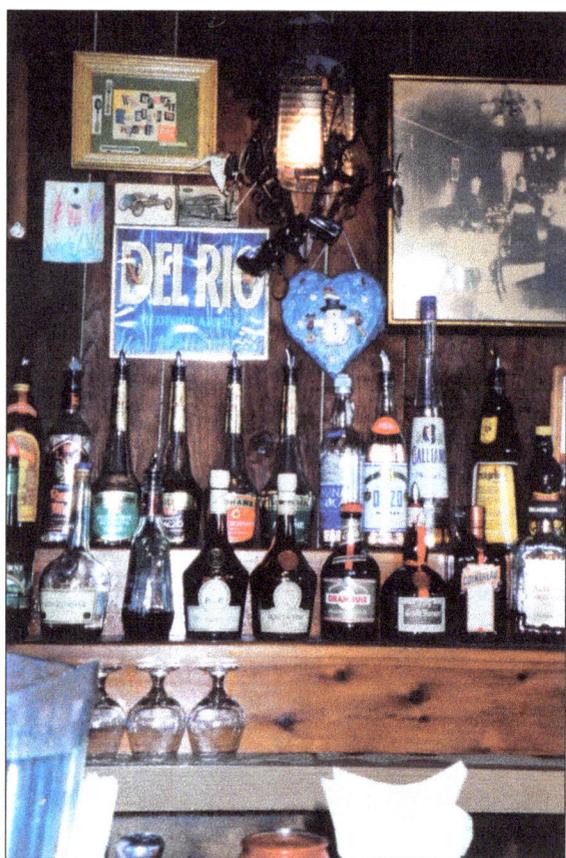

ALL TOGETHER NOW. Part political movement, part social experiment, and all landmark, the Del Rio had the best bathroom graffiti. Started in 1970 by Rick Burgess (who later owned the Earle) and Ernie Harburg (whose father wrote *The Wizard of Oz* lyrics), it ran as a cooperative, with the staff deciding everything. Antiwar and feminist groups met here, part of the cultural mix as eclectic as the music tapes along the walls. Burritos and chewy whole wheat pizza were popular, along with the Zapata and the tempeh Reuben. Many menu items were named after the staff, like the Detburger (named for cook Bob Detweiler). Chef Sara Moulton started here. Amazingly, this hippie halcyon lasted for 30 years. Then new owners changed things up, and the spirit was gone. It closed in 2004. But for many, late afternoon sunlight streaming through the windows, live jazz on Sundays, and sipping a Bass Ale will always be pretty close to perfect. (Above, photograph by Jim Rees; left, courtesy of Bentley Historical Library, University of Michigan.)

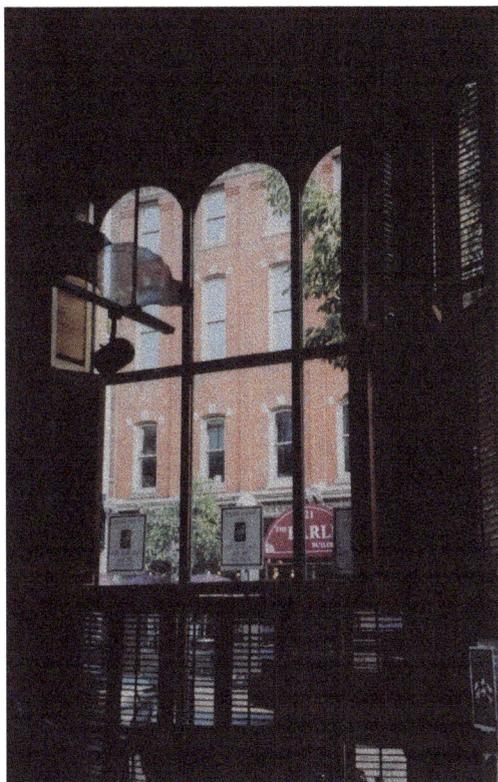

REGULARS. One former Del Rio waitperson remembers a night when the Colombian soccer team came in, broke glasses, and caused general mayhem. In the midst of chaos, a couple came in and quietly ordered burritos and beer. It was not until the next morning that the staff member realized the most normal part of her night had been serving Patti Smith and Fred "Sonic" Smith. Author, historian, educator, incredible source for this book, and all-around mensch Susan Wineberg and husband Lars Bjorn met at the Del Rio in 1976. She calls it "our Bicentennial romance," and they married seven years later. Every August, they celebrated their meeting and wedding anniversary. They always made sure they got their regular big round table near the door. (Both, courtesy of Susan Wineberg and the Bentley Historical Library, University of Michigan.)

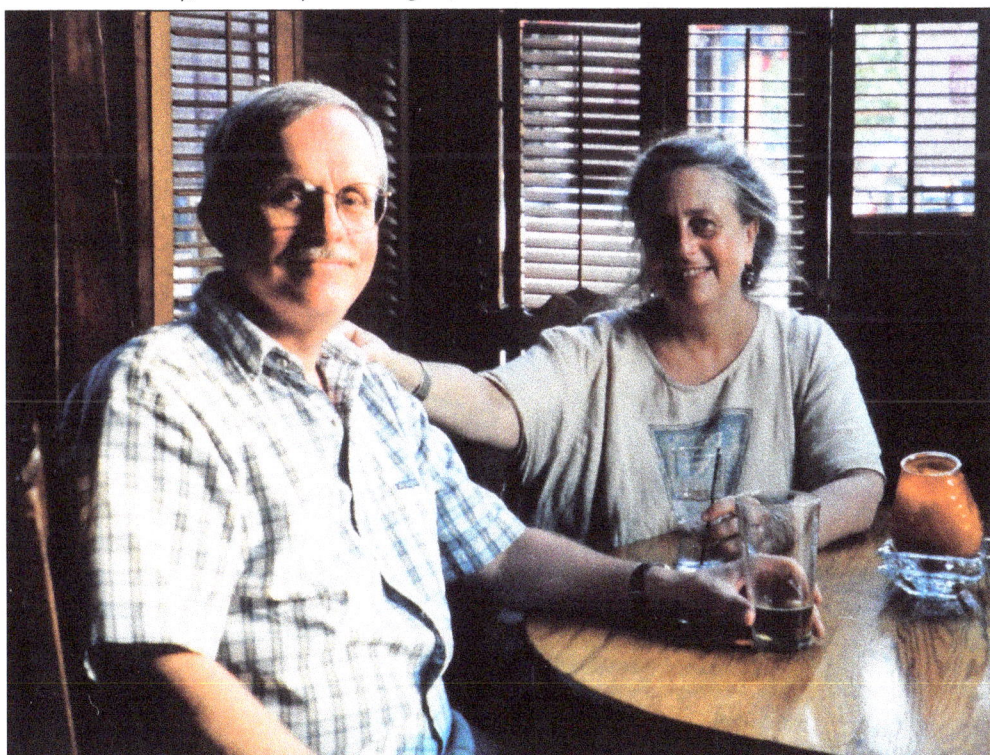

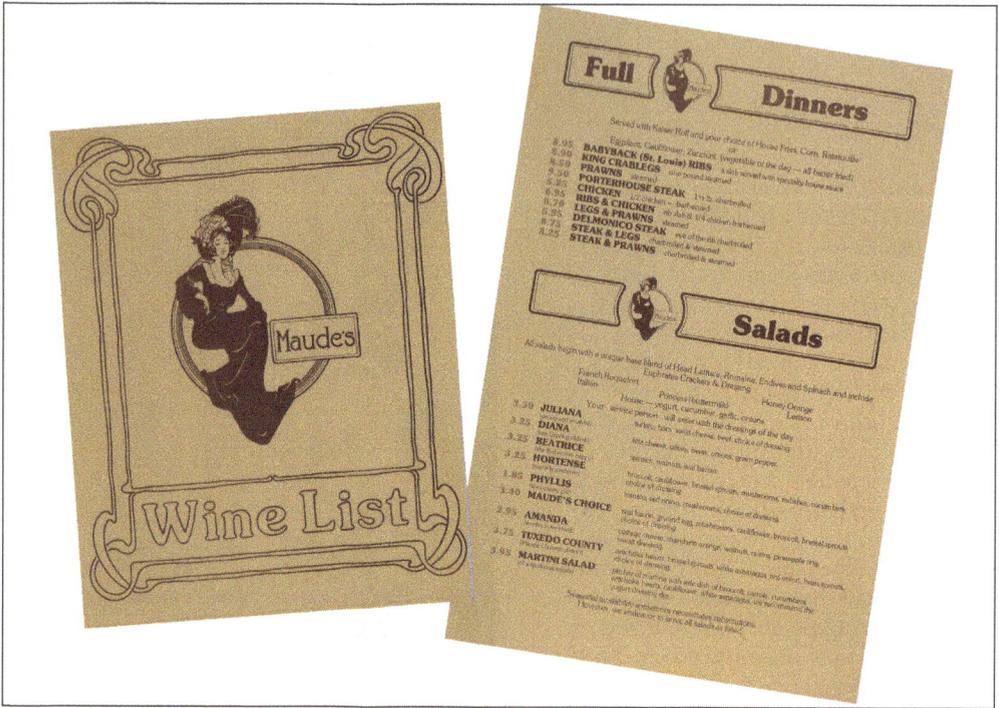

Who Was Maude, Anyway? The building started as an Edsel dealership, and when beloved Maude's opened in 1977 (in what was the Golden Falcon bar), in order to install a dishwasher, they first had to pull out a car lift cemented in the floor. Maude's had an elegant speakeasy feel, with potted palms, leaded glass, and wrought iron. Mention Maude's, and most people lovingly say "ribs." To find the perfect ones, owner Dennis Serras went to the famed Montgomery Inn in Cincinnati. He learned how to cook ribs from the husband, but the wife would not give up the sauce recipe (she called it "job security"). So, after much experimenting, Maude's developed their own sauce. Others fondly remember deep-fried vegetables, chicken with artichokes, and ice cream liquor drinks. Creative entrée-sized salads, prepared at an open salad station, included the martini salad, which was a pitcher of martinis accompanied by vegetables and dip (an early version of ranch called princess dressing). No meal was complete without the amaretto mousse—now it can be revealed that the secret to its velvety texture was marshmallow cream. Many of Maude's cooks and waitstaff now own or work at Ann Arbor icons like Zingerman's, Real Seafood, and others. (Both, courtesy of the JBLCA.)

SEE FOOD. Giant portions of fish and chips, spicy shrimp, great coleslaw, and Dungeness crab starred at the Cracked Crab in 1971. Quality seafood at student prices was served on paper plates. There was always a line, but no one seemed to mind. The restaurant also had a great beer list. The famous neon sign with musical notes was from the Town Bar—there was no music, they just added a crab. Closed in the mid-1990s, it is now home to Café Zola. (Courtesy of the Ann Arbor District Library.)

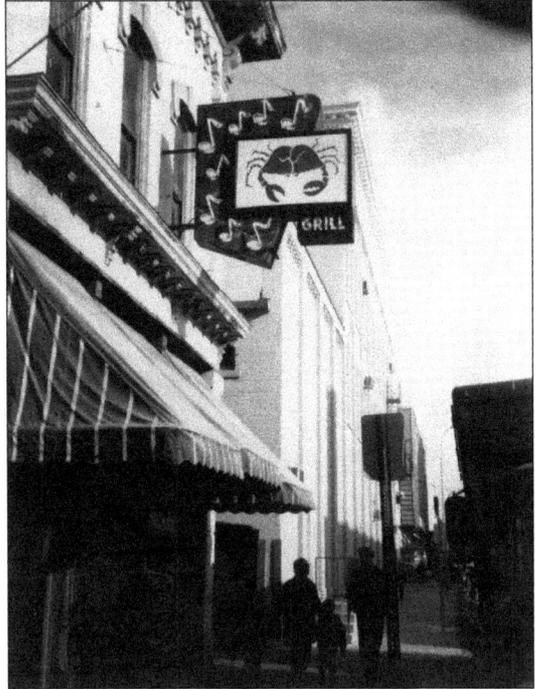

EDEN'S

Ann Arbor's Original since 1969

natural foods
grocery & deli

"Home of the Chapati"

November Specials

All Cosmetics	10% off
All Solgar Vitamins	10% off
Häagen Dazs Pints	$1.49 each

COME SEE!

Grocery: Mon.-Sat. 9-6; Tues. & Thurs. till 8
Deli: Mon.-Sat. 11-7:30

330 Maynard Street (right across from Nickel's Arcade)
995-0147 • 995-0148

EDEN'S

Natural Foods Restaurant

proudly presents

"TREES"

Ann Arbor's own female acoustic duo.

Playing three Fridays:
April 30, May 4 and May 14
6:30–8:30 p.m.

Enjoy dinner accompanied by the pleasant sounds of this accomplished group.

We will be open until 8:30 p.m. on these nights and serving dinner through closing.

330 Maynard
995-0147 • 995-0148

EDEN HEALTHY. The roots of Eden were a natural grains and beans co-op in the Teeguarden-Leabu secondhand clothes store on State Street. It grew through various people and locations, expanding to a retail store and deli on Maynard Street in 1973. Eden Deli was one of the first places in the country to get organic and macrobiotic food. The Sun Bakery was also part of the space, as were sprout and tofu co-ops. Eden Deli had a wonderful cafeteria-style selection, with a signature chipati sandwich made from fermented whole-wheat dough filled with "monster" (Muenster) cheese, sprouts, and hummus. Although the deli closed in the late 1980s, Eden Foods went on to become one of the largest natural and organic food companies in America. (Authors' collection.)

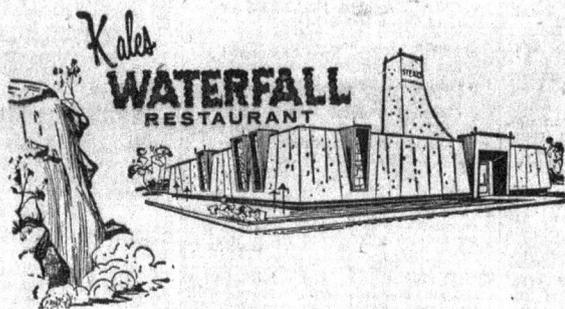

KALES WATERFALL. When James Kales opened his Waterfall Restaurant in 1963, it had the appearance of something pretty much out-of-this world. Kales (with architect James H. Livingston) originally designed it to look like a giant whale. When it materialized, the place featured a 35-foot waterfall and a labyrinth of dimly lit dining "caves." While steak and lobster were the specialties, the ambience was the star attraction. Many still recall the palpable intimacy of dining in the cavern-like culs-de-sac, the soft babble of the waterfall flowing nearby. Kales's son Alex, a professional pianist and singer (and lifelong educator), often provided dinner music, and sometimes there was a band for dancing. Kales sold the place in 1973, but the building and waterfall remained a centerpiece for Lim's Cantonese Restaurant and, later, Szechuan West. The building was demolished in 2011. At this writing, Jimmie Kales is 101 years old, retired, and living in Florida. (Above, authors' collection; left, courtesy of the Bentley Historical Library.)

STILL BURNS. The Lamplighter was a cozy place that everyone seems to miss. It had deep-dish pizza made with a chewy, sesame-topped crust—but that was just for starters. Greek specialties in a small-town diner setting made it feel extra homey. One could not help but feel intimate chatting among friends in the long, narrow, somewhat dimly lit room amid the small tables and booths, even when the place was packed. Near Liberty and Thompson Streets, the Lamplighter became a fast favorite for anyone who happened by, with some pretty heavy hitters among its fans, including Jimmy Stewart, Vincent Price, and even Eugene Ormandy and the Philadelphia Orchestra. U of M basketball teams, among other teams, ate here regularly. Pres. Gerald Ford once had to be turned away because his entourage was more than could be accommodated without displacing regular customers. (Above, photograph by Jim Rees; right, courtesy of the Ann Arbor District Library.)

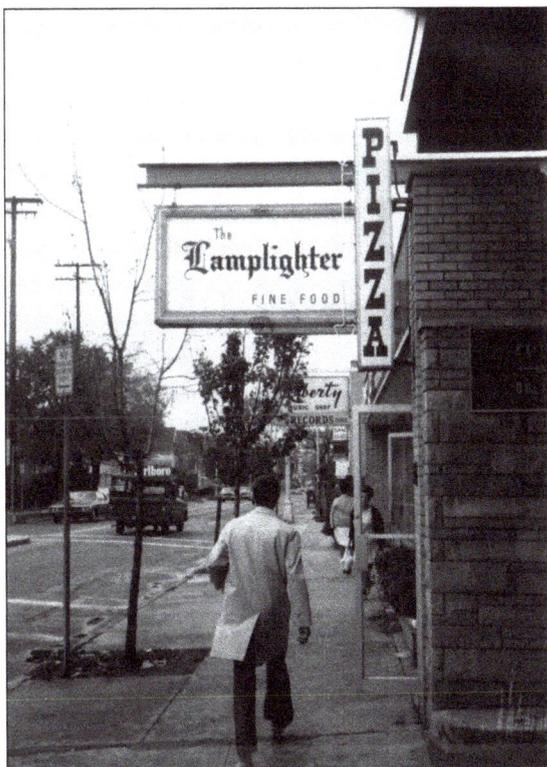

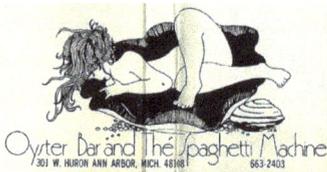

OYSTER BAR AND SPAGHETTI MACHINE. "Fresh plants. No plastic" claims a 1974 menu. Homemade noodles at the Oyster Bar and Spaghetti Machine were a no-brainer. Local legend Greg Fenerli had a pasta-making machine for customers to watch. He even held a patent for a one-handed spaghetti fork. Diners were especially fond of the fettuccine verdi, osso bucco, and garlic salad dressing, all while listening to opera music. It was gourmet yet casual. (Authors' collection.)

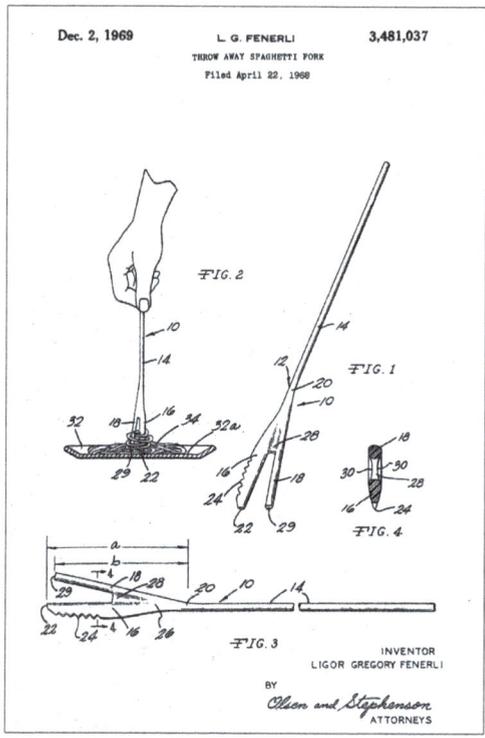

COMFORT FOOD. For over 60 years, one could get blue plate specials like salmon patties, cabbage rolls, and deviled eggs at the Round Table on Huron Street, then Liberty Street. Evelyn Stack started as a waitress, then bought the place in 1966. Regulars sat at the big round table in back, poured their own coffee, and mooned over Evelyn's homemade banana cream pie. It is said more lawsuits were settled in the Round Table than at the courthouse. (Authors' collection.)

Six

STILL HERE AND GOING STRONG

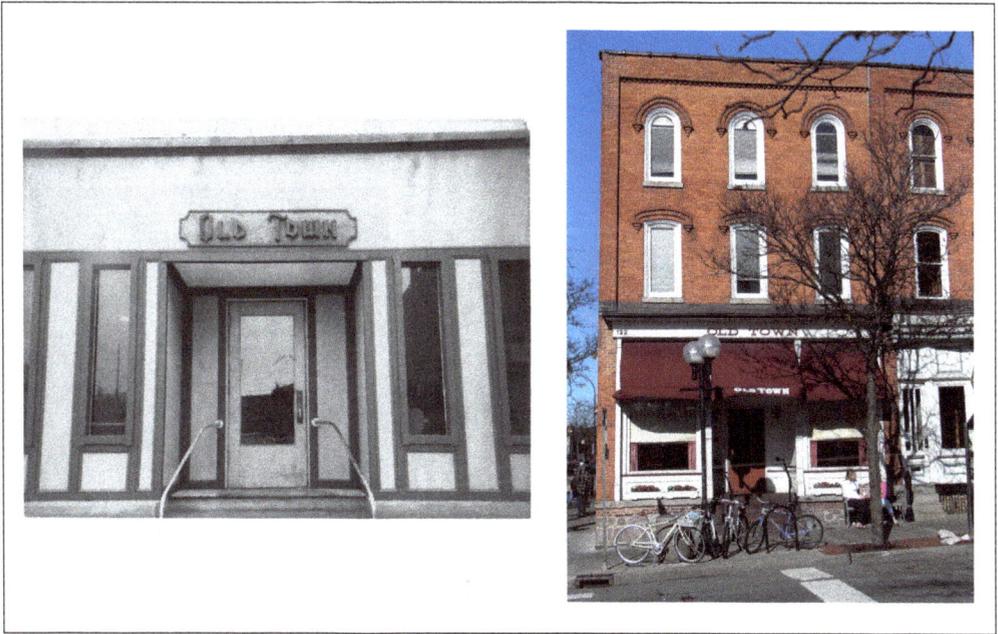

MY KIND OF TOWN. There is good bar karma when a place has been serving guests since 1898. Jerry Pawlicki bought Merkel's Friendly Corner in 1972 and started building up the Old Town by constructing the bar, tables, and cabinets. Early on, the bar opened at 6:00 a.m. for third-shift factory workers. Now, all walks of west siders come to hear music and eat burgers and gourmet grilled cheese. The Chenille Sisters started singing here. Now Jerry's sons Chris and Steve carry on dad's good ideas. (Above left, courtesy of the Ann Arbor District Library.; above right, authors' collection.)

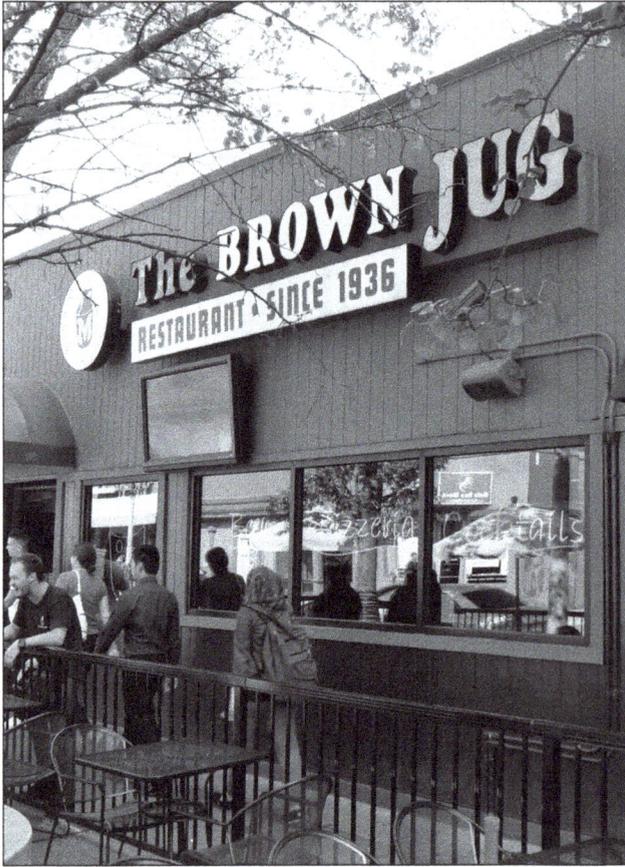

THE JUG. One of the oldest college sports rivalries led to a traveling trophy. And that led to a restaurant. The Brown Jug has been on South University Avenue since 1936. It was named for a jug left behind in Minnesota that Michigan coach Fielding Yost had to win back in the next game between the Wolverines and the Golden Gophers. That was in 1903, and the tradition still continues. So do many of the traditions at the Jug. The huge drink menu reflects that many 21st birthday celebrations are held here. University of Michigan memorabilia lines the walls, to the delight of students, alumni, and fans. Pizza is a favorite, along with food named for some of the former U of M players who chowed down here. Where else can folks get a Charles Woodson stacked ham sandwich? (Both, authors' collection.)

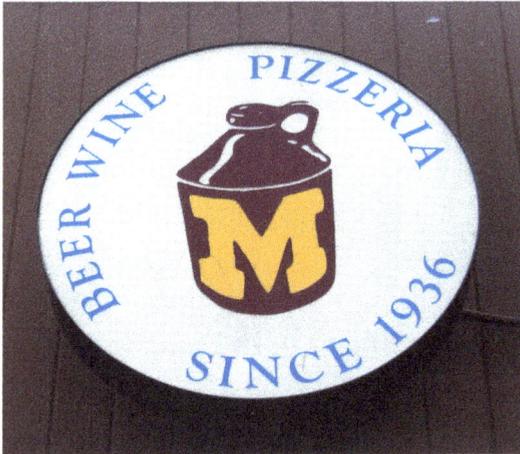

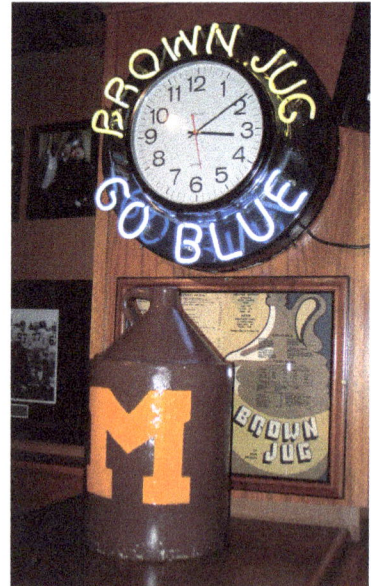

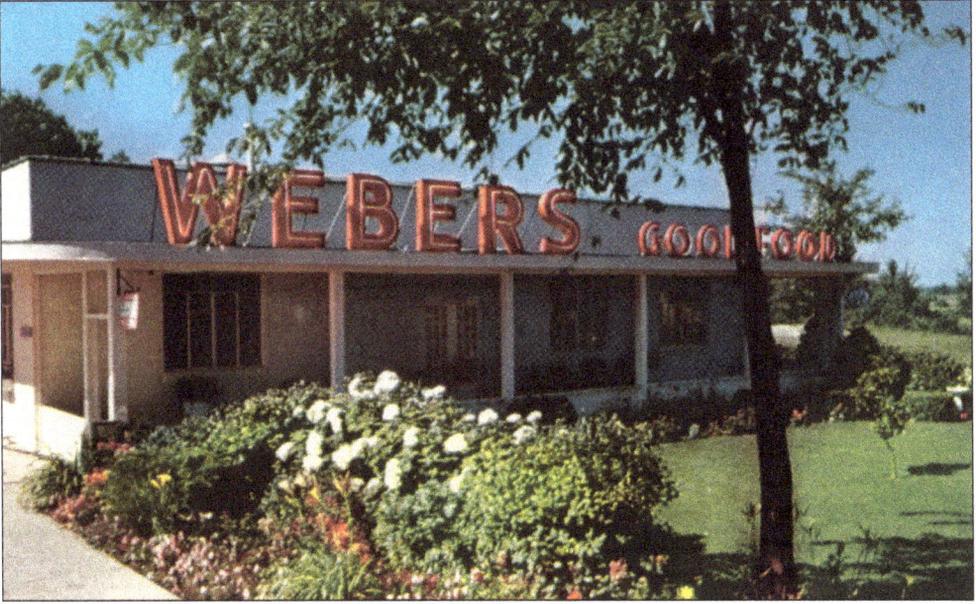

PRIME SPOT. Herman Weber grew up on a farm in nearby Chelsea and later worked as a dishwasher and cook at Metzger's. Along the way, he must have caught the "restaurant bug" because he opened his own restaurant in 1937, just along Jackson Road in nearby Scio Township. During the postwar years, when America took to the highways with a newfound hunger for the open road, Weber decided to add a series of tourist cabins he called Holiday House. By 1962, he moved Weber's to its current site just west of Maple Road, and he eventually added a 158-room hotel. Over the years, Weber's built a reputation for fine food served in an elegant setting and was known for its award-winning prime rib, steaks, and seafood. Today, the prime rib still accounts for nearly 30 percent of the meals served. In 2014, when Herman Weber passed away at the age of 100, he had managed to leave his family and Ann Arbor with one of the finest restaurants around. (Both, authors' collection.)

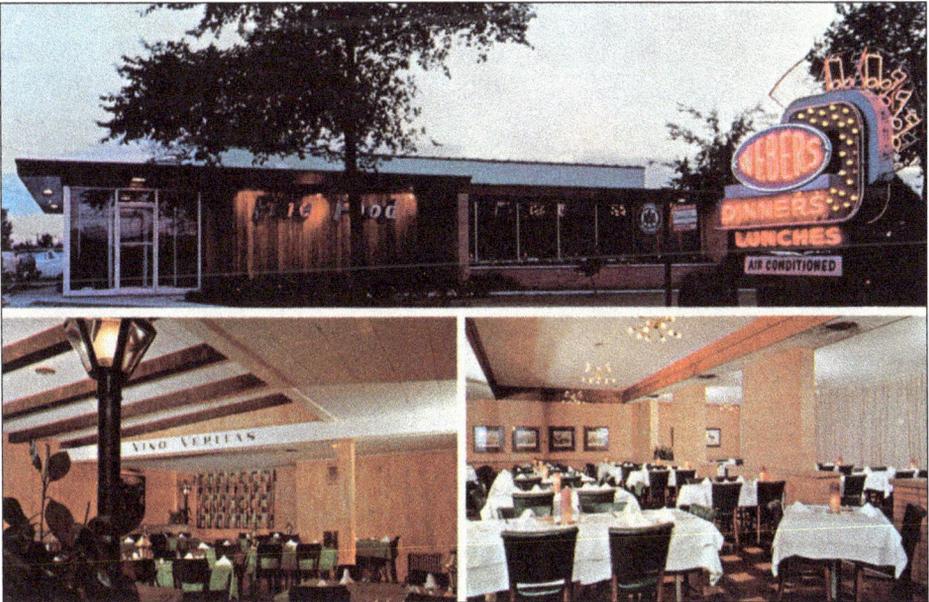

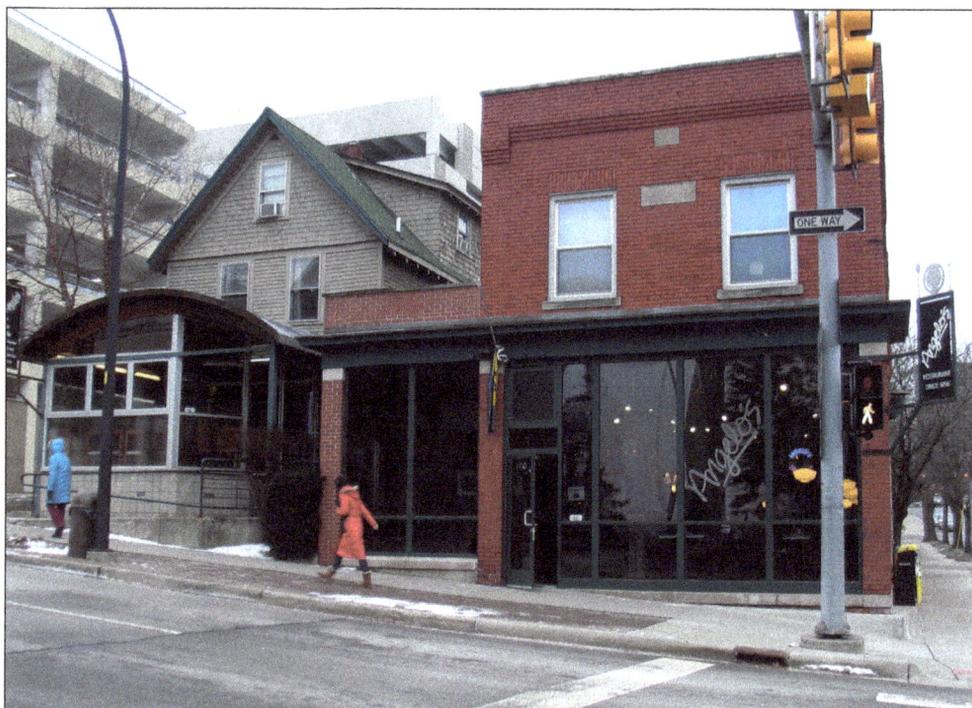

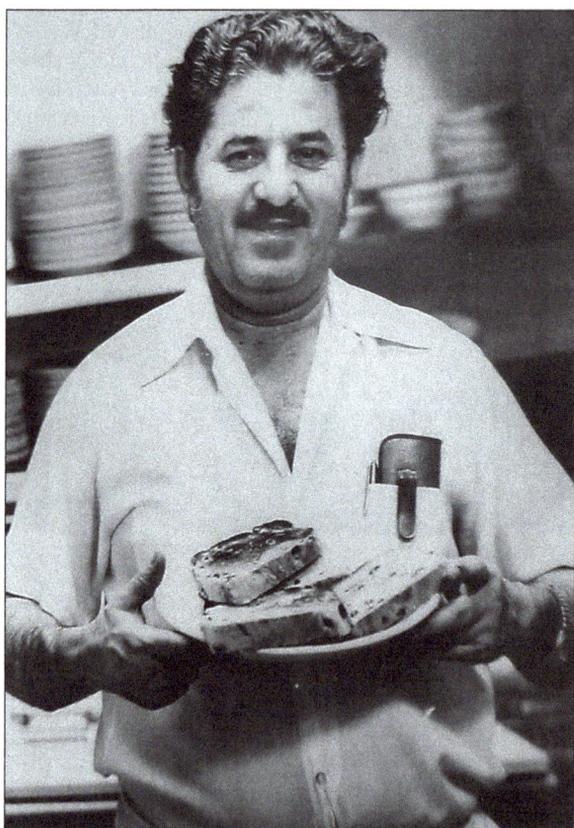

ANGELO'S. The story of Angelo's runs a bit like a movie about the great American dream. In 1951, Angelo Vangelatos (at left) left Greece and sailed for America, settling in Ann Arbor. In the few years that followed, he worked at Curtis' on South Main Street and married Patricia Verames, and together they scraped and saved enough money to buy his own place. In a "truth is stranger than fiction" moment, the place was already named Angelo's. In the years that followed, the cozy restaurant on the corner of Catherine and Glen Avenues became a local favorite, and by the 1970s, the family had to hire additional help to accommodate the ever-increasing flow of customers, with lines often running around the building. By the mid-1980s, Angelo's son Steve and his wife, Jennifer, had taken over the business, and Angelo retired. Sadly, Angelo passed away in 1989. (Above, authors' collection; left, courtesy of Steve Vangelatos.)

ANGELO ON THE SIDE. By the 1990s, Steve Vangelatos (right) expanded the business to include Angelo's On the Side, which serves as a coffeehouse providing Angelo's carry-out service. Both locations are connected via the in-house bakery, which provides the wonderful home-baked breads and raisin toast that Angelo's lovers have talked about for years. (Authors' collection.)

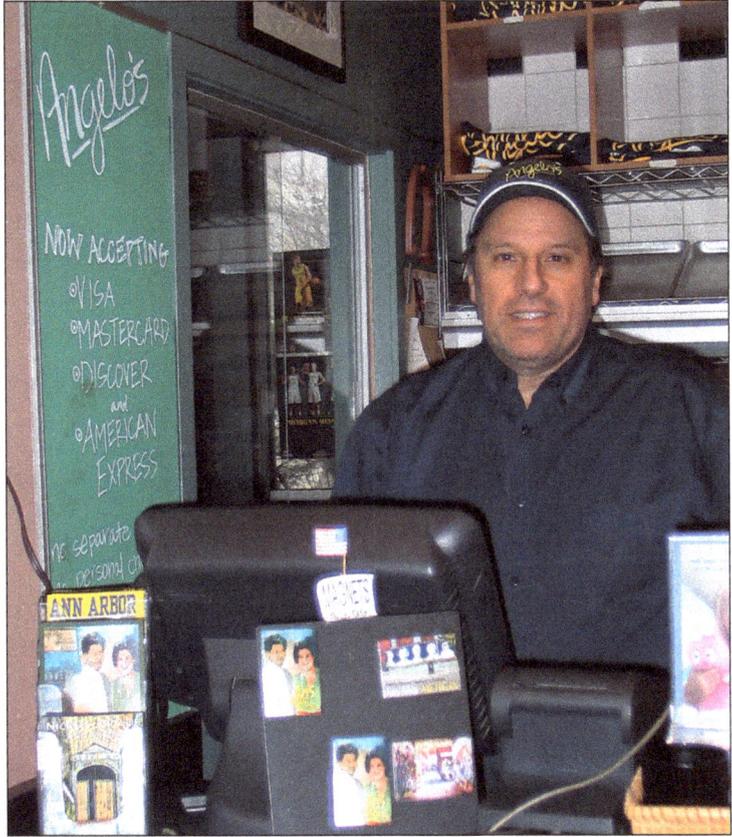

Eggs over easy, a plate of hash browns
Take my hand, mama, we're going to town
Oh, what a wonderful thing to do
Eggs over easy, hash browns and you

We'll have coffee, sausage, and hot buttered toast
Yes, this breakfast is really the most
Oh, what a wonderful thing to do
Eggs over easy, hash browns and you

We'll go to Angelo's, 'cause the place really hops
We'll go to Angelo's, where the service is tops
We'll go to Angelo's, we'll be licking our chops
Mama, we'll pull out the stops - Pop!

DICK SIEGEL AND EGGS OVER EASY. Singer-songwriter Dick Siegel captured the delight of breakfast at Angelo's back in 1980 when he penned his homage, "Angelo's (Eggs Over Easy)." It soon became the official anthem of its namesake and theme song for Pam Rossi's "Over Easy" program on WCXS, 94.7 FM. No stranger to Ann Arbor's iconic restaurants, Siegel even rates his own sandwich at Zingerman's Deli: No. 40, Siegel's Smoky Number. For more on Dick Siegel, visit dicksiegel.com. (Courtesy of Dick Siegel.)

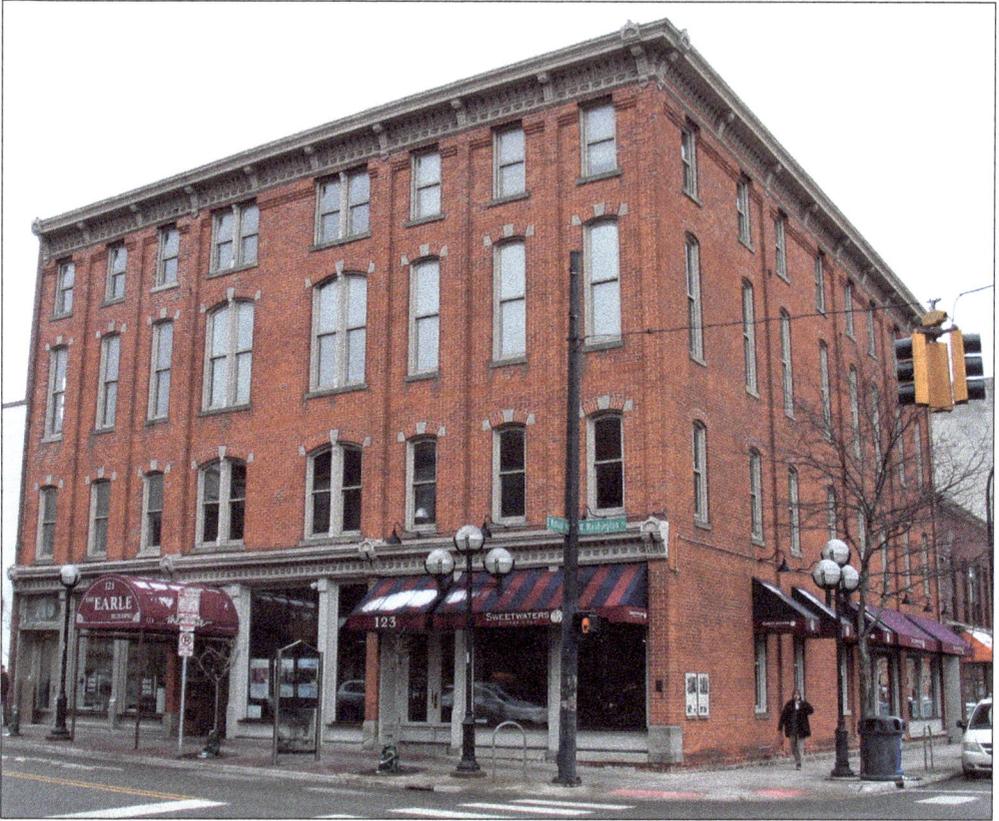

THE EARLE. In 1973, Del Rio owners Ernie Harburg and Rick Burgess decided to fulfil a shared dream and open a music club. Part of their plan involved purchasing and restoring the historic Earle Hotel (originally the Germania Hotel, built in 1885), which had fallen on hard times and faced demolition on several occasions. The process took several years, but when they were done, they had restored an architectural masterpiece and transformed the lower level into the perfect hideaway for live music. They called it the Earle and brought in Dennis Webster and David Rock of the University Cellar Bookstore as partners. Initially, the plan was to feature national acts and offer light dining fare. In the early years, the club hosted the likes of Dexter Gordon, McCoy Tyner, Betty Carter, Sonny Stitt, Ramsey Lewis, Herbie Mann, and the Persuasions. (Both, authors' collection.)

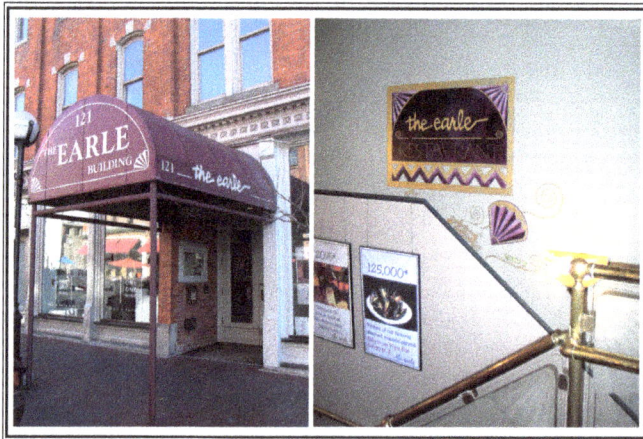

THE MUSIC CHANGES. By 1979, changes were in order. According to Webster (now the sole owner), "We sometimes found it difficult to sell tickets to national acts during the week. Ramsey would get a sparse crowd, here, but sell out Cobo on the weekend." But with so much talent around Ann Arbor, the change of direction seemed an obvious choice: keep the music local and focus on restaurant fare. That is when the Earle began transitioning to a full-scale French/Italian restaurant with world-renown chef Shelley Adams at the helm. It also features an award-winning, 1,200 bottle wine list and flavorful dishes like pistou soup, veal scallopini, and roast duck. (Both, authors' collection.)

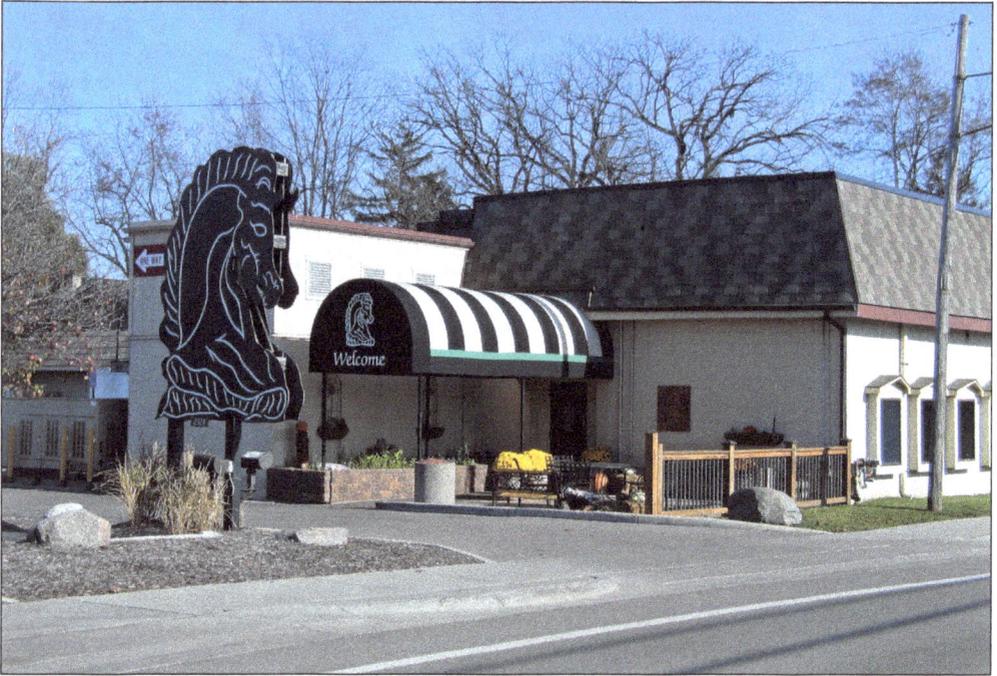

KNIGHT'S. Ray Knight grew up in Ann Arbor and worked at the local market. Then, as his son Don summarizes, "He went off to war, came back and bought the store!" So goes the short-form origin of a tasty Ann Arbor success story. It was 1952, and as modern supermarkets began encroaching on small local markets, Ray decided to convert to a meat market and, according to Don, "paid a 'meat man' from Swift's twenty bucks an hour to teach him the business" (a hefty sum for the 1950s). In time, Knight's meats gained notoriety as the best in town, and today, Knight's provides meat to more than 25 area restaurants. For many years, Ray and his wife, Mary, ran the family business and raised four children in a house next to the meat market. In 1984, they took their dream a step further and opened Knight's Steakhouse on Dexter Road. (Both, authors' collection.)

LONG DAY'S JOURNEY INTO KNIGHT'S. As the years progressed, Ray Knight brought his children into the business, and with their help, he opened a second location in Jackson in 2001. By 2010, Ray completed transitioning the business to sons Don, Jeffery, Raymond III, daughter Sherry, and her husband, Vernon Bedolla. Through their continued leadership, the family has continued to expand the legacy, recently opening Knight's Downtown Steakhouse (above) at Liberty and Maynard Streets and Knight's Kitchen (Jackson Road), a commercial kitchen that offers cooking classes, handles catering, and creates the prepared meals sold at Knight's Market. Yet despite all the many food options now available, "some things never change," says chief operations officer Don Knight. "Our filet is still the most popular cut, followed by Knight's daily lunch and dinner specials—which are practically a menu within a menu." There is definitely something at Knight's for everyone. (Both, authors' collection.)

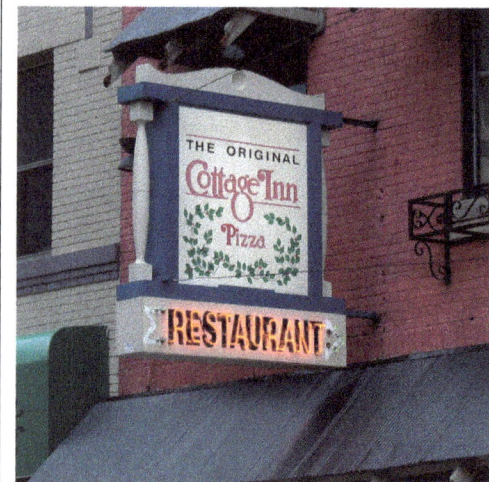

SQUARE ONE. Somebody had to be the first place in town to make pizza, and that was the Original Cottage Inn on William Street, which opened in 1948. Greek immigrant Nicholas Michos bought it in 1961. A kind, generous man who liked funny signs ("Banks don't make pizza, we don't cash checks."), he provided a free community Thanksgiving dinner for over 30 years. It is still family-owned and still makes classic round and square pizzas (try the spicy Mediterranean), pasta, and garlicky cheese bread. (Authors' collection.)

UPSTREAM. When Dennis Serras opened Real Seafood Company (RSC) in 1975, downtown was dead. The malls were hopping. But Serras, who had worked for the respected Muer restaurants, wanted a casual downtown version of the Gandy Dancer. With a name riff on Legal Seafood, Dennis opened with super-fresh catches, signature coleslaw, and even a retail seafood store, which later became Monahan's. Forty-one years later, RSC is still downtown, innovating and renovating. (Above left, authors' collection; above left, courtesy of the JBLCA.)

Seven

The Ann Arbor Food Continuum

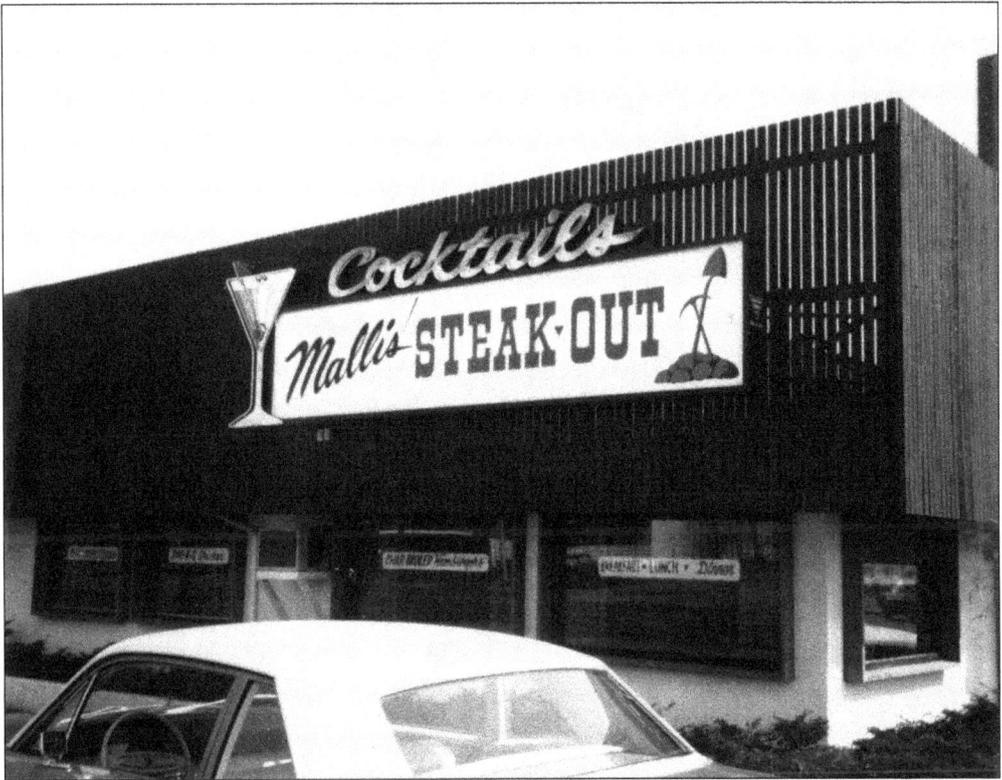

Discovery. Author Gail Offen asked for the photograph of Fowler's House of Pancakes, and coauthor Jon Milan erroneously gave her Mallis' Steak Out (above). "Wait," she gasped, "Isn't that La Pinata?" Suddenly, they realized it is all three. In some neo-Biblical fashion, Fowler's begat Mallis, and Mallis begat La Pinata—same building, different food! Then there is the "Gulvazen Effect," named for countless bars started by Andy Gulvazen himself: Full Moon, Kitty O'Sheas, and many more. Finally, there is "Six Degrees of Kevin Bacon," the Ann Arbor version. Everyone seems to have encountered a future partner along the way. A destiny from Mike Monahan leads to Paul Saginaw and Maude's, then on to Zingerman's. Or Mike Gibbons and Dennis Serras going from the Gandy Dancer to Mainstreet Ventures, with a few others along the way. The authors have dubbed this "The Ann Arbor Food Continuum." Somehow, this town is small enough, yet big enough, to inspire collaborations, startups, start overs, and reinventions. May the continuum continue. And, hopefully, inspire the next generation of iconic restaurants. (Courtesy of the AADL.)

We
Serve
To
Please

THE CHATTERBOX

DUNCAN HINE WAS NEVER HERE
or
HE WOULD HAVE TOLD YOU SO!

8oo SOUTH STATE STREET
ANN ARBOR, MICHIGAN

A RESTAURANT BY ANY OTHER NAME. For nearly 100 years, that low-level brick building with the Italianate arches has stood at 800 South State Street. It is unmistakable, and for most of those years, it was home to the Chatterbox. It was a handy place to breeze in at the corner of Hill Street where one could grab a quick breakfast or a reasonably priced lunch or even meet some friends for an afternoon soda. The place always had a lighthearted flair, as evidenced by the bright orange, mid-1930s menu (left) that flippantly declares "Duncan Hines Was Never Here, Or He Would Have Told You So!" (Left, authors' collection; below left, courtesy of Bentley Historical Library, University of Michigan; below right, courtesy of the Ann Arbor District Library.)

ENOUGH CHATTER. The Chatterbox had quite a run, but by the mid-1970s, it was reborn as the State Street Deli (above left), though externally, little more than the signage seems to have changed. A sub shop replaced it briefly in the 1990s. In more recent years, 800 South State Street has become the home of Quickie Burger Bar and Grill. (Above left, courtesy of the Ann Arbor District Library; above right, authors' collection.)

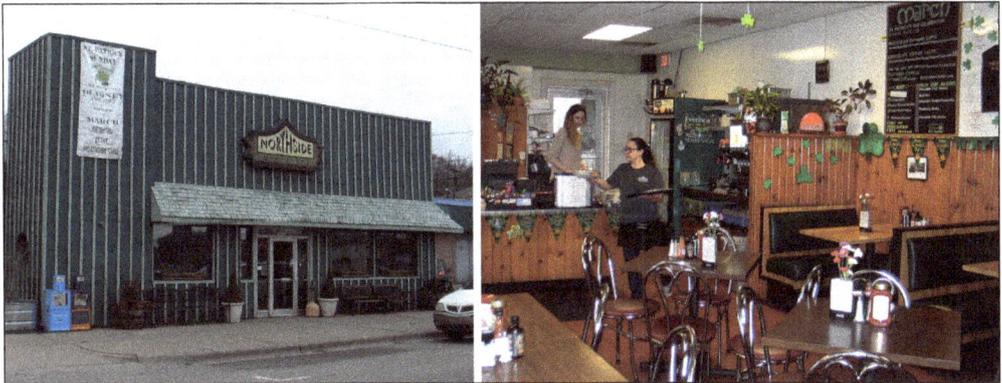

NORTHERN EXPOSURE. Once home to the Cloverleaf Dairy, 1015 Broadway Street has been the Northside Grill since 1993. Over the years, Jim Koli's strictly breakfast and lunch eatery (open daily 7:00 a.m. to 3:00 p.m.) has gained quite a fan base. To go along with its unmistakably warm and relaxed local diner feel, there are more than a few favorites to go around. The four deuces features two of four different breakfast items, and the northsider is by far the favorite breakfast sandwich. Come, dig in. (Authors' collection.)

WATCH THIS SPOT. For many years, the two-story, redbrick building at 328 South Main Street was a small local diner known as the White Spot (above left). Its neon sign still illuminates the mind's eye of many an old-timer, but by 1986, local restauranteur Dick Schubach (Casey's, Red Hawk, and others) had transformed it into the trendy 328 South Main Street. In 1991, the building's menu headed south of the border and reemerged as the Prickly Pear Southwest Café (above right), a popular favorite featuring a tasty twist on what it calls "southwest-inspired specialties." The Prickly Pear is widely known for its celebrated butternut squash soup, and Olympic swimmer Michael Phelps is a big fan of its buffalo meat enchiladas, but with a wide variety of tasty vegetarian dishes to choose from, it is known for appealing to just about every palate. The warm, comfortable wooden booths offer a cozy and romantic intimacy, and in summer, there is dining al fresco. (Above left, courtesy of the Bentley Historical Library, University of Michigan; above right, authors' collection; below, authors' collection.)

GOURMET HEYDAY. Tony and Maureen Perrault truly transformed Best Steak House at 217 South State Street (above left), a cafeteria famous for its Texas toast, into the fine-dining restaurant Escoffier (menu, above right). Terry McClymonds, the maître d' and later co-owner, shaped the elegant, unobtrusive service. Fresh napkins arrived with every course, which may have been cassoulet de fruits de mer, escargot with lime and ginger, or duck with figs and calvados. White chocolate mousse was the signature dessert. Tony was the chef, and Maureen was the sommelier. Known for its extensive wine list, in 1988 it won the equivalent of a wine Oscar from *Wine Spectator*. It moved to the Bell Tower Hotel on Thayer Street and is now Eve. The slate-shingled structure on State Street is now home to Suvai, Taste of India. (Above left, courtesy of the Ann Arbor District Library; above right, courtesy of the JBLCA; below, authors' collection.)

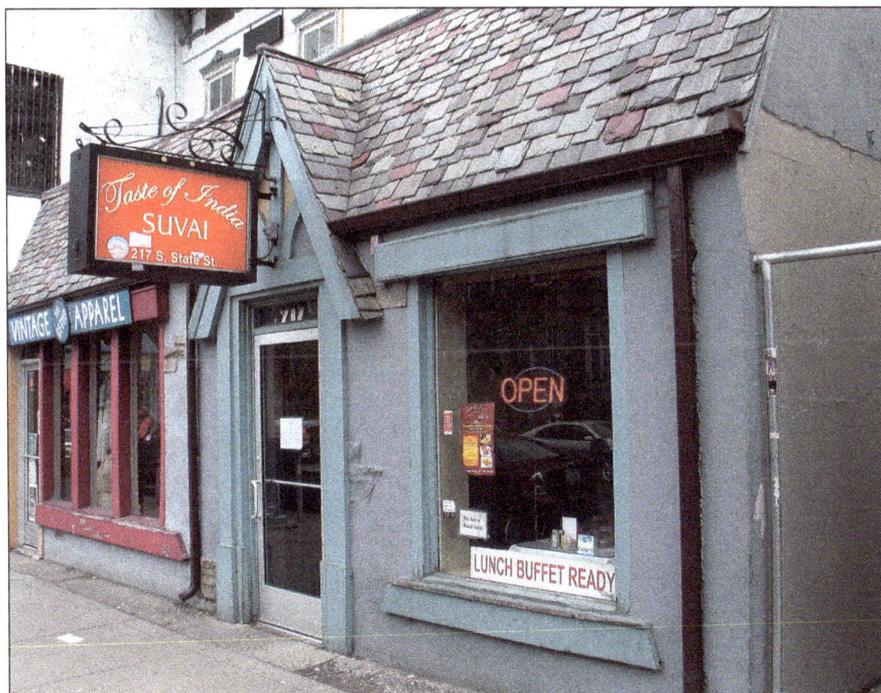

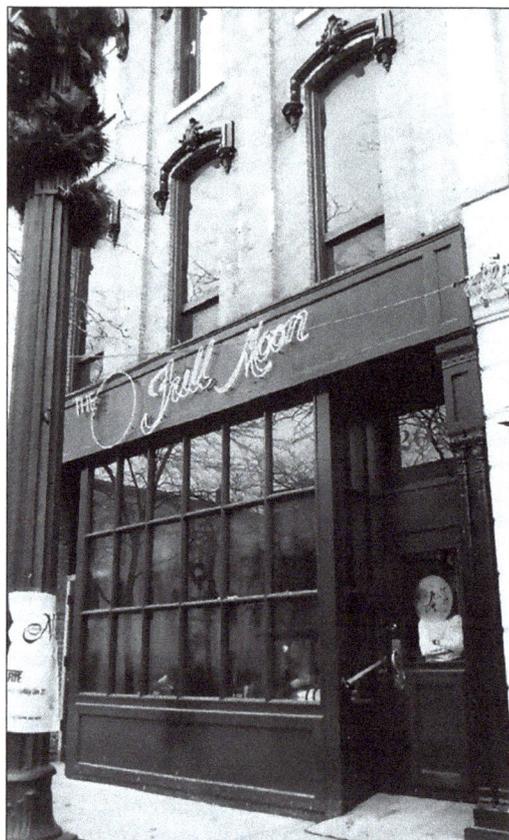

MANY MOONS. The Full Moon had two homes on Main Street around 1982. Owner Andy Gulvezan wanted to create an old Chicago feel. He installed Brunswick bars from the late 1800s he brought from the UP. The Moon had 100 different beer bottles plus a club whose members had their own pewter mugs and even a "Hall of Foam." The favorites were classic bar food: chicken wings and, for many, the best nachos in town. Other quirks included only female bartenders. Some of the waitstaff were U of M cheerleaders who would sometimes do backflips. They also held many charitable events. Everyone from Leonard Bernstein to Miles Davis stopped by the Moon. Andy Gulvezan was the landlord and innovator behind Armadillo Truck Stop, Monkey Bar, Whiffletree, One-Eyed Moose, Kitty O'Sheas, Crow Bar, and many others. When asked about reopening clubs or changing locations, he said, "Sometimes you have to take a step backwards to find exactly what you're looking for." Here is Gulvezan (below, middle) taking the first delivery of Frankenmuth Beer. The city closed down the streets for this. (Both, courtesy of Cindy Edwards.)

FLAME/AUT. In 1953, a Greek sailor named Harry Tselios started tending bar at the Cupid on Washington Street. It became the Flame (above), and more than 40 years later, Harry was still behind the bar. The Flame was a dark, smoky, cozy place that was gay-friendly starting in the 1960s. It was also known for its eclectic jukebox and dead plants in the window. Andy Gulvezan bought it in 1984 and, to the dismay of many, cleaned it up. He moved it to Liberty Street in 1995, where it flamed out three years later. Martin Contreras and Keith Orr met at the Flame in 1986. They turned Martin's mother's Mexican restaurant in Braun Court into the Aut Bar (right) in 1995, a sunny and welcoming place for the LGBTQ community and their straight friends. A popular weekend brunch features specialties like huevos motulenos and strawberry margaritas. Contrera and Orr also run the neighboring Common Language Bookstore and do numerous benefits and fundraiser. (Above, photograph by Jim Rees; right, authors' collection.)

FROM MOVIES TO MANGIA. With a big city but intimate vibe, stepping into Gratzi (left) always feels like the beginnings of a entertaining evening. And that is a tradition, as it started as the Orpheum Theater in 1913. (An original theater token is seen in the inset below). In 1987, Gratzi began its culinary tour through Italy, with its seasonally and regionally updated menu. Opening week was a challenge; the menu was in Italian, and they had not yet translated the names for the kitchen staff, causing confusion. Many *zuppes* and *dolcis* later, Gratzi is a Main Street landmark. Chef John Fischer regularly adds new tastes while keeping favorites like calamari, branzino, mezzaluna pasta, and tiramisu. The restaurant itself gets a face-lift every few years. In fact, while recently redoing the kitchen, they found five layers of floors underneath. No matter what, the bacchanal mural (below) stays, and many people stop by just to toast it. (Both, authors' collection.)

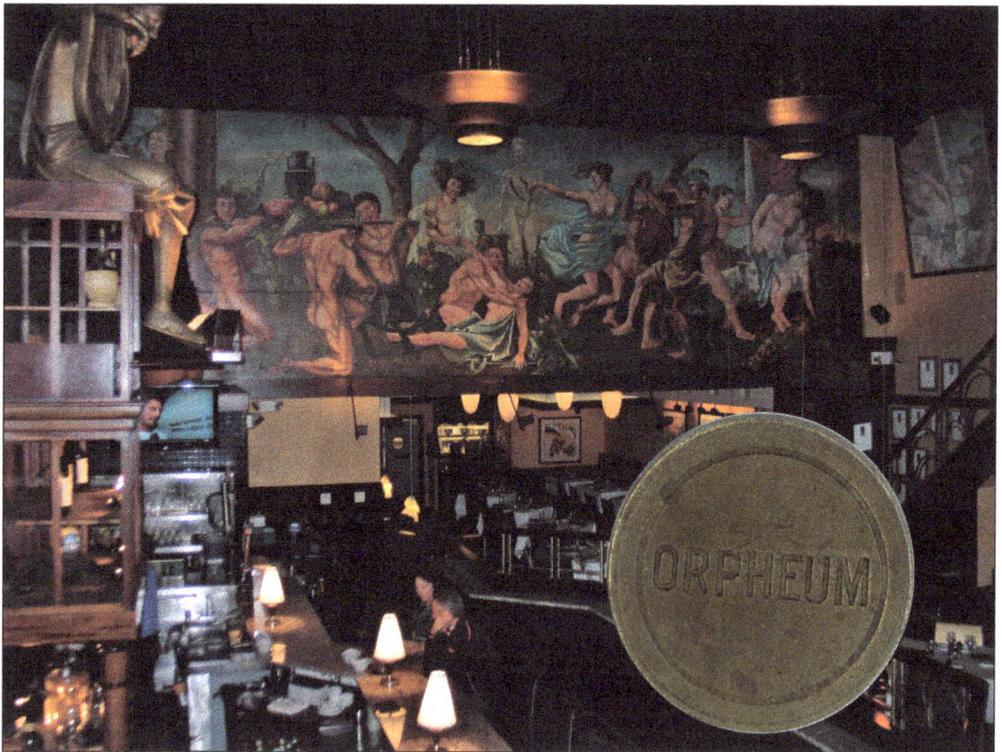

HAWKING GREAT FOOD. In 1992, the building at 316 South State Street broke a 100-year tradition as a bookstore and began providing more to digest than the printed word. That is when the Red Hawk came to roost, offering a unique menu that includes homemade stocks, sauces, and dressings. The Hawk is known for actively supporting local retailers and nonprofits and even features menu items that provide a portion of purchases to the Michigan Theater and the University Music Society. (Authors' collection.)

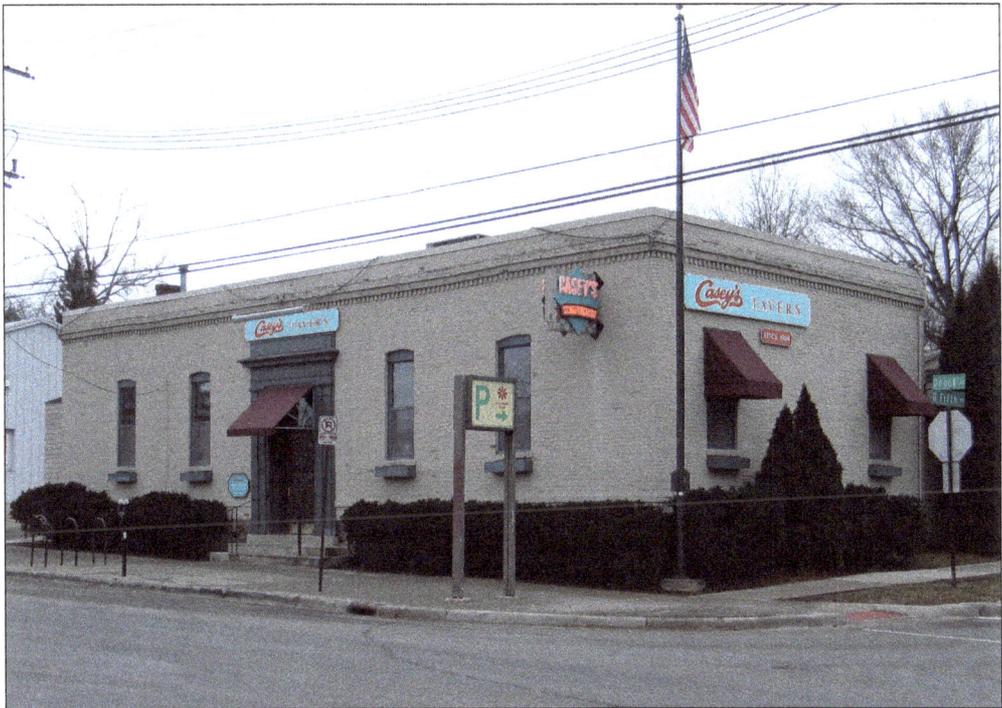

CASEY'S AT THE BAR. Folks can "pull up some lumber" at 304 Depot Street, but they will not find any for sale. Since 1986, the historic building that once housed Washtenaw Lumber has been home to Casey's Tavern (above), several times recipient of Current Magazine's "Best Burger in Town" award—no small achievement in this town! With a full menu and daily blackboard specials, Casey's walks the talk—"Lots of Good Cheap Food and Dozens of Beers." (Authors' collection.)

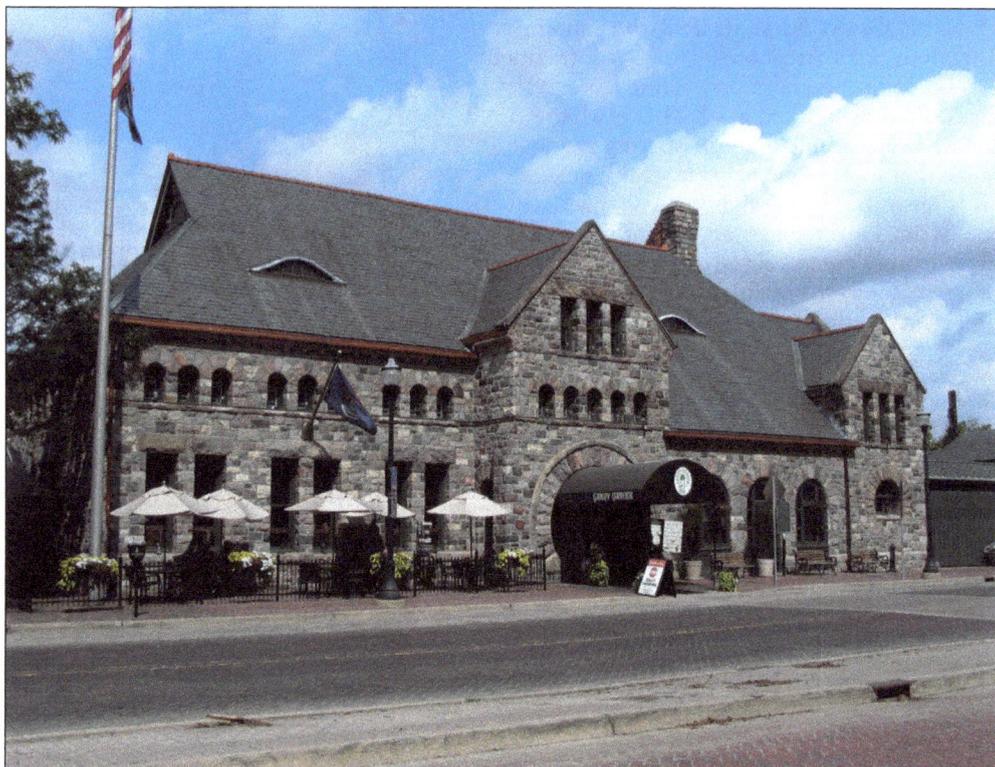

FOOD ON THE TRACKS. It was Michigan Central's finest depot between Buffalo and Chicago. Built in 1886, the Romanesque giant boasted a garden and remained a popular stop for students, celebrities, and politicians until the golden age of train travel came to an end. In 1970, restauranteur Chuck Muer gave it new life as the Gandy Dancer, a restaurant with a railroad theme where waitstaff wore engineer outfits and sang "I've been workin' on the railroad" as trains passed. A Muer meal was an event, and diners enjoyed Charley's chowder, the Down East feast, key lime pie, and salt and poppy seed topped bread. Many future restauranteurs also got their start here, including Mike Gibbons of Mainstreet Ventures, who remembers how they would turn tables by having the pianist play Elton John's "Burn Down the Mission." "Somehow it always did the trick!" Sadly, Chuck Muer was lost at sea in 1993, but the Gandy Dancer, now owned by the Landry Corporation, rolls on. (Both, authors' collection.)

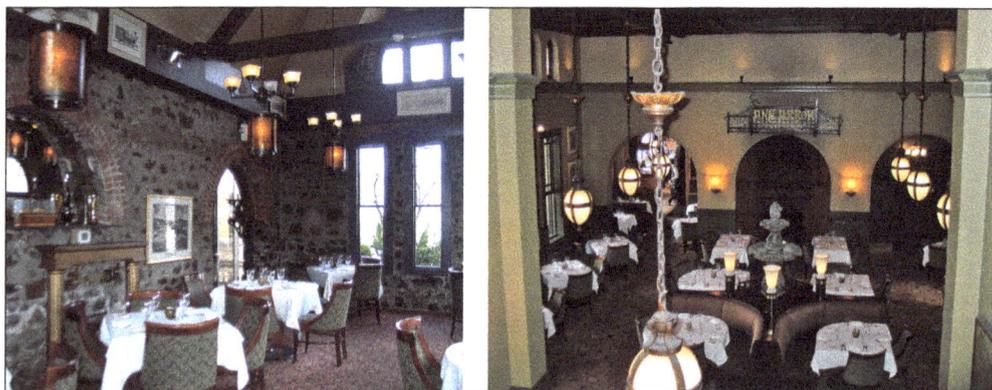

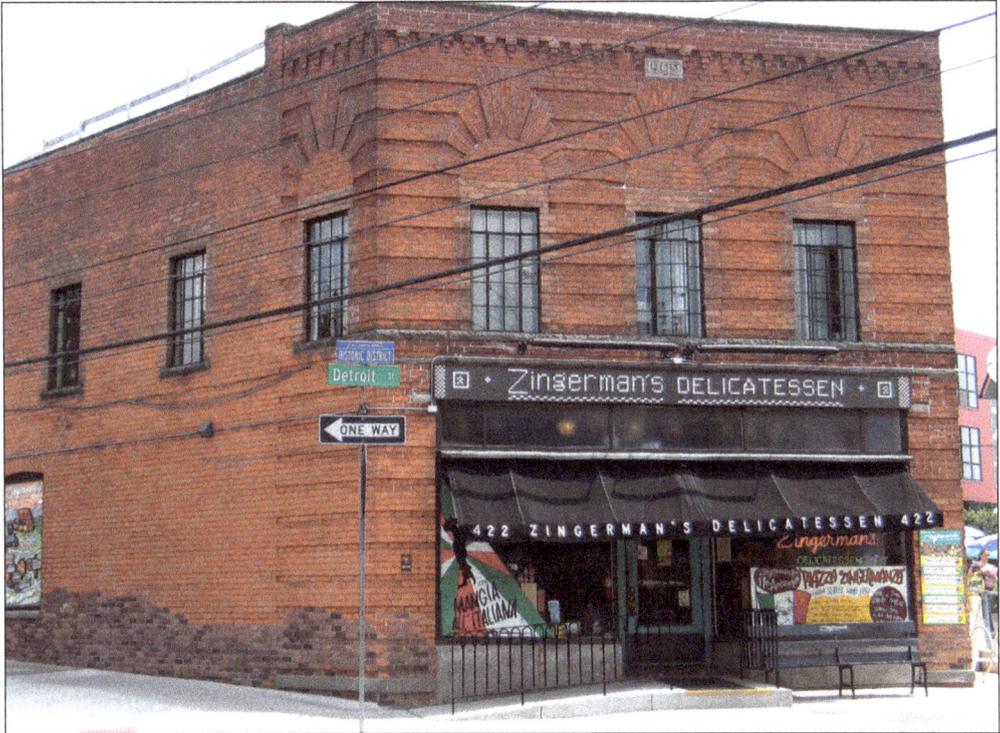

MAKE IT A REVOLUTION ON RYE. Never underestimate the power of pastrami and passion—they can start revolutions. In 1982, Paul Saginaw and Ari Weinzweig, two of Maude's veterans, teamed up and went off in search of genuine, soulful deli food, a quest that soon begat Zingerman's (it was almost named Greenberg's) in an old grocery on Detroit Street. From the beginning, everything had to be up to their now legendary standards, including their commitment of driving 40 miles to Oak Park every day to get true double-baked Jewish rye. Eventually, they decided to make their own, and in 1992, they teamed up with another Maude's veteran, Frank Corollo, to establish the Zingerman's Bakehouse (below left). The mail-order business followed in 1993, and very soon, magic brownies, babka, and monthly bacon club selections were winging their way across the country. The monthly newsletters (below right) became newsy, chatty long-form journalism. Ian Nagy's distinctive art style suddenly had people craving drawings almost as much as the food. (Both, authors' collection.)

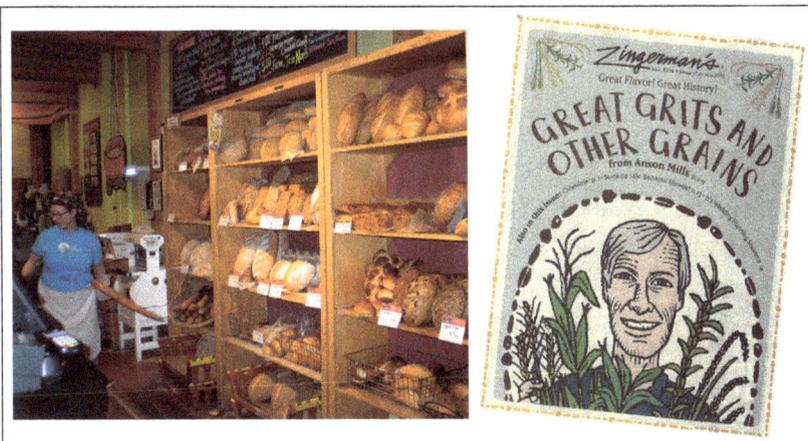

TAKE A NUMBER. THEY ARE DELICIOUS. It is one of the few places people order sandwiches by their number. Even President Obama had one of its Reubens during his 2014 visit. He shared his sandwich, then immediately regretted it. Zingerman's is one of the few places people are willing and even happy to stand in line. During football Saturdays, it is a bit like the DMV but with better smells. (Authors' collection.)

ALL IN THE FAMILY. In time, the Zingerman's Community of Businesses (above left) expanded to include the Creamery (above right); gelato, coffee, and candy companies; and Zingerman's Roadhouse. All this passion has been captured in books and even ZingTrain, a consulting/training business run by yet another Maude's veteran, Maggie Bayless. The Zingerman's philosophy is that every day is a chance to improve. The search for true deli food ultimately led to finding traditional food from around the world. (Authors' collection.)

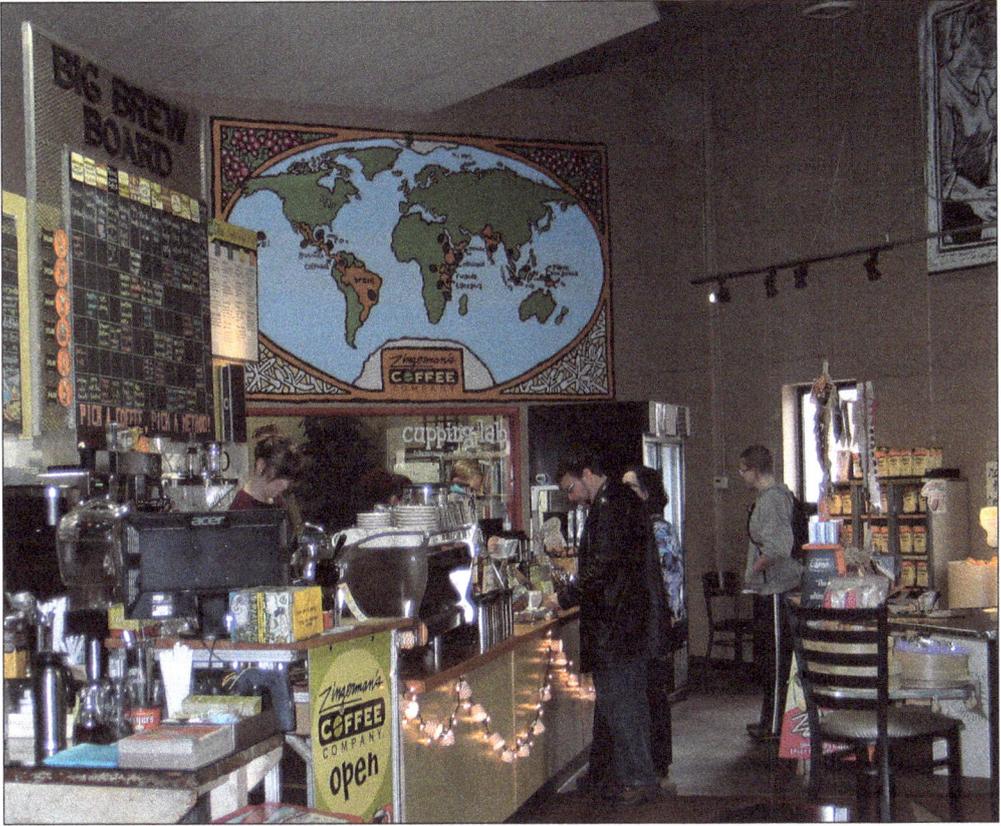

E. PLURIBUS UNUSUAL. Some unique family businesses make only one product wonderfully. Zingerman's makes several wonderful products themselves—like cream cheese, candy, and gelato. "It's all about finding people with the passion and introducing them to our philosophy of 'visioning,'" noted Ari Weinzweig, cofounder. "When people focus on the end result rather than logistical issues, they start thinking about what success looks and feels like, and creative, out-of-the-box ideas flow more freely." Below left, Zingerman's founders Paul Saginaw and Ari Weinzweig are pictured around 1982. Below right, the cofounders are pictured many loaves later. (Above, authors' collection; below, courtesy of Zingerman's.)

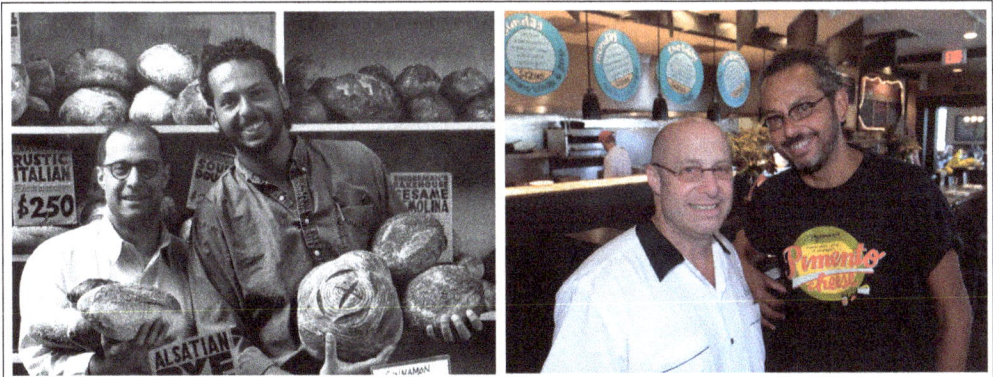

Visit us at
arcadiapublishing.com

· ·

www.ingramcontent.com/pod-product-compliance
Lightning Source LLC
Chambersburg PA
CBHW050640150426
42813CB00054B/1128